MASTER DRAWINGS

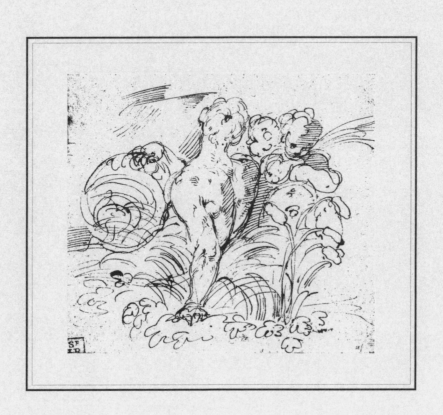

MASTER DRAWINGS

in the Los Angeles County Museum of Art

Bruce Davis

LOS ANGELES COUNTY MUSEUM OF ART

DISTRIBUTED BY HUDSON HILLS PRESS, NEW YORK

PUBLISHED BY
Los Angeles County Museum of Art
5905 Wilshire Boulevard
Los Angeles, California 90036

DISTRIBUTED BY
Hudson Hills Press, Inc.
Suite 1308, 230 Fifth Avenue
New York, New York 10001-7704

EDITED BY
Matthew Stevens

DESIGNED BY
Amy McFarland

PHOTOGRAPHY BY
Barbara Lyter,
Jay McNally & Steve Oliver

PRODUCTION COORDINATED BY
Rachel Ware

TYPESET IN
Truesdell

PRINTED & BOUND BY
Amilcare Pizzi S.P.A.
Milan, Italy

Library of Congress Catalog Card Number
97-73596

ISBN: 1-55595-152-X (CLOTH)
ISBN: 0-87587-180-1 (PAPER)

COVER IMAGE
Catalogue no. 29
Benedetto Luti
Florence 1666–1724 Rome
The Head of an Apostle, 1712
Pastel
16 1/8 x 13 in. (41 x 33 cm)
Gift of the 1996 Collectors Committee, AC1996.29.1

CONTENTS

7

Foreword

8

Introduction

13

Catalogue

239

Index

FORE**W**ORD

WORKS OF ART on paper have been a notable feature of the museum's permanent collection since its opening, in 1913, as part of the Los Angeles Museum of History, Science, and Art. The earliest significant works to enter the collection—gifts from Mr. and Mrs. William Preston Harrison in the 1920s and 1930s—were drawings by what were then contemporary artists: Georges Braque, Charles Demuth, and Pablo Picasso. Drawings by old masters did not enter the museum until the 1950s, when the collection was guided by Ebria Feinblatt, its first curator. Since then growth has been steady, so that each century from the Renaissance to the present is well represented, and the Los Angeles County Museum of Art can now claim to hold its own with other leading American museums. ❧ ❧ ❧ Because of the fragility of the paper and inks, drawings cannot be placed on permanent view alongside paintings, sculptures, and other more durable and stable artworks. Consequently, the museum's holdings of drawings, watercolors, and pastels are not as well known as they might be to the visiting public. *Master Drawings in the Los Angeles County Museum of Art* not only represents an attempt to redress this situation, it reflects the museum's ongoing commitment to publishing its permanent collection. Bruce Davis, author of *Master Drawings* and curator of prints and drawings at LACMA, has contributed handsomely to this goal. His prior achievements include writing catalogues of the museum's holdings in the Robert Gore Rifkind Center for German Expressionist Studies as well as the Cirrus Editions Archive. He has organized a range of exhibitions showcasing the museum's collection of prints and drawings; indeed, the idea for *Master Drawings* originated in one such exhibition, *Why Artists Draw*. ❧ ❧ ❧ Reflecting the historical scope of the collection, *Master Drawings* is organized chronologically; the 104 drawings were selected primarily on their individual beauty and significance as works of art. Their scope—covering over five centuries—is considerable: from Rosso Fiorentino's *Judith with the Head of Holofernes* to Carle Van Loo's *Portrait of an Unidentified Man* to Käthe Kollwitz's *Self-Portrait* to Eva Hesse's *Untitled*. ❧ ❧ ❧ Essential to the growth of the collection have been gifts and financial support from generous donors. In addition to the individuals cited in the credit lines are LACMA's valued "institutional" donors that support acquisitions: the Art Museum Council, the Graphic Arts Council, the Modern and Contemporary Art Council, and the Collectors Committee. It is with great pleasure that we publish some of the fruits of these long-standing efforts. ❧

GRAHAM W. J. BEAL
Director and Executive Vice President
Los Angeles County Museum of Art

INTRODUCTION

THIS BOOK is the first publication to survey seriously the collection of drawings in the Los Angeles County Museum of Art. While it is intended to provide a visual overview for the general public, it also includes the complete histories of each sheet, the first time this information has been gathered together for these drawings. The selection reflects some of the strengths of the collection (Italian old masters) and some of the weaknesses (German, French, and Netherlandish old masters). Some of the drawings (Vincent van Gogh's *The Postman Joseph Roulin* and Winslow Homer's *After the Hunt*) are very well known and have been frequently exhibited and reproduced, while others are not known at all and are published here for the first time. The selection ends essentially with the abstract expressionists because the subsequent generation is not very well represented in the collection. The final work, however, is Edward Ruscha's gunpowder drawing *L.A.* from 1970 because the author deemed it appropriate to end this book on LACMA's drawings with a work by one of the city's most esteemed artists. ❦ ❦ ❦ The museum's collection of works of art on paper was formally recognized in 1947, when a separate curatorial department was established for prints and drawings with Ebria Feinblatt as its first curator; she had begun working at the museum the year previously as an assistant to director-consultant William R. Valentiner. The public art collection in Los Angeles was founded in 1913 as a division of the Los Angeles Museum of History, Science, and Art (note the order!). As in many museums without established collections of graphic art, acquisitions of works of art on paper were made only sporadically and without a definable goal. The first drawings, some minor American watercolors, were acquired in 1920, and a second gift was received in 1924. The earliest important gifts of drawings were from the William Preston Harrison collection, given primarily during the 1920s and 1930s. The Harrison collection is the foundation of the museum's holdings of modern drawings, with particular emphasis on the early-twentieth-century school of Paris. During the 1920s and 1930s the Harrisons bought actively in Paris on the advice of artist André Lhote, and over the course of several years they donated about one hundred drawings and watercolors. Among the significant European works from the Harrisons in this book are drawings by Georges Braque, Marc Chagall, Edgar Degas, Fernand Léger, and Pablo Picasso; among the American works are outstanding drawings by Mary Cassatt, Charles Demuth, Preston Dickinson, Childe Hassam, Joseph Pennell, and Maurice Prendergast. One of the strongest local supporters of the museum was the Mabury family, and in 1939 the museum received the splendid Winslow Homer watercolor and a group of drawings and sketchbooks by Edward Burne-Jones, including the magnificent cartoon of the risen Christ included here. ❦ ❦ ❦ In the late 1940s the Hollywood songwriter and motion picture producer George Gard De Sylva worked with Valentiner on the donation of a collection of art for the museum. Incredibly, De Sylva was able to purchase for relatively modest amounts paintings by Degas (*The Bellelli Sisters*), Camille Pissarro (*Place du Théâtre Français*), and Henri de Toulouse-Lautrec (*The Opera "Messalina" at Bordeaux*), as well as drawings included here by Vincent van Gogh and Odilon Redon. ❦ ❦ ❦ Until 1953–54 the only old master drawings in the collection were a handful of anonymous sheets. At that time, however, sixteen seventeenth- and eighteenth-century Italian drawings were purchased (for a total of eight hundred dollars) from German art historian Hermann Voss, who needed to sell them because

of postwar economic hardships in Europe. This group included drawings here by Gaetano Gandolfi, Rutilio Manetti, and Francesco Solimena. Since that date the museum's collection of old master drawings has grown fitfully, almost entirely through purchases, and principally in the area of Italian seventeenth-century drawings, the area of specialization of Ebria Feinblatt and the author. The only important private collection of old master drawings in Los Angeles was owned by Norton Simon, and the museum hoped and expected that collection to provide a foundation similar to that of the Harrison collection. When Feinblatt wrote a modest handbook in 1970 surveying the museum's collection of drawings, it was enhanced substantially by the inclusion of sheets in Simon's collection by Antoine Watteau and Rembrandt van Rijn. In the 1970s, however, relations cooled between the collector and the museum; the paintings were removed to the newly established Norton Simon Museum in Pasadena, and the drawings were sold. ▼ ▼ ▼ Since Victor Carlson came to the museum in 1985 after Feinblatt's retirement, attention has shifted to his area of specialization, the French school of the eighteenth and nineteenth centuries. Outstanding drawings acquired by him include works by Rodolphe Bresdin, Degas, Eugène Delacroix, Pierre-Paul Prud'hon, Hubert Robert, and Carle Van Loo. ▼ ▼ ▼ Before the museum moved in 1965 to its present site in Hancock Park, essentially the only source of acquisition funds for the department was distributed at the director's discretion from the annual allocation of twenty-five thousand dollars (for the entire museum) from the County of Los Angeles. From this meager amount Feinblatt was able to garner support for the purchase of sheets by Hans van Aachen, François Boucher, Francesco Guardi, Pellegrino Tibaldi, and Giovanni Domenico Tiepolo. Since 1965 the principal source of funds for acquisition has been the Graphic Arts Council, formed in that year by Feinblatt and a small group of interested collectors. Through a variety of fundraising methods, including the sale of prints commissioned from contemporary artists and art auctions, the council has supported several significant purchases of drawings; included here are works by Baccio Bandinelli, Aubrey Beardsley, Eva Hesse, Jackson Pollock, and Prud'hon. ▼ ▼ ▼ The collection has grown through the backing of other sources as well. The Art Museum Council, a group dedicated to the support of the museum in general, has purchased spectacular drawings by Delacroix, John Singer Sargent, and Elihu Vedder. The museum's modern and contemporary art department and its council have acquired or supported the purchase of the sheets by Willem de Kooning, Pollock, and Edward Ruscha. In recent years a new museum support group, the Collectors Committee, has voted to purchase the works here by Jean-Jacques Henner, Benedetto Luti, and Guido Reni. Drawings have been purchased usually from dealers, although occasionally through private negotiation, including the group from Hermann Voss, the two sheets by Käthe Kollwitz, and Giovanni Battista Tiepolo's *A Falling Figure*. The museum has very rarely purchased drawings at auction, but in the 1980s support was found to bid successfully on the works by Giovanni Benedetto Castiglione, Carlo Maratta, and Tanzio da Varallo. Notable gifts in recent years have come with the acquisition of the Robert Gore Rifkind collection of German Expressionist art, focused primarily on prints and a substantial library. The Rifkind collection (all of which is reproduced in the author's catalogue of it) includes the fine drawings included here by Oskar Kokoschka and Ludwig Meidner. A bequest of modern prints and drawings from Mr. and Mrs. Austin Young brought

to the museum the cubist works here by Alexander Archipenko, Fernand Léger (*Still Life with Shell*), and Louis Marcoussis. ❦ ❦ ❦ Writing this catalogue was facilitated by the often-groundbreaking research conducted by Feinblatt; her articles and catalogues are noted in the bibliography of many sheets. Victor Carlson's expertise has been used substantially for the French drawings (particularly by Van Loo and Henner). The author's contributions have been primarily in the field of Italian and American drawings and are indebted especially to the conversations over the years with friends and colleagues Alfred Moir and Nicholas Turner. ❦ ❦ ❦ Several members of the museum's staff have made substantial contributions to this project. Mitch Tuchman, former editor in chief, has been a strong advocate since the beginning. Editor Matthew Stevens, designer Amy McFarland, photographers Barbara Lyter, Jay McNally, and Steve Oliver, and paper conservator Victoria Blyth Hill deserve plaudits for their work. ❦

BRUCE DAVIS
Curator of Prints and Drawings
Los Angeles County Museum of Art

❧ ABBREVIATED REFERENCES ☙

CAMPBELL AND CARLSON

Richard J. Campbell and Victor Carlson. *Visions of Antiquity: Neoclassical Figure Drawings*. Exh. cat. Los Angeles: Los Angeles County Museum of Art, 1993.

DAVIS

Bruce Davis. *In Honor of Ebria Feinblatt, Curator of Prints and Drawings, 1947–1985*. Exh. cat. Appeared in *Los Angeles County Museum of Art Bulletin* 28 (1984).

FEINBLATT, 1970

Ebria Feinblatt. *Drawings in the Collection of the Los Angeles County Museum of Art*. Alhambra, Calif.: Borden Publishing Co., 1970.

FEINBLATT, 1976

Ebria Feinblatt. *Old Master Drawings from American Collections*. Exh. cat. Los Angeles: Los Angeles County Museum of Art, 1976.

FORT AND QUICK

Ilene Susan Fort and Michael Quick. *American Art: A Catalogue of the Los Angeles County Museum of Art Collection*. Los Angeles: Los Angeles County Museum of Art, 1991.

HARRISON, 1929

Catalogue of the Mr. and Mrs. Wm. Preston Harrison Collection of Modern French Art. Los Angeles: privately printed, 1929.

HARRISON, 1934

[William] Preston Harrison, comp. *A Catalogue of the Mr. and Mrs. William Preston Harrison Galleries of American Art: A Gift to the People*. Los Angeles: Saturday Night Publishing, 1934.

LUGT

Fritz Lugt. *Les marques de collections de dessins et des estampes*. Amsterdam: Vereenigde Drukkerijen, 1921.

LUGT SUPPL.

Fritz Lugt. *Les marques de collections de dessins et des estampes: Supplement*. The Hague: Martinus Nijhoff, 1956.

CATALOGUE

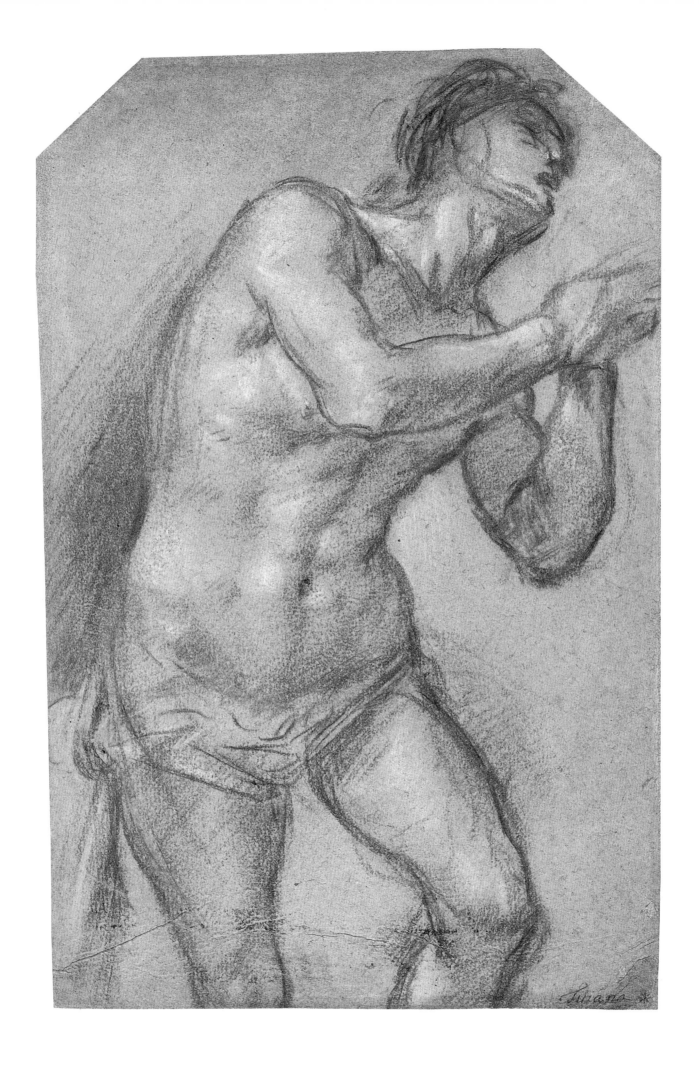

I

PARIS BORDONE

Treviso (Italy) 1500–1571 Venice

Study of a Supplicant Male Figure, about 1525–35

Black chalk, heightened with white, on blue paper

10 x 6 ⅞ in. (25.4 x 17.5 cm)

INSCRIPTION

LOWER RIGHT: Titiano

———

PROVENANCE

Nicholas Lanier (Lugt and Lugt Suppl. 2908); Mia Weiner, New York (cat. 1987, no. 6); purchased by the museum in 1989

———

Purchased with funds provided by Ebria Feinblatt, M.89.39

By 1518 Bordone was in Venice, where he probably studied with Titian. The Venetian master had a profound effect on Bordone's style, particularly in religious and mythological compositions with figures set in lush landscapes. Bordone was especially well-known for his paintings with erotic overtones, and it was this sensibility that undoubtedly prompted his invitation in 1559 by King Francis II to work in France, where he would have contact with the painters of the so-called "second school of Fontainebleau," who shared his taste for the erotic.

Like many Venetian Renaissance drawings of dynamic single figures rendered loosely in black chalk, this sheet was once attributed to Titian, the greatest and most influential artist in sixteenth-century Venice; the great connoisseur Philip Pouncey, however, suggested

Bordone as the author. The sheet illustrates the influence on Bordone of Titian's manner of draftsmanship, particularly the painterly and atmospheric application of chalk on colored paper. The drama, dynamism, and emotional character implied by the pose of the figure exemplifies the influence on Bordone of the art of Giovanni Antonio da Pordenone. The figure's torso and arms recall (in reverse) those of Christ in Bordone's painting *The Baptism of Christ* of about 1535 in the National Gallery of Art, Washington, D.C.,[1] while the legs resemble (also in reverse) the stance of Saint Christopher in the *Sacra Conversazione* of about 1525–26 in the Accademia Tadini, Lovere.[2] Alessandro Ballarin (conversation with the author) does not support the attribution to Bordone and suggests it dates from later in the sixteenth century.

NOTES

1. The painting is dated to about 1535 in Fern Rusk Shapley, *National Gallery of Art: Catalogue of the Italian Paintings* (Washington, D.C.: National Gallery of Art, 1979), 1: 77–78; and to about 1546–47 in Giordana Canova, *Paris Bordon* (Venice: Edizioni Alfieri, 1964), 117, fig. 81.

2. Ibid., 82, fig. 15.

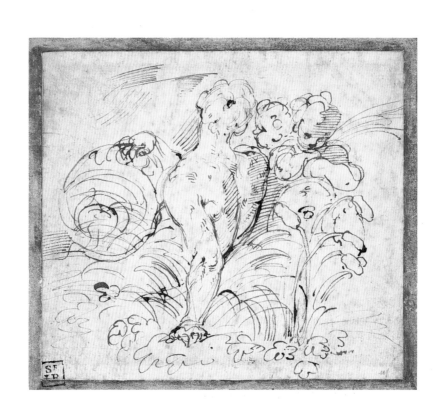

2
GIROLAMO FRANCESCO MARIA MAZZOLA, CALLED PARMIGIANINO
Parma (Italy) 1503–1540 Casalmaggiore
Nude Figure among Foliage Holding a Globe, and Two Putti, about 1527–31
Brown ink
4½ x 5⅛ in. (11.4 x 13 cm)

PROVENANCE
Sir Joshua Reynolds (Lugt 2364); Barry Delaney (Lugt 350); Paul Prouté et Fils, Paris
(cat. 1965, no. 2); purchased by the donor in 1965

BIBLIOGRAPHY
A. E. Popham, *Catalogue of the Drawings of Parmigianino*
(New Haven and London: Yale University Press, 1971), 1: 216, no. 750; 3: pl. 269

EXHIBITION
Feinblatt, 1976, no. 83

Gift of Lois T. Handler and family in honor of the twenty-fifth anniversary of the museum, M.89.172

Parmigianino received his early artistic training from his uncles, who were also artists. In 1524 he went to Rome, where he became one of the favored artists of Pope Clement VII. In Rome he met other first-generation mannerist artists, particularly Rosso Fiorentino and Perino del Vaga, but was especially influenced by the works of Raphael, transforming the grace of Raphael into a highly refined and elegant manner. After the Sack of Rome in 1527, Parmigianino fled to Bologna, where he began to experiment with etching and became the first great practitioner of the medium. In 1530 he went to Parma and spent the remainder of the decade on the commission, never completed, of frescoing the apse and vault of the church of Santa Maria della Steccata. His influence in the sixteenth century on court painting in Europe, especially in Fontainebleau and Prague, was profound.

The title was employed by Popham, who dated the drawing to about 1527–31 and described the subject as obscure. The object held by the figure, however, may in fact be an amphora rather than a globe, thus identifying the figure more specifically as a personification of a river god.

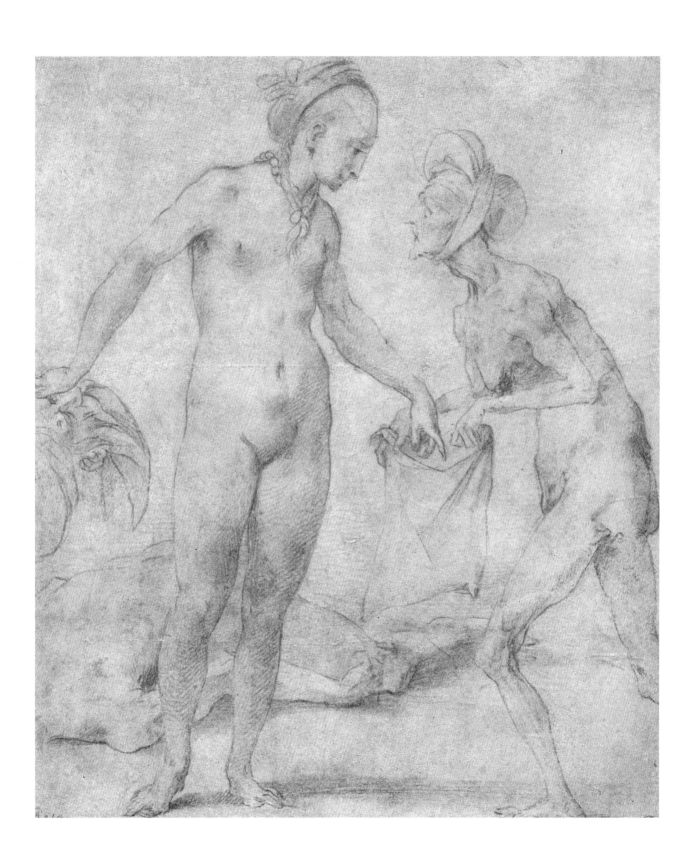

3

GIOVANNI BATTISTA DI JACOPO, CALLED ROSSO FIORENTINO

Florence 1494–1540 Paris

Judith with the Head of Holofernes, about 1535–40

Red chalk

9 ⅛ x 7 ¾ in. (23.2 x 19.7 cm)

INSCRIPTION

LOWER LEFT: Rosa

———

PROVENANCE

Private collection, Holland; Eugène Rodrigues (Lugt 897); David Carritt, London;
purchased by the museum in 1977

———

BIBLIOGRAPHY

Eugene A. Carroll, "A Drawing by Rosso Fiorentino of Judith and Holofernes,"
Los Angeles County Museum of Art Bulletin 24 (1978): 25–49; Jan Białostocki,
The Message of Images: Studies in the History of Art (Vienna: IRSA, 1988), 125

———

EXHIBITIONS

Edward J. Olzewski, *The Draftsman's Eye*, exh. cat. (Cleveland: Cleveland Museum of Art, 1979), no. 26;
Davis, 18–19, no. 67; Eugene A. Carroll, *Rosso Fiorentino: Drawings, Prints, and Decorative Arts*,
exh. cat. (Washington, D.C.: National Gallery of Art, 1987), no. 116

———

Dalzell Hatfield Memorial Fund, M.77.13

Together with Jacopo Pontormo, Rosso Fiorentino has long been recognized as one of the principal exponents of an anticlassical reaction to the perfection of the High Renaissance and one of the most original artists of early mannerism. He studied initially with Andrea del Sarto, the leading painter in Florence after the departures of Leonardo da Vinci, Raphael, and Michelangelo. After developing his early mannerist style in Florence and Rome in the 1520s, Rosso was invited to France by King Francis I to spearhead the decoration of the royal palace at Fontainebleau. Rosso's audacious and inventive decorative scheme, in which he effectively combined painting, sculpture, and decorative arts into a complete ensemble, was matched by his bold treatments of traditional subjects.

This superb drawing, dated by Eugene Carroll to the end of Rosso's period in France (1530–40), is an example of his cheeky approach to a traditional biblical subject. Jan Białostocki has noted some earlier examples in which artists depicted the Jewish heroine Judith as nude; but this drawing may be unique in its depiction of Judith's handmaiden in the nude as well. Furthermore, Rosso has emphasized the contrast between Judith's classicizing and serene beauty with the haggard and sagging body of the old crone. The story can generally be interpreted as the triumph of love and beauty over vice and war, and Rosso's interpretation stresses the contrast between the virtue represented by Judith and the evils represented by Holofernes.

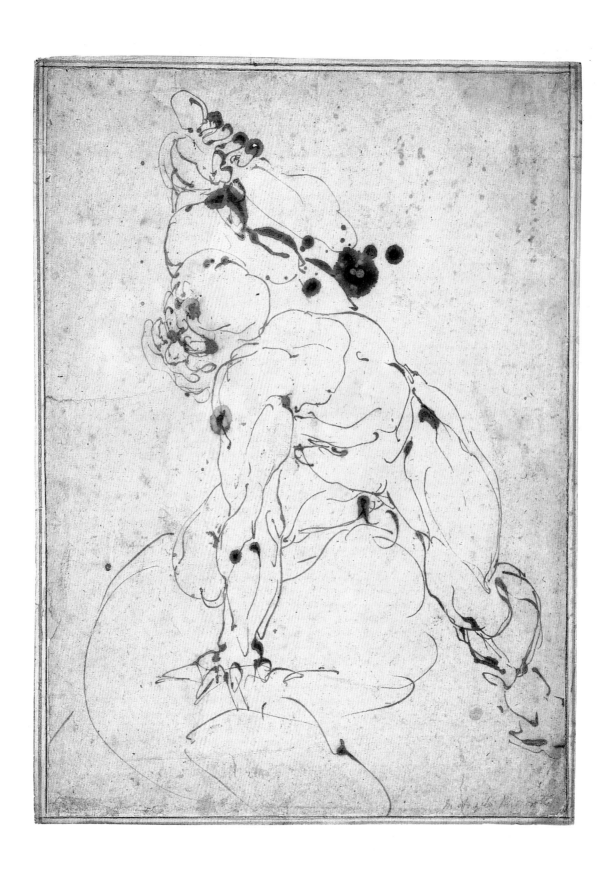

4

LUCA CAMBIASO
Moneglia (Italy) 1527–1585 El Escorial (Spain)
Hercules, about 1544
Brown ink, laid down
14¾ x 10⅝ in. (37.5 x 27 cm)

INSCRIPTION
LOWER RIGHT: M. Angelo

———

PROVENANCE
Zeitlin and Ver Brugge, Los Angeles; purchased by the museum in 1957

———

BIBLIOGRAPHY
Ebria Feinblatt, "An Early Drawing by Luca Cambiaso,"
Los Angeles County Museum Bulletin of the Art Division 12, no. 1 (1960): 3–7

———

EXHIBITION
Feinblatt, 1976, 107, no. 128

———

Los Angeles County Fund, 57.22.2

———⊗⊗⊗———

Cambiaso is generally considered the founding father of the Genoese school of painting and its first distinctive personality. He studied the frescoes of Perino del Vaga in the Palazzo Doria in Genoa and Michelangelo's and Raphael's in Rome. Along with Giovanni Battista Castello, called Il Bergamesco, Cambiaso helped establish the tradition of decorative frescoes in Genoese churches and palaces. He was a prolific and highly influential draftsman, thus his drawings are frequently confused with those of his school and followers.

This vibrant and highly fluid sketch was made by Cambiaso in preparation for his early fresco *Hercules Fighting the Amazons* of 1544 in the Palazzo della Prefettura (formerly Palazzo Antonio Doria, later Spinola) in Genoa, executed when the artist was only seventeen.[1] There are two other drawings for the figure of Hercules, one in the National Gallery of Scotland, Edinburgh,[2] and one formerly in the Wessner collection in Saint Gall, Switzerland.[3]

NOTES
1. Bertina Suida Manning and William Suida, *Luca Cambiaso, la vita e le opere* (Milan: Casa Editrice Ceschina, 1958), 75, fig. 2.
2. Keith Andrews, *National Gallery of Scotland: Catalogue of Italian Drawings* (Cambridge: Cambridge University Press, 1968), 1: 26, no. RSA 166; 2: fig. 201.
3. Suida Manning and Suida, *Cambiaso*, 193, fig. 10. Another drawing by Cambiaso of Hercules, though unrelated to the figure in the Los Angeles sheet but very similar in conception and draftsmanship, was formerly in the collection of Michel Gaud. See his sale, Sotheby's, Monaco, 20 June 1987, lot 85.

5

MARCO PINO

Siena (Italy) 1525–after 1579 Naples

Battle of Nude Men, about 1545–50

Brown ink and wash, heightened with white gouache

11 x 16¼ in. (27.9 x 41.3 cm)

PROVENANCE

Vallardi (Lugt 1223); Westside Studio, Beverly Hills

BIBLIOGRAPHY

John Gere and Philip Pouncey, *Italian Drawings in the Department of Prints and Drawings in the British Museum: Artists Working in Rome, c. 1550 to c. 1640* (London: British Museum Publications, 1983), 1: 142; Linda Wolk-Simon, *Italian Old Master Drawings from the Collection of Jeffrey E. Horvitz*, exh. cat. (Gainesville: Samuel P. Harn Museum of Art, University of Florida, 1991), 38

EXHIBITIONS

Feinblatt, 1976, no. 28; Edward J. Olszewski, *The Draftsman's Eye*, exh. cat. (Cleveland: Cleveland Museum of Art, 1979), no. 20

Given anonymously, M.63.38

Pino studied initially in Siena with Domenico Beccafumi. By 1544 he was in Rome, where he was elected to the Accademia di San Luca and where he soon joined the group of artists working under the supervision of Perino del Vaga, decorating the Castel Sant'Angelo for Pope Paul III. In 1557 he was living in Naples, where he remained for about a decade. Thereafter he traveled frequently between Rome and Naples. Among his late works are paintings in Rome in the Oratorio del Gonfalone and in the churches of Santa Maria in Aracoeli and Santa Maria della Concezione.

This sheet was formerly attributed to Taddeo Zuccaro, but the present attribution to Pino was suggested by John Gere and Philip Pouncey at the time of its acquisition (letters, departmental files). The subject has traditionally been called *The Battle of Anghiari*, but there is no compelling visual evidence to indicate what specific battle is represented. The depiction of the battle of Anghiari is known in the history of art essentially via Leonardo da Vinci's destroyed painting of the subject formerly in the Palazzo Vecchio in Florence. Indeed, Pino's representation of the soldiers as nudes has more in common with Michelangelo's cartoon *The Battle of Cascina*, also commissioned by the Florentine Republic for the Palazzo Vecchio. The interest in battle scenes in the Italian Renaissance was undoubtedly inspired by representations of battling figures on ancient Roman sarcophogi.[1] The drawing may be related, at least in its general subject, to Pino's fresco *The Assault on Pera* of 1546–47 in the Sala Paolina in the Castel Sant'Angelo.[2] Both compositions feature wildly gesticulating figures in the foreground; each scene is bisected diagonally.

A drawing similar in theme and composition, with the same striding and gesturing man in the foreground, is in the Albertina, traditionally attributed to Beccafumi but now classified as Sienese, sixteenth century.[3]

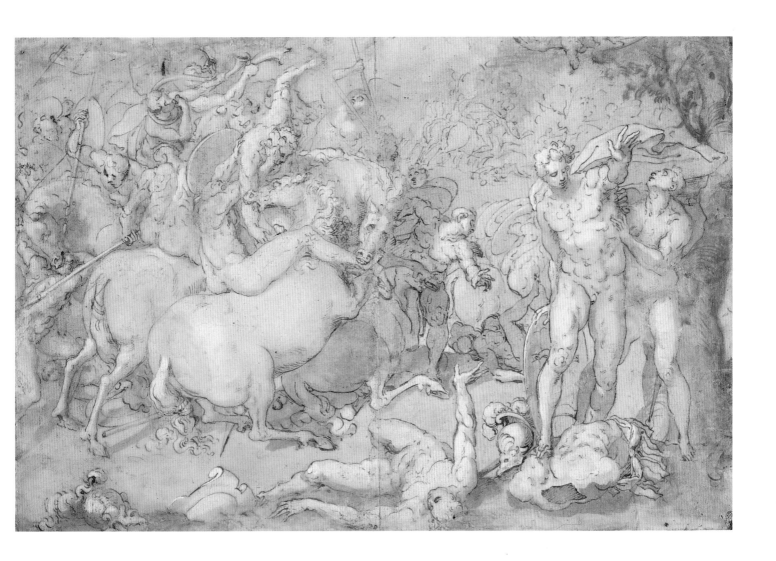

NOTES

1. For a brief discussion of the theme in the context of Domenico Campagnola's engraving *Battle of Nude Men*, see Bruce Davis, *Mannerist Prints: International Style in the Sixteenth Century*, exh. cat. (Los Angeles: Los Angeles County Museum of Art, 1988), 68–69.

2. Filippa M. Aliberti Gaudiosi, *Gli affreschi di Paolo III a Castel Sant'Angelo: Progetto ed esecuzione 1543–1548*, exh. cat. (Rome: Museo Nazionale di Castel Sant'Angelo, 1981), 1: 163, pl. 11. Another brown ink and wash drawing by Pino for one of the Sala Paolina frescoes, *Alexander the Great and the High Priest of Jerusalem*, is in the Uffizi; see ibid., 2: 138–39, no. 86.

3. Veronika Birke and Janine Kertész, *Die italienischen Zeichnungen der Albertina: Generalverzeichnis, Band 1. Inv. 1–1200* (Vienna: Böhlau Verlag, 1992), 165, no. 280.

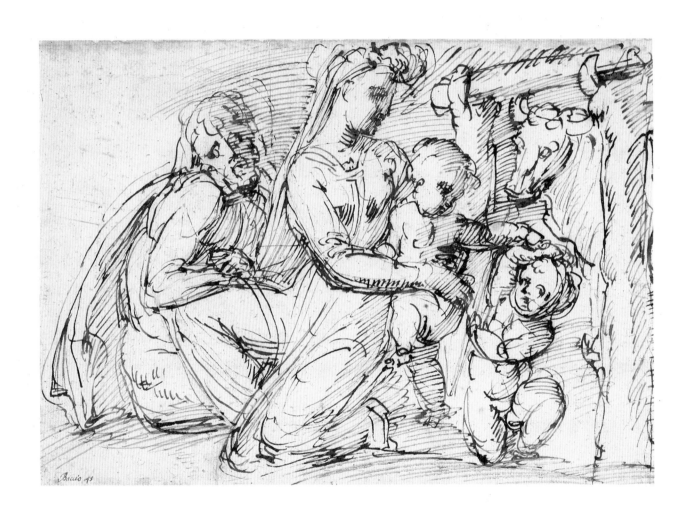

6

BACCIO BANDINELLI

Florence 1493–1560 Florence

The Holy Family with Saint John the Baptist, about 1550

Brown ink

10 ¼ x 14⅝ in. (26 x 37.2 cm)

INSCRIPTION

LOWER LEFT: Baccio 45

———

PROVENANCE

Edward Wrangham; Mr. and Mrs. Hugh Squire; their sale, Sotheby's, London, 4 July 1975, lot 7;

P. and D. Colnaghi, London; purchased by the museum in 1977

———

BIBLIOGRAPHY

Roger Ward, "Baccio Bandinelli as a Draughtsman" (Ph.D. diss., Courtauld Institute of Art,

University of London, 1982), 193, under no. 11; 308–9, no. 228; fig. 209

———

Graphic Arts Council Fund, M.77.54.1

After Michelangelo, whose drawings he emulated, Bandinelli was the principal Florentine sculptor during the first half of the sixteenth century. After spending a number of years in Rome, he worked on such lucrative commissions in Florence as *Hercules and Cacus* in the Piazza della Signoria, the sculptures in the Sala dei Cinquecento in the Palazzo Vecchio, and the high altar in the Duomo. His style was vilified, however, by his contemporaries and later critics (among them, Bernard Berenson).

Roger Ward has dated this vibrant and scintillating sheet to late in Bandinelli's career, about 1550. He has related it to several other compositions of the Holy Family, noting that the familial intimacy of the subject is unusual in Bandinelli's oeuvre. Furthermore, the calligraphic pen line is much more fluid than is often found in Bandinelli's drawings, in which the figures are shaded with more regular and systematic hatching. Other drawings by Bandinelli of the subject are found in the Uffizi.[1] The arrangement of the figures within a relatively shallow space suggested to Ward that the composition may have been intended for a sculptural relief. While no such work by Bandinelli is known, Ward has pointed out a possible relationship to a small sculpture of the Holy Family in the Victoria and Albert Museum with similar dimensions, attributed to Bandinelli's pupil Pierino da Vinci.[2]

NOTES

1. Annamaria Petrioli Tofani, *Gabinetto Disegni e Stampe degli Uffizi: Inventario. Disegni di figura,* 1 (Florence: Leo S. Olschki Editore, 1991), 230–34, nos. 542 F, 544 F, 547 F, 548 F, recto, 550 F, and 551 F.
2. John Pope-Hennessy, *Catalogue of Italian Sculpture in the Victoria and Albert Museum* (London: Her Majesty's Stationery Office, 1964), 2: 444; 3: fig. 469.

7

PELLEGRINO TIBALDI
Puria di Valsolda (Italy) 1527–1596 Milan
'Dancing Figure' (recto);
'Dancing Figure' and Other Studies (verso), about 1555–58
Brown ink and wash
13 x 10¾ in. (33 x 27.3 cm)

INSCRIPTIONS
RECTO, UPPER LEFT: di Baltazar da Siena
VERSO, CENTER RIGHT: Rafaello da Reggio

———

PROVENANCE
Hollstein and Puppel, Berlin, 6 May 1931, lot 1177; Comte Rey de Villette
(Lugt Suppl. 2200a); Schaeffer Galleries, New York; purchased by the museum in 1960

———

BIBLIOGRAPHY
Ebria Feinblatt, "A Drawing by Pellegrino Tibaldi," *Los Angeles County Museum Bulletin of the Art
Division* 13, no. 2 (1961): 3–12; "Rassegna bibliografica," *Emporium* 135
(February 1962): 94; Winslow Ames, *Drawings of the Masters: Italian Drawings from the Fifteenth to the
Nineteenth Centuries* (New York: Shorewood Publishers, 1963), 110;
Los Angeles County Museum of Art Handbook (Los Angeles: Los Angeles County Museum of Art,
1965), 122; Feinblatt, 1970, n.p.; Catherine Johnston,
Mostra di disegni bolognesi dal XVI al XVIII secolo, exh. cat.
(Florence: Gabinetto Disegni e Stampe degli Uffizi, 1973), 21; *Los Angeles County Museum of Art
Handbook* (Los Angeles: Los Angeles County Museum of Art, 1977), 72–73;
John Gere and Philip Pouncey, *Italian Drawings in the Department of Prints and Drawings
in the British Museum: Artists Working in Rome, c. 1550 to c. 1640*
(London: British Museum Publications, 1983), 1: 165

———

EXHIBITIONS
European Master Drawings, 1450–1900, exh. cat. (Santa Barbara: Santa Barbara Museum of Art, 1964),
no. 8; Jurgen Schulz, *Master Drawings from California Collections*, exh. cat.
(Berkeley: University Art Museum, University of California, 1968), no. 53;
The Fortuna of Michelangelo, exh. cat. (Sacramento: Crocker Art Gallery, 1975), no. 37; Feinblatt, 1976,
64, no. 87; Mimi Cazort and Catherine Johnston, *Bolognese Drawings in North American Collections,
1500–1800*, exh. cat. (Ottawa: National Gallery of Canada, 1982), no. 10; Davis, 20, no. 74; Diane De
Grazia, *Correggio and His Legacy: Sixteenth-Century Emilian Drawings*, exh. cat.
(Washington, D.C.: National Gallery of Art, 1984), no. 105

———

Los Angeles County Fund, 60.74

———

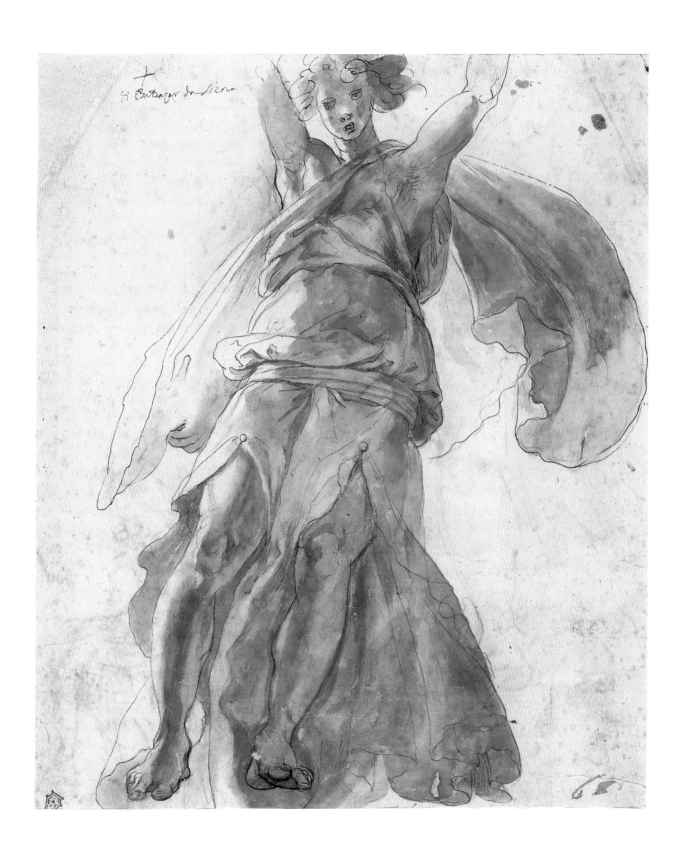

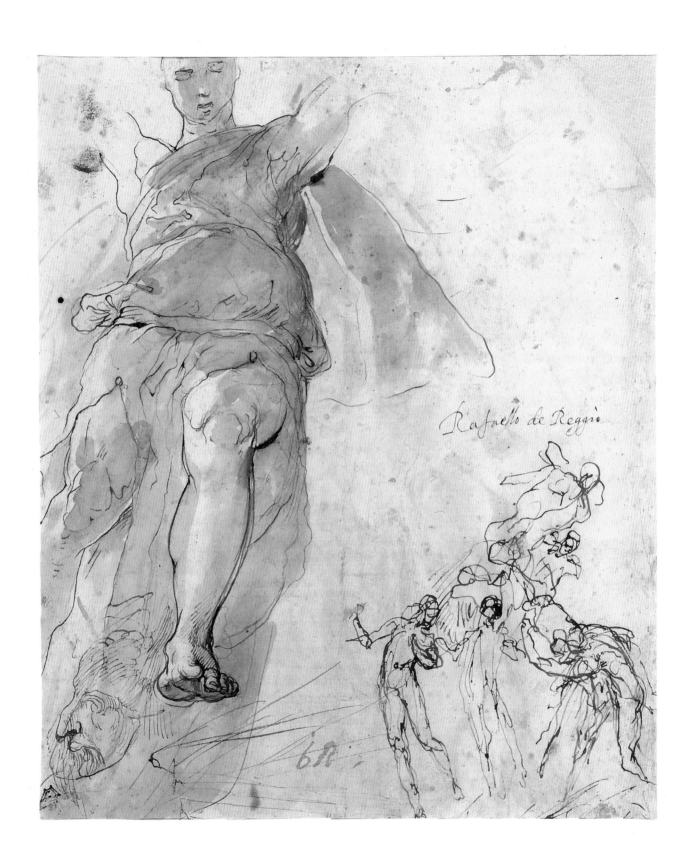

Rafaello de Reggio

Although trained in Bologna with his architect father, Pellegrino Tibaldi spent a few crucial years in the late 1540s in Rome, where he worked on several major commissions, such as the Rovere Chapel in the church of Santissima Trinità dei Monti and the Sala Paolina in the Castel Sant'Angelo, with Daniele da Volterra, Marco Pino, Jacopino del Conte, Sicolante da Sermoneta, and other leading mannerist painters. Perhaps most significant for Tibaldi's development was his absorption of Michelangelo's vigorous style and its exaggerated muscularity, represented at that time by *The Last Judgment* and the Cappella Paolina frescoes. Tibaldi returned to Bologna about 1553, where his most important patrons were the Poggi family. His later career was spent in Milan and Spain.

The wiry and curvilinear delineation of these figures owes a considerable stylistic debt to Perino del Vaga's draftsmanship, with which Tibaldi would have been familiar during his stay in Rome. The daring and bravura perspective, however, is Tibaldi's own invention. The figures were employed in his ceiling fresco decoration, datable to about 1555–58, in a room in the Palazzo Poggi in Bologna devoted to the story of Ulysses. The dancing figures were used as decorative devices, boldly viewed *di sotto in sù* (seen from below), with no relation to the historical narrative of the Greek hero. His innovative architectural illusionism had significant impact on later Bolognese artists, particularly the Carracci family and other decorative painters.

8

LUCA CAMBIASO

Moneglia (Italy) 1527–1585 El Escorial (Spain)

The Martyrdom of Saint Sebastian, about 1555–60

Brown ink and wash over traces of black chalk

16 ½ x 11 ¼ in. (41.9 x 28.6 cm)

INSCRIPTIONS

RECTO, LOWER LEFT: Dello Stesso Luca Cangiasio

VERSO, LOWER LEFT: BW

———

PROVENANCE

John and Paul Herring, New York; purchased by the museum in 1976

———

EXHIBITIONS

Gloria del Arte: A Renaissance Perspective, exh. cat.

(Tulsa: Philbrook Art Center, 1979), no. 25; Davis, 21, no. 10

———

Graphic Arts Council Fund, M.76.127

The composition of the museum's sketch is similar in its dramatic and choreographic grace to another, larger version of the subject by Cambiaso in the collection of Bertina Suida Manning and Robert Manning.[1] They considered their drawing to be an early work by the artist, datable to about 1555–60, and the museum's sheet probably dates from the same period. Both drawings are similar in conception to an altarpiece of the subject from 1561 by another Genoese painter, Giovanni Battista Castello (il Bergamesco).[2]

NOTES

1. Jacob Bean and Felice Stampfle, *Drawings from New York Collections: I. The Italian Renaissance*, exh. cat. (New York: Metropolitan Museum of Art, 1965), no. 120.

2. For a related drawing by Castello formerly attributed to Cambiaso, see Lawrence Turcic, "Review: *Le dessin à Gênes du XVIe au XVIIIe siècle*," *Master Drawings* 23–24, no. 2 (1986): 244, pl. 54a.

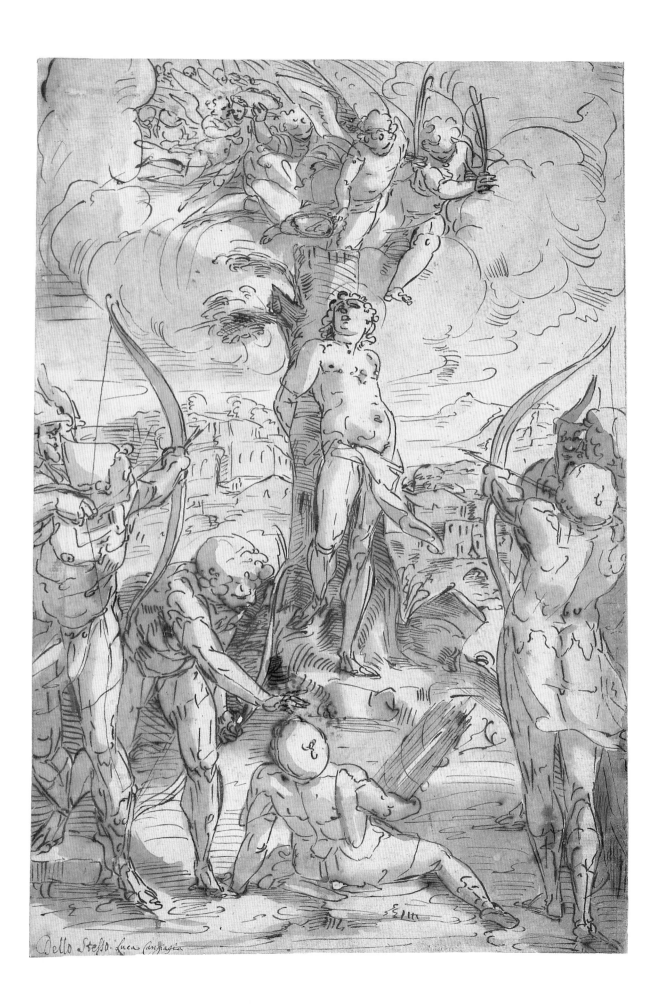

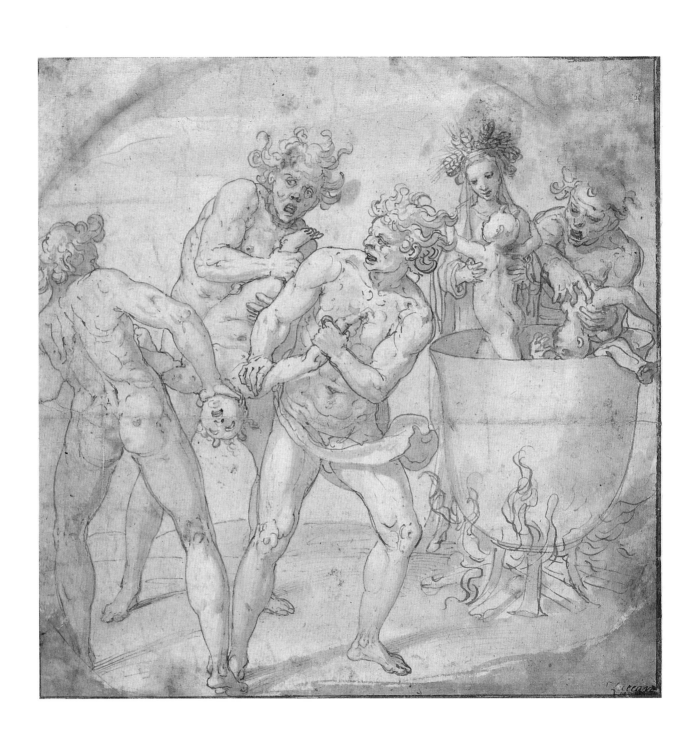

9

TADDEO ZUCCARO

San Angelo in Vado (Italy) 1529–1566 Rome

The Infant Bacchus Killed by the Titans and Restored to Life by Rhea, about 1561–66

Brown ink and wash, laid down

10 1/16 x 10 1/16 in. (25.6 x 25.6 cm)

INSCRIPTION

LOWER RIGHT: Zuccaro [in John Skippe's hand]

———

PROVENANCE

John Skippe; J. Rayner-Wood, by descent; Christie's, London, 21 November 1958, lot 232a
(as Federico Zuccaro); Lord Brooke; Richard Collins, New York; purchased by the museum in 1979

———

BIBLIOGRAPHY

John Gere, *Taddeo Zuccaro: His Development Studied in His Drawings*
(Chicago: University of Chicago Press, 1969), 170, no. 116, pl. 132;
Italo Faldi, *Il Palazzo Farnese di Caprarola* (Turin: SEAT, 1981), 55

———

EXHIBITION

E. James Mundy, *Renaissance into Baroque: Italian Master Drawings by the Zuccari*, exh. cat.
(Milwaukee: Milwaukee Art Museum, 1989), no. 39

———

Purchased with funds provided by the Dalzell Hatfield Memorial Fund and
Richard G. Benter, M.79.124

———

According to Giorgio Vasari, Zuccaro arrived in Rome at the age of fourteen. He was essentially self-taught, guided particularly by the examples of Polidoro da Caravaggio and Perino del Vaga, and was perhaps the most original and talented late mannerist painter in Rome. He executed several commissions for Pope Julius III and Pope Pius IV and for the Farnese family in the Palazzo Farnese in Rome and the Villa Farnese in Caprarola. He died tragically young at the age of thirty-six.

This drawing is a rather complete and detailed study for one of the medallion frescoes in the Camera dell'Autunno on the ground floor of the Villa Farnese. The frescoes, probably begun in 1561 and continued after Zuccaro's death by his brother Federico and others, are considered one of the landmarks in Italian Renaissance decoration. The drawing's degree of finish and exact correspondence to the painted composition may be related to its probable use as a guide for one of Zuccaro's assistants. The subject, rather rare in the history of art, is an appropriate one for the country house of a landed aristocrat because of its theme of cyclical renewal, in which the Titans, under orders from the goddess Juno, captured the infant Bacchus, tore him to pieces, and placed him in a boiling cauldron. He was then rescued by his grandmother Rhea and restored to life.

10

HANS VON AACHEN
Cologne 1551/52–1615 Prague
Augustus and the Tiburtine Sibyl, about 1580–85

Brown ink and wash, heightened with white gouache (partly oxidized), squared in black chalk

13 x 11 in. (33 x 27.9 cm)

INSCRIPTIONS

LOWER LEFT: S.R. [or J.R.]

ON OLD MOUNT: Salvator Rosa

———

PROVENANCE

Oscar Salzer Galleries, Los Angeles; purchased by the museum in 1959

———

BIBLIOGRAPHY

Ebria Feinblatt, "Recent Purchases of North Italian Drawings,"
Los Angeles County Museum Bulletin of the Art Division 10, no. 3 (1958): 15–16, fig. 6
(as Venetian or Emilian, late sixteenth–early seventeenth century); Thomas DaCosta Kaufmann,
Drawings from the Holy Roman Empire 1540–1680, exh. cat.
(Princeton: Art Museum, Princeton University, 1982), 144 (as Von Aachen)

———

Los Angeles County Fund, 59.25.2

———

Von Aachen received his initial training in Cologne, but the most significant years of his education were spent in Italy. He was in Venice in 1574 and in Rome by the following year, where he became an active member of the large colony of northern artists. He remained in Italy until 1587, when he returned north of the Alps and commenced a successful career employed by the courts in Munich and Prague. Along with Joseph Heintz and Bartholomeus Spranger, Von Aachen was one of the principal and most influential exponents of Rudolfine mannerism, which was named after Emperor Rudolf II and his Prague court style of about 1600.

Because the inscription in the lower-left corner has been interpreted in the past as "S.R.," the drawing was earlier attributed to Salvator Rosa or Sebastiano Ricci. Konrad Oberhuber, however, attributed it to Von Aachen (letter, departmental files). The richly elaborated articulation of the figures, with parallel hatching in the shadows, dark accents with splotches of brown ink, tonal washes, and touches of white gouache, are characteristic of Von Aachen's drawings from his Italian period. The crisp angularity of the drapery folds, the pools of shadow encircling the eye sockets, and the cocked positioning of the heads are found in other Von Aachen drawings of the 1580s, such as *The Temptation of Christ* in the Museum of Fine Arts, Houston,[1] and *The Judgment of Paris* in the Albertina, Vienna.[2]

NOTES

1. DaCosta Kaufmann, *Drawings*, 144, no. 51.
2. *Prag um 1600: Kunst und Kultur am Hofe Kaiser Rudolfs II*, exh. cat. (Vienna: Kunsthistorisches Museum, 1988), 2: 147, no. 608.

11

JACOPO NEGRETTI, CALLED PALMA GIOVANE
Venice 1548–1628 Venice
Sheet of Studies of Saint Jerome (recto);
Studies of Jael and Sisera and Other Figures (verso), about 1590–1600
Brown ink and wash, laid down
15 x 10⅝ in. (38.1 x 27 cm)

INSCRIPTION
VERSO, LOWER CENTER OF MOUNT: dalla collezione Zanetti/dal Palma

———

PROVENANCE
Anton Maria Zanetti [his original mount]; Moatti, Paris; purchased by the museum in 1980

———

BIBLIOGRAPHY
"Museum Acquisitions," *Drawing* 2, no. 5 (1981): 115; *Los Angeles County Museum of Art Report:
July 1, 1979–June 30, 1981* (Los Angeles: Los Angeles County Museum of Art, 1982), 66, fig. 3

———

EXHIBITION
Davis, 21, no. 58

———

Dalzell Hatfield Memorial Fund and Museum Acquisition Fund, M.80.91

———

Jacopo Negretti was called Palma Giovane (Palma the Younger) to distinguish him from his great-uncle, the painter Palma Vecchio (Palma the Elder). He spent a number of years in Rome, where he likely absorbed the late interpretations of Michelangelo's art by artists Taddeo and Federico Zuccaro. Upon Palma's return to Venice in 1578 he was commissioned to paint the ceiling of the Sala di Maggior Consiglio in the Palazzo Ducale. He completed Titian's *Pietà*, now in the Galleria dell'Accademia, Venice, left unfinished after the death of Titian in 1576. It was the dramatic manner of Jacopo Tintoretto, however, that had the most impact on Palma. After the deaths of Titian, Veronese, and Tintoretto, Palma assumed leadership of the Venetian school.

As noted on the mount, this sheet comes from the notable eighteenth-century Venetian collection of Anton Maria Zanetti. In fact, it originates from one of two albums of Palma drawings owned by Zanetti, one of which is now in the British Museum, the other dispersed.[1] Palma depicted the subject of Saint Jerome several times, not all of which have survived.[2] The figures in this sheet are perhaps closest in general disposition to those in a now-lost painting sent to Duke Francesco Maria of Urbino, recorded in an engraving dated 1596 by Hendrick Goltzius,[3] and to a painting of Saint Jerome datable to about 1590–95 in the Brass collection in Venice.[4] The studies of Jael and Sisera on the verso may be related to a later painting (about 1600–1610) in the Musée Thomas Henry, Cherbourg.[5]

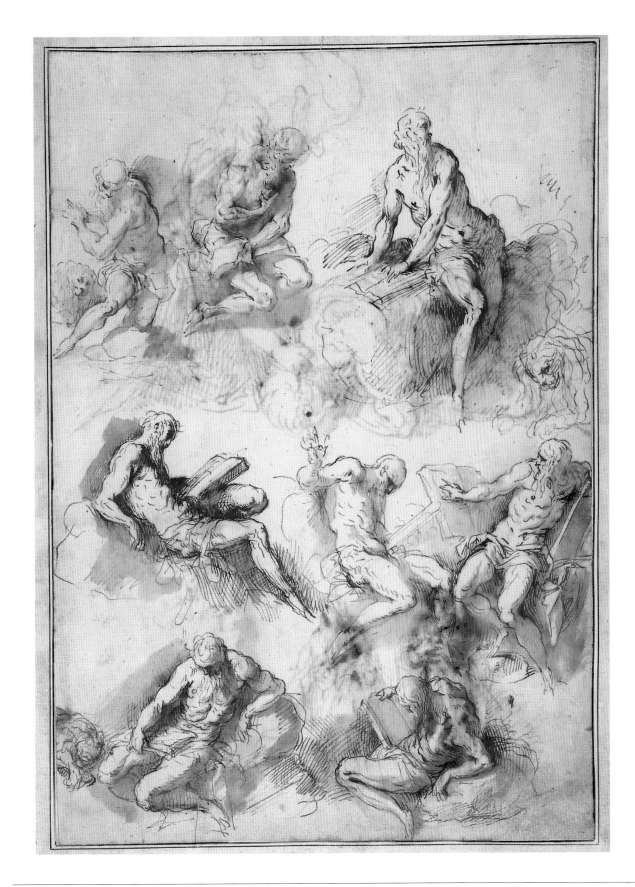

NOTES

1. Stefania Mason Rinaldi, "Il libro dei disegni di Palma Giovane del British Museum," *Arte Veneta* 27 (1973): 125–43.

2. Carlo Ridolfi described several now-lost paintings of the saint, in *Le maraviglie dell'arte ovvero le vite degli illustri pittori veneti e dello stato,* ed. Detlev Freiherrn von Hadeln (1648; reprint, Berlin: G. Grote, 1924), 2: 178.

3. For the engraving, see Walter Strauss, *Hendrik Goltzius: The Complete Engravings and Woodcuts* (New York: Abaris Books, 1977), 2: 616, no. 335.

4. Stefania Mason Rinaldi, *Palma il Giovane: L'opera completa* (Milan: Alfieri Electa, 1984), 135, no. 502, fig. 187.

5. Ibid., 80, no. 58, fig. 419.

DOMENICO CRESTI, CALLED DOMENICO PASSIGNANO

Passignano (Italy) 1550/55–1638 Florence

Deposition from the Cross, about 1595

Brown ink and wash

10 ½ x 7 ⅞ in. (26.7 x 20 cm)

INSCRIPTION

LOWER LEFT: Barrochio detto il []

———

PROVENANCE

Vallardi (Lugt 1223); Walter Laemmle, Los Angeles; purchased by the museum in 1957

———

Los Angeles County Fund, 57.25

———※———

Passignano was a pupil of the Florentine late mannerists Girolamo Macchietti and Federico Zuccaro. Decisive for his development were the years he spent in the 1580s in Venice, when he modified his Florentine style with Venetian colorism. During the first decade of the seventeenth century Passignano was one of the leading painters among the Florentine colony in Rome, where he received significant commissions for the churches of Saint Peter's, Sant'Andrea della Valle, and Santa Maria Maggiore. By 1616, with the ascendancy in Rome of Bolognese and Caravaggesque painters, he was back in Florence.

Despite the inscription attributing the sheet to Federico Barocci, Philip Pouncey suggested Domenico Passignano as the author; an opinion shared, though not unanimously, by other scholars. Joan Nissman (letter, departmental files) compares the museum's drawing with some studies connected with paintings by Passignano, most notably a drawing in Christ Church, Oxford,[1] for *Saint Peter Healing a Cripple* of about 1594–95 in the Museo di Villa Guinigi, Lucca, and two drawings in the Uffizi for *The Adoration of the Shepherds* in the church of Santo Stefano, Empoli.[2] All these drawings feature a similar calligraphic, ornamental, and meandering line to delineate the figures, the heads often repeated by the artist, searching for a solution for their placement.

Venturi records paintings by Passignano of Christ after the Crucifixion, one in the church of Santo Stefano, Pescia, and another in the Galleria Borghese, Rome (the latter is a pietà).[3]

NOTES

1. James Byam Shaw, *Drawings by Old Masters at Christ Church, Oxford* (Oxford: Clarendon Press, 1976), 1: 93, no. 254; 2: pl. 181. Another study for the painting is in the Uffizi; see Annamaria Petrioli Tofani, *Gabinetto Disegni e Stampe degli Uffizi: Inventario. Disegni di figura,* 1 (Florence: Leo S. Olschki Editore, 1991), 370–71, no. 873 F. Nissman notes two other Uffizi drawings for the Lucca painting, nos. 8304 F and 8393 F.

2. Petrioli Tofani, *Uffizi,* 369–70, nos. 870 F and 871 F.

3. Adolfo Venturi, *Storia dell'arte italiana: La pittura del Cinquecento,* vol. 9, parte 7 (Milan: Ulrico Hoepli, 1934), 654–55.

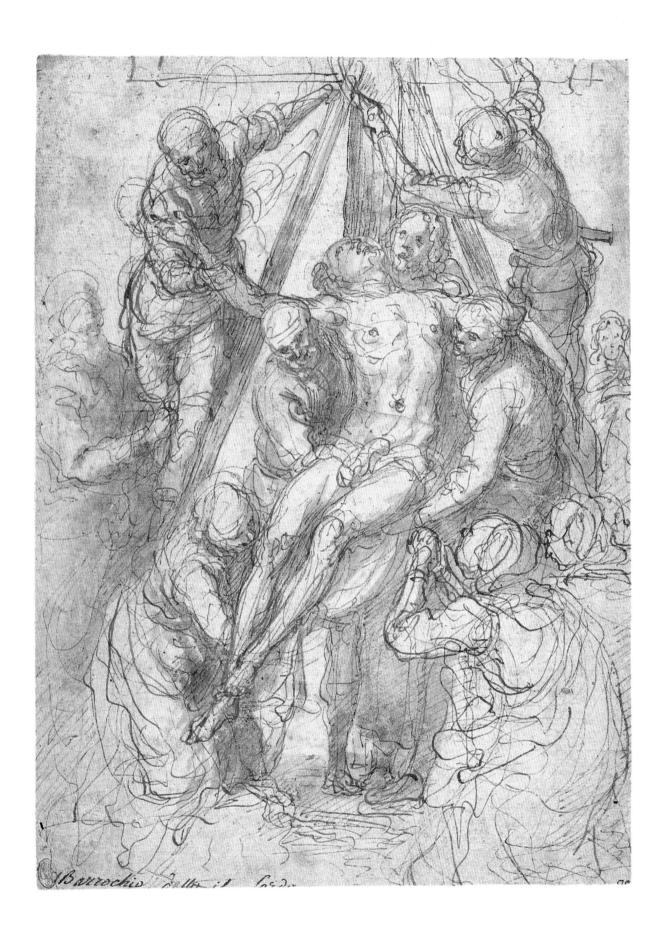

Barrochio *detto il* *ordi*

13

DOMENICO TINTORETTO
Venice about 1560–1635 Venice
Saint Mark Enthroned and Worshipped by a Kneeling Donor, about 1600–1614
Oil on paper, laid down
12 ³/₁₆ x 9 ¾ in. (31 x 24.8 cm)

PROVENANCE

Cardinal Albani [?]; A. G. B. Russell (Lugt 2770a); Goudstikker Gallery, Amsterdam
(1929 cat., no. 42, as Jacopo Tintoretto); Van Staaten; Dr. Scharf; Trude Krautheimer;
Schaeffer Galleries, New York; purchased by the museum in 1966

BIBLIOGRAPHY

Rosanna Tozzi, "Disegni di Domenico Tintoretto," *Bollettino d'Arte* 31 (1937): 30;
Hans Tietze and Erika Tietze-Conrat, *Drawings of the Venetian Painters in the Fifteenth and Sixteenth
Centuries* (New York: J. J. Augustin, 1944), 260, no. 1472; Rosanna Tozzi Pedrazzi,
"Le storie di Domenico Tintoretto per la Scuola di S. Marco," *Arte Veneta* 18
(1964): 86, fig. 90; Feinblatt, 1970, n.p.

EXHIBITIONS

Feinblatt, 1976, 35, no. 53; Alfred Moir, ed., *Regional Styles of Drawing in Italy, 1600–1700*, exh. cat.
(Santa Barbara: Art Galleries, University of California, 1977), no. 53

Graphic Arts Council Fund, M.66.36

Domenico Tintoretto was the son, collaborator, and artistic heir of Jacopo Tintoretto, one of the most brilliant painters of the Venetian Renaissance. He inherited his father's drawings and as head of the Tintoretto workshop continued his father's tradition of protobaroque drama in his paintings. Consequently, the attribution of their paintings and drawings has been confused in the past, most notably regarding an album of drawings in the British Museum.[1]

This drawing, or more precisely, oil sketch, is part of the complicated history of a painting in the Scuola di San Marco, Venice. The altarpiece *Saint Mark in Glory with Saint Peter and Saint Paul* was mentioned in the early seventeenth century by Marco Boschini as a work by Palma Giovane. After the vicissitudes of the Napoleonic wars, it was described in the early nineteenth century as

by Domenico Tintoretto. Documentary evidence, however, has proven Palma's authorship. But the situation is further complicated by the fact that Palma's painting, dated 1614, substituted an earlier one of the same subject by Tintoretto. Furthermore, the museum's sheet is rather different in composition from Palma's painting and the two Tintoretto drawings in the British Museum associated with the San Marco commission.[2] The British Museum drawings feature a celestial congregation above the figure of Saint Mark, whereas the museum's sketch does not. The upward gazes of several figures here, however, would indicate that such a scene was intended, as would the clouds and what may be the remnants of a figure's limb. In comparison with the tall and narrow formats of the British Museum drawings, this partially seen glory indicates that this sheet has been cut down.

[40]

NOTES

1. See Tietze and Tietze-Conrat, *Venetian Painters*, 263–66, no. 1526.

2. One is reproduced in ibid., 265, no. 1526, pl. CXX (no. 2); and the other in Tozzi Pedrazzi, "Le storie," 87, fig. 89.

[41]

14

RUTILIO MANETTI
Siena (Italy) 1571–1637 Siena
Emperor Julian Enrolls Saint Martin in the Cavalry, about 1605–10
Oil on paper
16 ½ x 11 ½ in. (41.9 x 29.2 cm)

PROVENANCE
Hermann Voss, Berlin; purchased by the museum in 1954

———

BIBLIOGRAPHY
Alessandro Bagnoli, *Rutilio Manetti*, exh. cat. (Siena: Palazzo Pubblico, 1978), 140, fig. XX

———

EXHIBITIONS
Feinblatt, 1976, no. 31; Alfred Moir, ed., *Regional Styles of Drawing in Italy, 1600–1700*, exh. cat.
(Santa Barbara: Art Galleries, University of California, 1977), no. 29

———

Los Angeles County Fund, 54.12.2

Manetti developed his style under the influences of Francesco Vanni and Ventura Salimbeni, the two principal Sienese followers of Federico Barocci. Manetti spent most of his career in Siena but in the second decade of the seventeenth century probably traveled to Rome, where he absorbed the Caravaggesque manner in ascendancy at that time. Most significant for Manetti were works by Orazio Gentileschi and Bartolommeo Manfredi as well as by the Dutch painters Dirck van Baburen and Gerrit van Honthorst.

This *bozzetto*, or oil sketch, is drawn on a page from an account book from 1505, thus sharing the same paper support as three other *bozzetti* by Manetti: two studies of heavily draped female figures in the Biblioteca Comunale, Siena, and *Lot and His Daughters* in a private collection in Bologna.[1] The four drawings possibly all date from the early 1620s, as the Los Angeles study is related to a now-lost fresco in the church of San Martino, Siena, recorded in a guidebook to Siena in 1625–26, while the Bologna sheet is a preparatory study for Manetti's painting of 1623–26 in the Museo de Bellas Artes, Valencia. In style and composition, however, *Saint Martin* has more in common with Manetti's 1606 study of *The Funeral of Saint Roch* in the royal collection at Windsor Castle.[2] Whereas the other drawings on sheets of paper from the account book are characterized by a strongly Caravaggesque flavor of dramatic chiaroscuro, as filtered through influence from Honthorst, *Saint Martin* is sweeter, more lyrical, and theatrically staged, like the work of Manetti's Sienese predecessors Vanni and Salimbeni.

NOTES
1. Bagnoli, *Manetti*, nos. 78–79, 81.
2. Ibid., no. 70.

GUIDO RENI

Calvenzano (Italy) 1575–1642 Bologna
Head of a Man [Nicholas Lanier?], about 1625–30
Red and black chalk on gray paper
16 ½ x 11 ½ in. (41.9 x 29.2 cm)

PROVENANCE

Kate Ganz, London; purchased by the museum in 1993

———

BIBLIOGRAPHY

Susan E. James, "Reni's Drawing of Nicholas Lanier: A Recent Discovery at LACMA," *Apollo* 144
(October 1996): 14–18.

———

EXHIBITION

Kate Ganz, *Heads and Portraits: Drawings from Piero di Cosimo to Jasper Johns*, exh. cat.
(New York: Jason McCoy Inc., 1993), no. 11

———

Gift of the 1993 Collectors Committee, AC1993.21.1

———

Reni studied initially in Bologna with the Flemish painter Denys Calvaert before transferring to the Carracci's Accademia degli Incamminati, then headed by Lodovico Carracci. From this master Reni undoubtedly learned the qualities of lyrical grace and sweetness that would characterize his later works. Reni went to Rome in 1600, but unlike his fellow Carracci pupils Francesco Albani and Domenichino, he did not join Annibale Carracci's workshop in the decoration of the Galleria Farnese. Reni remained in Rome for fourteen years, during which he received significant commissions for the decoration of the Cappella dell'Annunciazione in the Palazzo Quirinale and the *Aurora* ceiling for Cardinal Scipione Borghese's villa. He returned to Bologna and was the dominant artistic personality there for nearly thirty years.

Reni was renowned during his day as a painter of biblical and mythological subjects; only rarely did he explore portraiture, as in the museum's painting *Portrait of Cardinal Roberto Ubaldino*. He made many studies from models in preparation for his narrative works, but those sheets differ strikingly in character from the present

drawing. The directness of the sitter's gaze and the life-sized presentation of the subject give it a sense of immediacy and riveting power that is rarely encountered in Reni's usually more idealized works. Reni's very loose, spontaneous, and open hatching enlivens the three-dimensional form, and his naturalistic use of red chalk around the eyes, mouth, and nostrils makes the man come alive.

In the past the subject has been suggested to be a self-portrait, an identification derived mostly it would seem from the immediacy of the portrayal rather than from a comparison with Reni's known self-portraits, most of which date from later in his career. More recently, Susan James has proposed the English musician and drawings collector Nicholas Lanier (1588–1666) as the sitter. The resemblance is striking, and Lanier and Reni are recorded as having exchanged drawings. Lanier served as King Charles II's agent in Italy, principally in northern Italy and Venice from 1625 to 1628, and could very plausibly have sat for this drawing at that time.

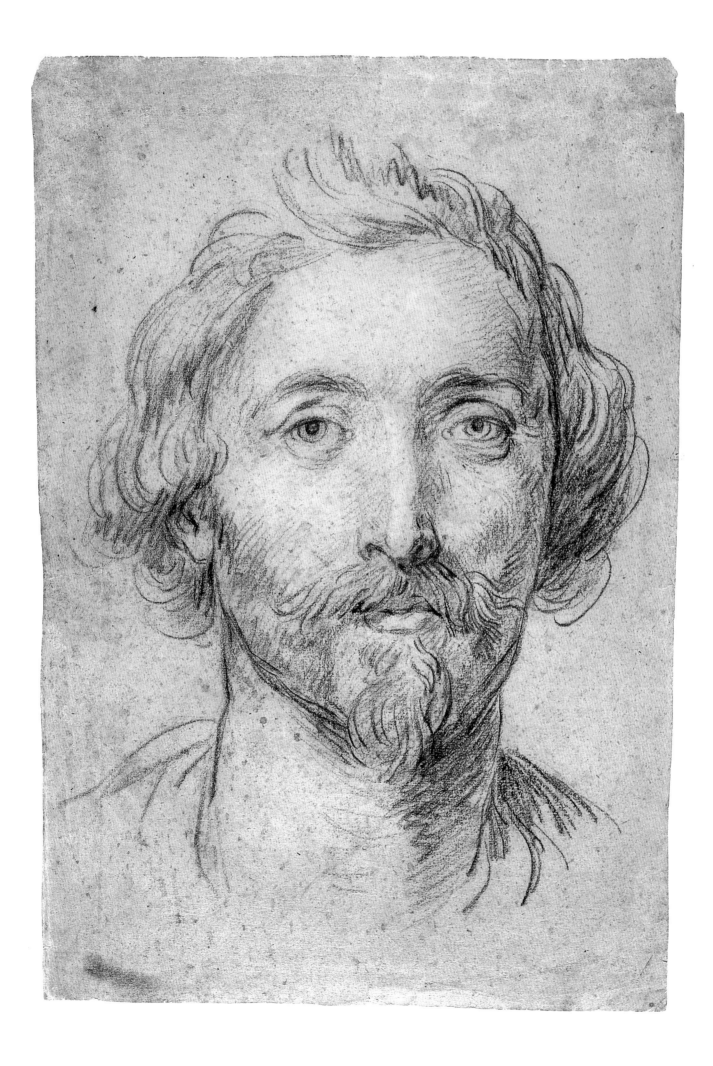

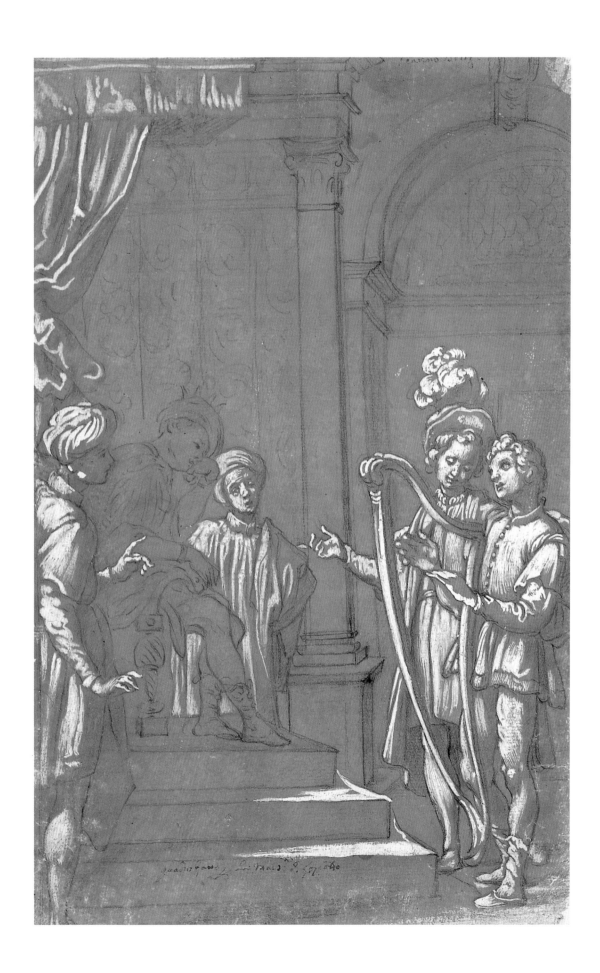

16

JACOPO VIGNALI
Pratovecchio (Italy) 1592–1664 Florence
David Playing the Harp before King Saul, date unknown
Black chalk and white gouache on green prepared paper
15¼ x 9⅝ in. (38.7 x 24.5 cm)

INSCRIPTIONS
UPPER RIGHT: Tiarino Bolognese
LOWER CENTER: quadro fatto per [] Madonna di []

———

PROVENANCE
Mia Weiner, New York; purchased by the museum in 1988

———

Purchased with funds provided by Ebria Feinblatt, M.88.4

⊷⊶

A highly precocious artist, Vignali at age thirteen entered the studio of Matteo Roselli, the leading painter in Florence. He was engaged in 1615–20 in the decoration of the Casa Buonarroti, working alongside all of the principal Florentine artists of the period. The sweetly melancholic tone of Vignali's art is a characteristic that he passed on to his better known pupil, Carlo Dolci.

The painterly delineation of the forms with white gouache over preliminary drawing in black chalk on prepared paper, representative of Vignali's draftsmanship, is firmly within the seventeenth-century Florentine tradition established early in the century by Il Cigoli and Jacopo da Empoli. Also typical of Florentine baroque art is Vignali's presentation of the biblical narrative using figures in contemporary dress, a Counter Reformation approach that attempted to bring religious subjects closer to their audience. A nearly identical drawing by Vignali is in the Musée Magnin, Dijon.[1] Christel Thiem has noted other instances of Vignali making replicas of his drawings.[2] Mia Weiner (letter, departmental files) reports a painting by Vignali of this subject, with some compositional differences, in the Rambaldi collection, Ospedaletto, Coldirodi (San Remo).

NOTES

1. Arnauld Brejon de Lavergnée, *Dijon, Musée Magnin: Catalogue des tableaux et dessins italiens (XVe–XIXe siècles)* (Paris: Réunion des Musées Nationaux, 1980), no. D.48.
2. For example, two identical versions in the Uffizi of *The Martyrdom of Saint Lucy* (inv. nos. 15261 F and 15262 F); see Christel Thiem, *Florentiner Zeichner des Frühbarock* (Munich: Bruckmann, 1977), 366, no. 149.

17

GIOVANNI FRANCESCO BARBIERI, CALLED IL GUERCINO

Cento (Italy) 1591–1666 Bologna
An Assembly of Learned Men, about 1625–27
Brown ink and wash
10 5/8 x 15 3/8 in. (27 x 39.1 cm)

PROVENANCE

Paul Brandt, Amsterdam; Frederick Anthon Gallery, Beverly Hills; purchased by the museum in 1964

BIBLIOGRAPHY

Feinblatt, 1970, n.p.; Renato Roli, *Guercino* (Milan: Aldo Martello Editore, 1972), no. 39, pl. 39;
John Varriano, "Notes on Some Princeton Drawings: Guercino, Bonfanti, and
Christ Among the Doctors," *Record of the Art Museum, Princeton University* 32, no. 1 (1973): 15 n. 5

EXHIBITIONS

Walter Vitzthum, *A Selection of Italian Drawings from North American Collections*, exh. cat.
(Regina, Saskatchewan: Norman Mackenzie Art Gallery, 1970), no. 34; Feinblatt, 1976, no. 94; Davis,
30, no. 37; David M. Stone, *Guercino, Master Draftsman: Works from North American Collections*, exh. cat.
(Cambridge: Harvard University Art Museums, 1991), no. 18

Los Angeles County Fund, 64.24

Giovanni Battista Barbieri was called Il Guercino (the squinter) because of an eye condition he reportedly developed as a child. His artistic formation was determined by the presence in Cento after 1591 of Ludovico Carracci's altarpiece *The Holy Family with Saint Francis*.[1] The painting's rich coloring, smoky chiaroscuro, and dramatic composition were very influential on Guercino's early style. He eventually became one of the most esteemed and significant Italian baroque artists. He was in Rome from 1621 to 1623 during the pontificate of Gregory XV (a fellow Emilian from Bologna), and there he painted, among other commissions, the *Aurora* ceiling in the Casino Ludovisi and the *Saint Petronilla* altarpiece for Saint Peter's. After the death of Gregory XV, Guercino returned to Cento, where he lived until 1642, when he moved to Bologna after the death of Guido Reni.

Guercino succeeded Reni as the city's leading painter and was heavily patronized by an international clientele.

Guercino also was one of the century's most prolific draftsmen, as he prepared each of his many paintings by producing numerous compositional studies, sketches of individual figures, and drawings of heads, limbs, and drapery. In addition to his preparatory drawings, he also made many sheets as independent works, such as landscapes, genre scenes, caricatures, and *capricci*. In regard to these different types of drawings, Guercino followed the practice established at the end of the sixteenth century by members of the Carracci family in Bologna.

An Assembly of Learned Men has been connected by some scholars with an altarpiece of about 1625–27 by Antonio Bonfanti in the church of San Francesco, Ferrara, for which Guercino provided the design. This

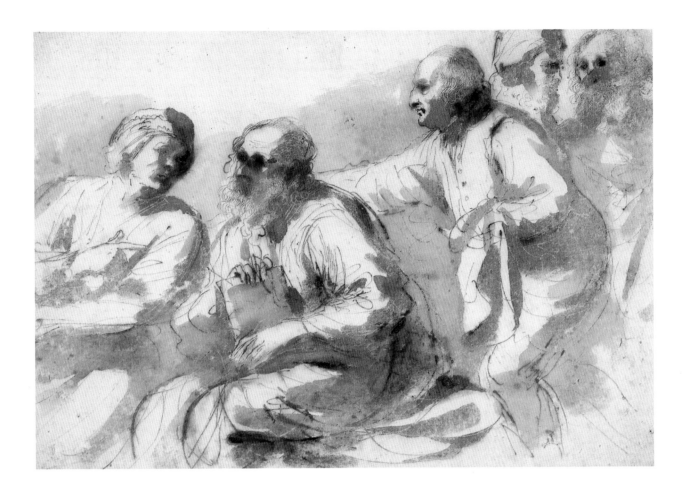

sketch does not agree closely with the corresponding figures of Hebrew elders in either Bonfanti's painting or Guercino's other compositional studies for the painting; but that is not unusual in Guercino's customary manner of working from drawings to paintings, and it is close enough in style, apparent subject, general disposition of the figures, and physical types to imply the relationship. The quite specific physiognomies of some of the men,

such as the one seated at the left and the man striding at the right, suggest that they were intended as portraits of particular individuals. The same observation can be made of Bonfanti's painting. Consequently, both the painting and the related drawing can be interpreted as group portraits (probably a gathering of scholars, given the subject matter) rather than simply a New Testament narrative.

NOTE

1. *The Age of Correggio and the Carracci: Emilian Painting in the Sixteenth and Seventeenth Centuries*, exh. cat. (Washington, D.C.: National Gallery of Art, 1986), no. 108.

ANTONIO D'ENRICO, CALLED TANZIO DA VARALLO

Riale d'Alagna (Italy) 1575/80–1635 Varallo

Studies of the Virgin, Drapery, and the Hand of Saint John the Baptist Holding a Shell,

about 1628

Red chalk, heightened with white, on pink prepared paper

7 13/16 x 5 15/16 in. (19.8 x 15.1 cm)

PROVENANCE

Carlo Prayer, Milan (Lugt 2044); Christie's, London, 1 April 1987, lot 57, purchased by the museum

BIBLIOGRAPHY

Philip Conisbee, Mary L. Levkoff, and Richard Rand,

The Ahmanson Gifts: European Masterpieces in the Collection of the Los Angeles County Museum of Art

(Los Angeles: Los Angeles County Museum of Art, 1991), 81–82, fig. 19a

Gift of The Ahmanson Foundation, M.87.109

Tanzio was one of the principal artists of the Counter Reformation in Lombardy and contributed several paintings to the decoration of the Sacra Monte in his hometown of Varallo, one of the key monuments of the Counter Reformation, in which the compositions have the character of *tableaux vivants* in order to engage the viewers. Tanzio made such drawings as the present one to render the character of intense naturalism found in his paintings.

The museum acquired this sheet because the figure of the Virgin Mary has a close relationship to the figure of her in the museum's painting by Tanzio of about 1628–30, *Adoration of the Shepherds with Saint Francis and Saint Carlo Borromeo.* A nearly identical study of the female figure, in the same technique though on a smaller sheet, is in the Louvre.[1] The Paris sheet has been related to another painting by Tanzio, documented to 1628, depicting the Virgin and child flanked by the two saints.[2] Because of the similarity in the position of the Virgin in the two canvases and because of the unknown relationship between the Los Angeles and Varallo paintings, it is impossible to speculate for which painting the present drawing was first employed. A study for the figure of Saint Francis, with the same unknown relationship between drawing and painting, is in the Pierpont Morgan Library.[3]

The coloristic effects here are very characteristic of Tanzio's oeuvre as a draftsman, a good sampling of which was included in the graphics section of the 1973 exhibition *Il Seicento lombardo* in Milan.[4] All but two of the drawings in that exhibition were executed in the same technique as the museum's sheet, red and white chalk on paper washed with red chalk. Also like this drawing, they are detailed studies of individual figures, heads, and limbs.

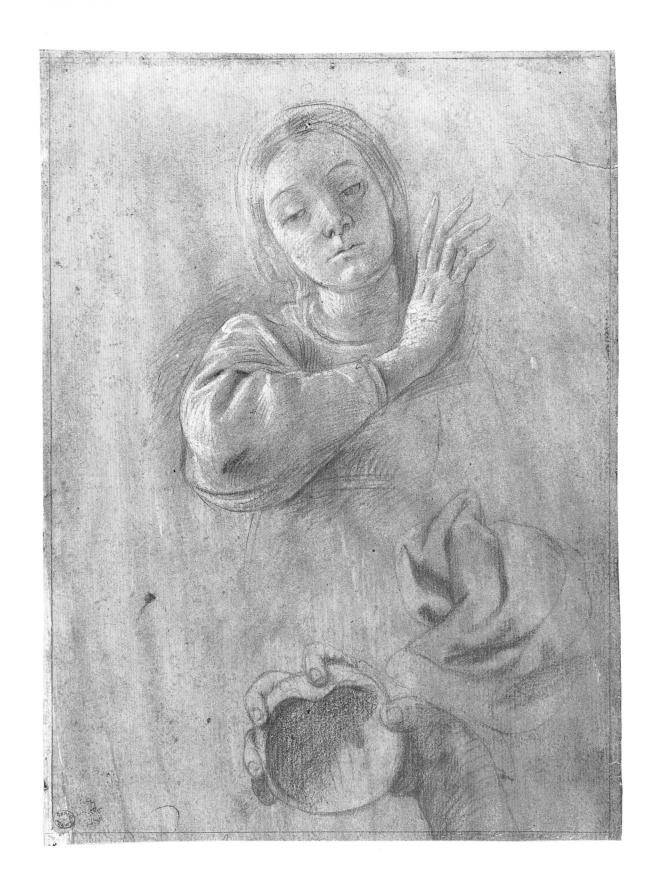

NOTES

1. *Acquisitions 1984–1989*, exh. cat. (Paris: Cabinet des Dessins, Musée du Louvre, 1990), 32, no. 19. The museum's drawing is not mentioned.

2. Originally in the Oratorio di San Carlo in Sabbia, the painting is now in the Pinacoteca, Varallo. See *Il Seicento lombardo. Vol. 2: Catalogo dei dipinti e delle sculture*, exh. cat. (Milan: Palazzo Reale; Electa Editrice, 1973), 66, no. 169, pl. 183.

3. Janos Scholz, *Italian Master Drawings 1350–1800 from the Janos Scholz Collection* (New York: Dover Publications, Inc., 1976), xvi, no. 67.

4. *Il Seicento lombardo. Vol. 3: Catalogo dei disegni, libri, stampe*, exh. cat. (Milan: Pinacoteca Ambrosiana; Electa Editrice, 1973), 31–32, nos. 119–31.

19

GIOVANNI FRANCESCO BARBIERI,
CALLED IL GUERCINO

Cento (Italy) 1591–1666 Bologna

Saint John the Baptist and Saint John the Evangelist, about 1631–32

Red chalk with some stumping

10 13/16 x 10 3/4 in. (27.5 x 27.3 cm)

INSCRIPTION

LOWER RIGHT: Guerchino

———

PROVENANCE

Casa Gennari, Bologna; Henry Oppenheimer, London; his sale,

Christie's, London, 10 July 1936, lot 102b; Denis Mahon, London;

Baron P. Hatvany; his sale, Christie's, London, 27 November 1973, lot 346;

Thomas Agnew and Sons, London (cat. 1976, no. 29); purchased by the museum in 1978

———

BIBLIOGRAPHY

Francesco Bisogni, "A Fragment of Guercino's Pesaro Altarpiece,"

Burlington Magazine 117 (1975): 342, fig. 6; Denis Mahon,

I disegni del Guercino nella collezione Mahon (Bologna: Alfa, 1976), 46, under no. 22;

Denis Mahon and David Ekserdjian, *Guercino Drawings from the Collections of*

Denis Mahon and the Ashmolean Museum, exh. cat. (Oxford: Ashmolean Museum, 1986), 15, under

no. 24; Luigi Salerno, *I dipinti del Guercino* (Rome: Ugo Bozzi Editore, 1988), 234, under no. 141;

Denis Mahon and Nicholas Turner, *The Drawings of Guercino in the Collection of*

Her Majesty the Queen at Windsor Castle

(Cambridge: Cambridge University Press, 1989), 184, under nos. 624–25

———

EXHIBITIONS

Davis, 30, no. 38; David M. Stone, *Guercino, Master Draftsman:*

Works from North American Collections, exh. cat.

(Cambridge: Harvard University Art Museums, 1991), no. 27

———

Graphic Arts Council Fund, M.78.25

———

This drawing is a study for two figures in a now-lost altarpiece of 1631–32, which depicted the Madonna and child with Saints Lucy, Francis, John the Evangelist, and John the Baptist; only a fragment with Saint Lucy survives. Early in his career Guercino used oiled, black chalk for making figure studies, a method he may have learned from studying drawings by Annibale Carracci, Pietro Faccini, Giacomo Cavedone, and other Bolognese artists. Later Guercino frequently executed this kind of drawing in red chalk. By stumping—that is, smudging the chalk with either his finger or with a blunt piece of rolled paper (known as a stump)—Guercino was able to achieve soft

[52]

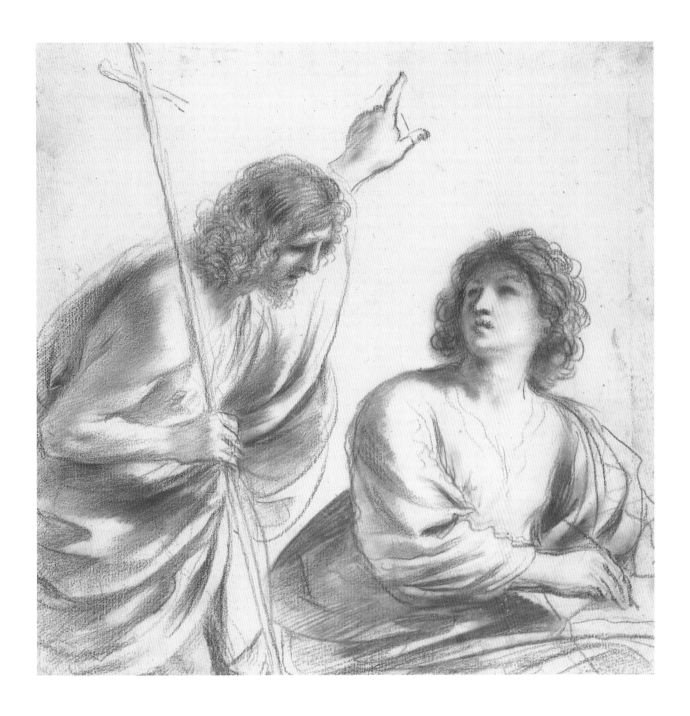

tonal gradations with subtle effects of muted lighting and vaporous chiaroscuro. This effect is particularly beautiful in the rendering of the head of Saint John the Evangelist in this sheet. As noted by Guercino specialist Nicholas Turner, the artist may have learned about the tradition of the use of red chalk from studying the drawings of Annibale Carracci while in northern Italy or from the large community of Florentine artists in Rome when Guercino was there in the early 1620s.

The sheet was dampened, perhaps in the eighteenth century, in order to produce a counterproof. This offset is now in the Queen's collection at Windsor Castle.

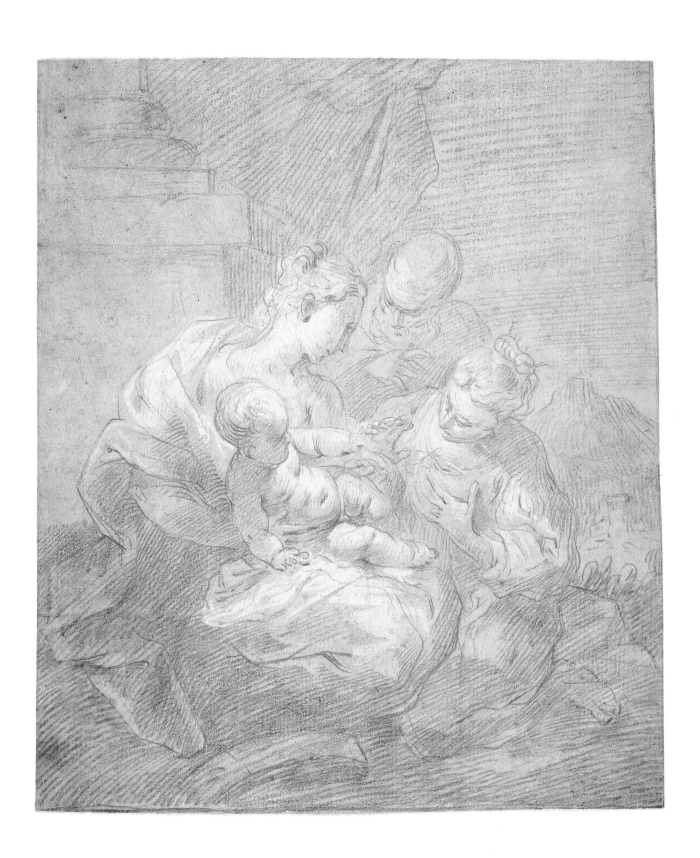

20

BARTOLOMEO BISCAINO
Genoa 1629–1657 Genoa
The Mystic Marriage of Saint Catherine, about 1650–57
Red chalk, heightened with white
9 3/16 x 8 1/16 in. (23.3 x 20.5 cm)

PROVENANCE
Robert Dance, New York; purchased by the donor in 1989

Gift of Ebria Feinblatt, M.89.109

Biscaino initially learned the art of painting from his father, Giovanni Andrea, and later studied under Valerio Castello. There are hardly any documented paintings by Biscaino; he died tragically in the plague of 1657 at the young age of twenty-eight. This sheet is characteristic for Biscaino in its subject and technique. Scenes of the Holy Family are frequently encountered among Biscaino's drawings and etchings, and the Los Angeles sketch is comparable in style to *The Rest on the Flight into Egypt* in the Pierpont Morgan Library,[1] particularly the delineation with repeated parallel strokes of red chalk and the definition of the drapery volumes with white gouache. The Los Angeles drawing's composition is similar to other works by Biscaino: the spatial relationship and poses of Mary and Joseph, also seen in the Morgan sheet; the figure of Saint Catherine sweeping in from the side, similar to the shepherd in Biscaino's etching *The Nativity*;[2] and the foreshortened, squirming Christ child, like the infant Moses in Biscaino's drawing in the Uffizi, *The Finding of Moses.*[3]

The debt owed by Biscaino to the art of Parmigianino and his northern Italian heirs, such as Camillo Procaccini and the Carracci, has been long recognized. One particular source may be noted for *The Mystic Marriage of Saint Catherine*: Lodovico Carracci's etching *The Madonna and Child with Angels*,[4] in which Christ is held by the Madonna in a like fashion.

NOTES

1. Mary Newcome, *Genoese Baroque Drawings*, exh. cat. (Binghamton: University Art Gallery, State University of New York, 1972), 31, no. 78.

2. Adam Bartsch, *Le peintre graveur* (Vienna: Pierre Mechetti, 1821), 21: 184, no. 5.

3. Mary Newcome Schleier, *Disegni genovesi dal XVI al XVIII secolo*, exh. cat. (Florence: Gabinetto Disegni e Stampe degli Uffizi, 1989), 138–39, no. 67, fig. 92.

4. Adam Bartsch, *Le peintre graveur* (1821; reprint, Leipzig: J. A. Barth, 1870), 18: 24–25, no. 2.

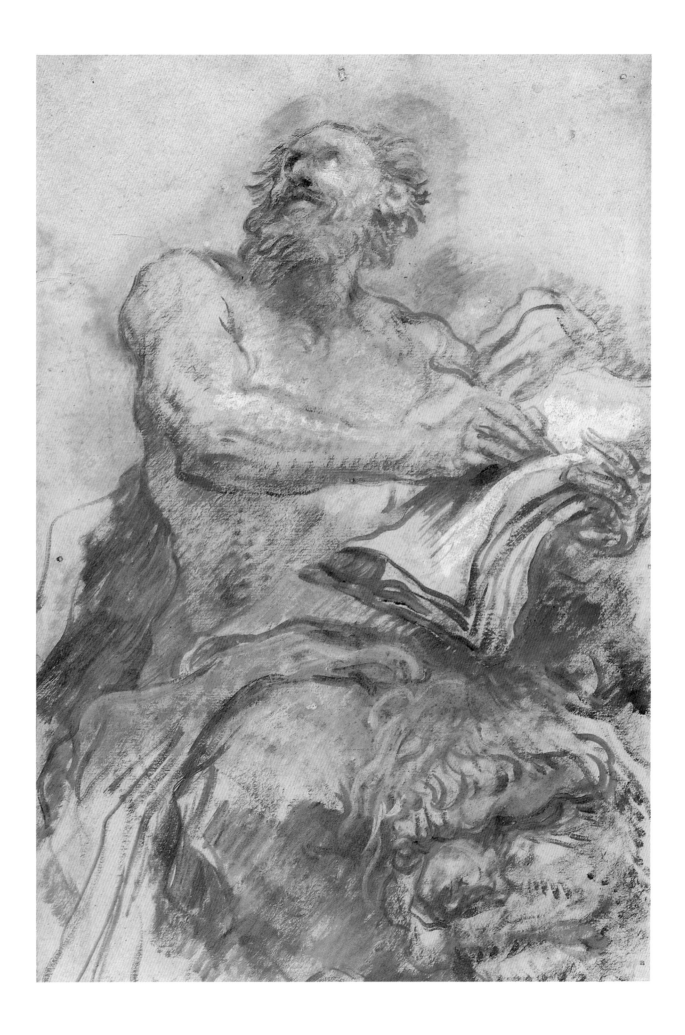

21

GIOVANNI BENEDETTO CASTIGLIONE
Genoa 1609–1664 Mantua
Saint Mark, 1650s
Brown and red-brown paint with blue, pink, and white gouache
14 ⅜ x 9 ¾ in. (36.5 x 24.8 cm)

PROVENANCE

Jonathan Richardson Jr. (Lugt 2170); Henry Oppenheimer, London; his sale, Christie's, London,
10 July 1936, lot 64; Rosenthal; Sotheby's, London, 25 March 1982, lot 4, purchased by the museum

———

BIBLIOGRAPHY

"The Sale Room," *Apollo* 116 (1982): 68, fig. 7; James Byam Shaw,
"On the Origin of a Drawing by Francesco Guardi," *Notizie da Palazzo Albani* 12, nos. 1–2 (1983):
274–76, fig. 3; Lorna Price, *Masterpieces from the Los Angeles County Museum of Art Collection*
(Los Angeles: Los Angeles County Museum of Art, 1988), 125

———

EXHIBITION

Davis, 31, no. 14

———

Purchased with funds provided by the Garrett Corporation, M.82.73

Castiglione was a pupil of the Genoese painters Giovanni Battista Paggi and Giovanni Andrea de Ferrari, though the influence of Antony van Dyck from his presence in the city in the 1620s was significant for Castiglione's development. Also consequential were his several sojourns in Rome, where he encountered the elegiac and romantic works of Nicolas Poussin, Salvator Rosa, Pietro Testa, and Pier Francesco Mola.

This majestic sheet cannot be related to a particular finished work by Castiglione. Ann Percy considers it a late work by the artist (conversation with the author), from the 1650s, when Castiglione was in the service of the duke of Mantua. While he was in Emilia, he likely visited Parma,[1] where he would have studied the frescoes by Correggio in the church of San Giovanni Evangelista. As noted by Byam Shaw, Castiglione's figure may have been inspired by Correggio's apostles and saints in the cupola and pendentives. Single figures such as the museum's drawing are quite rare in Castiglione's oeuvre, as he generally employed this painterly technique of brush and oil paint on paper for full compositions. The most comparable drawing is the half-length figure of an oriental potentate in the Institut Néerlandais, Paris,[2] which is very similar to contemporary paintings of such figures by Mola.

NOTES

1. As noted by Ann Percy, *Giovanni Benedetto Castiglione: Master Draughtsman of the Italian Baroque*, exh. cat. (Philadelphia: Philadelphia Museum of Art, 1971), 38.

2. James Byam Shaw, *The Italian Drawings of the Fritz Lugt Collection* (Paris: Institut Néerlandais, 1983), 1: 415, no. 417; 3: pl. 468.

22

JACOB JORDAENS
Antwerp 1593–1678 Antwerp
Drapery Study of a Seated Man Wearing a Cap (recto);
Study of a Hand in a Sleeve and Partial Sketch of a Child (verso), about 1655–65
Black chalk and brown, gray, and blue wash, heightened with white
11 ¼ x 10 ½ in. (28.6 x 26.7 cm)

INSCRIPTION
LOWER CENTER: Jordaens

———

PROVENANCE
R. Stora, New York; purchased by the museum in 1954

———

BIBLIOGRAPHY
Ira Moskowitz, ed., *Great Drawings of All Time* (New York: Shorewood Publishers, 1962),
2: no. 560; Colin T. Eisler, *Drawings of the Masters: Flemish and Dutch Drawings* (New York: Shorewood
Publishers, 1963), 28, 82, no. 51; Feinblatt, 1970, n.p.; R.-A. d'Hulst, *Jordaens Drawings*
(London and New York: Phaidon, 1974), 2: 434, no. A368; 4: figs. 386–87

———

EXHIBITIONS
European Master Drawings, exh. cat. (Santa Barbara: Santa Barbara Museum of Art, 1964), no. 12;
Michael Jaffe, *Jacob Jordaens*, exh. cat. (Ottawa: National Gallery of Canada, 1968), no. 238;
Feinblatt, 1976, 200–201, no. 219

———

Los Angeles County Fund, 54.24

———

Jordaens studied with Adam von Noort, who was a teacher of Peter Paul Rubens and whose daughter Jordaens married in 1616. Jordaens collaborated with Rubens in 1635 on the decorations for the celebration of the visit to Antwerp of the Cardinal-Infante and in 1637 on the Torre de la Parada commission for King Philip IV of Spain. After Rubens's death in 1640 and Antony van Dyck's in 1641, Jordaens became the most celebrated painter in Antwerp; with a large workshop he executed the numerous commissions from foreign and both Catholic and Protestant authorities. Unlike Rubens and Van Dyck, however, he did not fit the stereotypical mold of a court painter. His art is more earthy and bourgeois in temperament, frequently with moralizing overtones in his explorations of human nature.

This study cannot be associated with a specific work by Jordaens; the pose of the figure is similar to ones frequently used for sleeping apostles in typical compositions of the Agony in the Garden. Jaffe, who discovered another sketch on the verso of the sheet, dated it to the late 1650s or early 1660s. In this drapery study Jordaens is more interested in the complicated play of the folds in the material than in the body underneath, a Flemish tradition that goes back to the late medieval figures by sculptor Claus Sluter and painter Robert Campin.

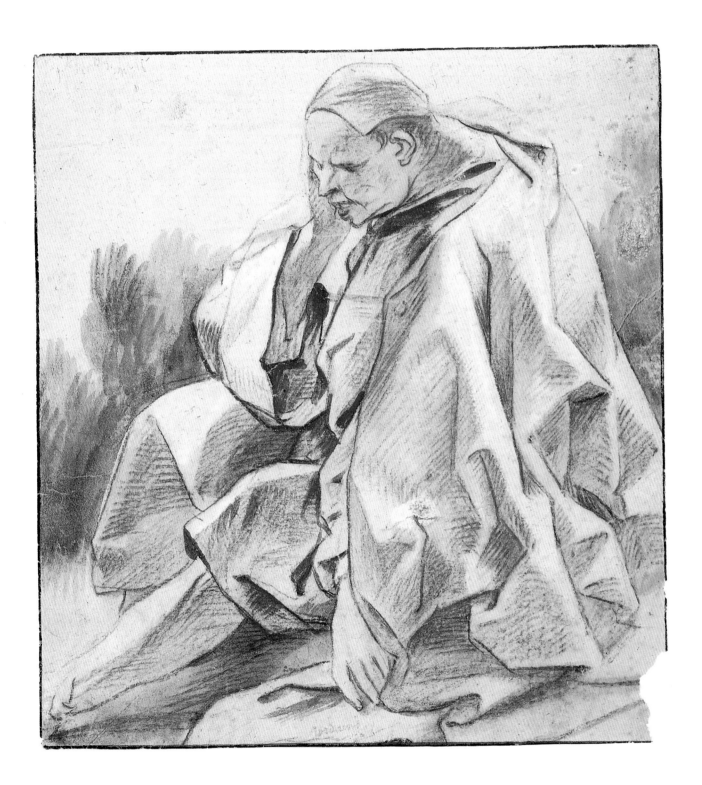

23

PIETRO BERRETTINI, CALLED PIETRO DA CORTONA
Cortona (Italy) 1596–1669 Rome
Study of a Male Figure with Right Arm Raised, about 1664–65
Black and white chalk on bluish gray paper
19 ⅛ x 12 ⅞ in. (48.6 x 32.7 cm)

INSCRIPTIONS
VERSO, RIGHT: Pietro di Cortona, Disegni Originali; Pietro di Cortona

———

PROVENANCE
Sotheby's, London, 21 June 1978, lot 3; Yvonne Tan Bunzl, London;
purchased by the museum in 1982

———

BIBLIOGRAPHY
Bruce Davis, "Pietro da Cortona Drawings for Frescoes," *Source: Notes in the History of Art* 2, no. 4
(1983): 16, fig. 3; Jörg Martin Merz, "I disegni di Pietro da Cortona per gli affreschi
nella Chiesa Nuova a Roma," *Bollettino d'Arte* 86–87 (1994): 70, fig. 38

———

EXHIBITION
Davis, 31–32, no. 15

———

Purchased with funds provided in honor of Ebria Feinblatt by
Dr. David I. and Frances R. Elterman and Bella Mabury by exchange, M.82.131

———

Cortona went to Rome at an early age and studied with fellow Tuscans Baccio Ciarpi and Andrea Commodi. Cortona's dramatic and visually opulent style developed, however, under the influence of Venetian Renaissance painting and ancient sculpture. He was patronized by the Barberini family of Pope Urban VIII and became renowned equally as a decorator, painter, and architect. He was president of the Accademia di San Luca in 1634–36. Among his masterpieces in painting are the frescoes in the Palazzo Barberini and Palazzo Pamphili in Rome and the Palazzo Pitti in Florence; and in architecture the churches Santi Luca e Martina and Santa Maria della Pace in Rome.

Compared to the numerous studies (mostly in the Uffizi) for his decoration of the Palazzo Pitti, preparatory drawings for his other decorative projects are not very plentiful. His most important religious work was the group of frescoes in the Oratorian church of Santa Maria in Valicella (also known as the Chiesa Nuova) in Rome, consisting of the decoration of the cupola, apse, and nave, a painting campaign that lasted from 1647 to 1665. Cortona's last major fresco was *The Vision of Saint Filippo Neri during the Construction of the Church*, painted in the nave of the Chiesa Nuova in 1664–65.[1] Only three drawings for it are known: a sheet in the Ashmolean Museum, Oxford, for the entire scheme;[2] one in the Istituto Nazionale per la Grafica, Rome, for one of the saint's attendants;[3] and the museum's drawing, a majestic study for the workman hoisting a beam at the middle-left of the fresco.

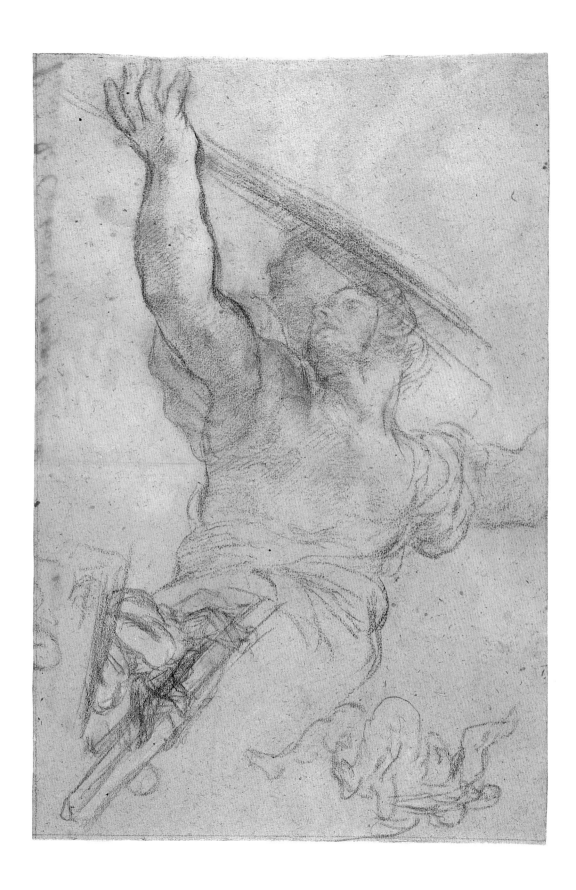

NOTES

1. Giuliano Briganti, *Pietro da Cortona, o della pittura barocca* (Florence: Sansoni, 1962), pl. 278.

2. K. T. Parker, *Catalogue of the Collection of Drawings in the Ashmolean Museum: II. Italian Schools* (Oxford: Clarendon Press, 1956), no. 831.

3. Maria Giannatiempo, *Disegni di Pietro da Cortona e Ciro Ferri* (Rome: Gabinetto Nazionale delle Stampe, 1977), no. 12.

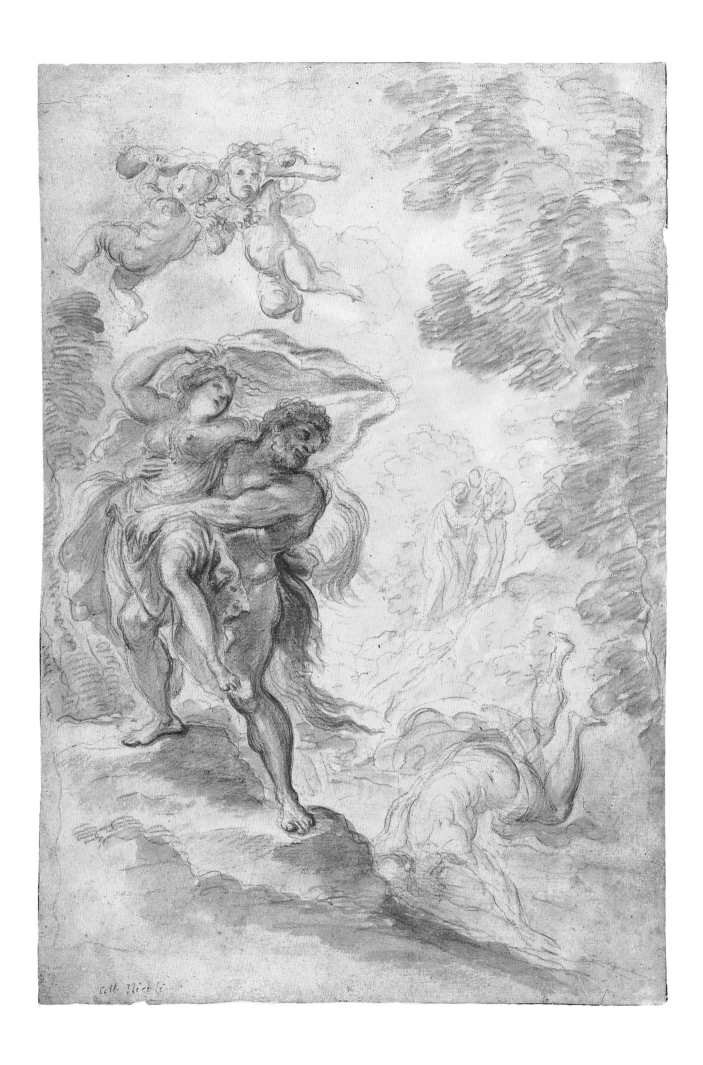

24

DOMENICO MARIA CANUTI

Bologna 1626–1684 Bologna

Hercules Rescuing Deianira, about 1669–71

Red chalk and red wash, laid down

11 ³⁄₈ x 8 ¹⁄₈ in. (28.9 x 20.6 cm)

INSCRIPTION

LOWER LEFT: Coll. Nicoli

———

PROVENANCE

Clemente Nicoli [?]; Sotheby's, Florence, 6–7 April 1976, lot 190; Yvonne Tan Bunzl, London;
purchased by the museum in 1977

———

EXHIBITION

Mimi Cazort and Catherine Johnston, *Bolognese Drawings in North American Collections, 1500–1800*,
exh. cat. (Ottawa: National Gallery of Canada, 1982), no. 69

———

Purchased with funds provided by Mr. and Mrs. Billy Wilder by exchange, 77.1

⊶⊷

Canuti was the principal high baroque decorator in Bologna, heir to the tradition begun there by the Carracci family. He studied with a succession of Carracci pupils, including Francesco Albani and Guido Reni. Especially crucial for Canuti's development were the years 1647–51, when he was in Rome. These were the years when Giovanni Benedetto Castiglione was also in the city, when Pier Francesco Mola returned after years in northern Italy, and when Pietro da Cortona returned after a decade in Florence. These artists, especially Cortona, were all key figures in the creation of the late baroque style in Italy. Canuti subsequently introduced Cortona's exuberant and dramatic decorative style to northern Italy.

The museum's drawing is one of Canuti's rare chalk studies, as calligraphically curvilinear drawings in ink and wash are encountered more frequently. The sheet heretofore has not been connected with a particular painting by Canuti, but it may be related to one of his most significant decorative projects: the ceiling frescoes of 1669–71 representing *The Apotheosis of Hercules on Olympus* together with scenes of his various labors in the *gran salone* of the Palazzo Pepoli Campogrande, Bologna.[1] Another drawing by Canuti of this subject is in the Prado; though different in composition, it has been related to the Pepoli decorations.[2]

NOTES

1. Simonetta Stagni, *Domenico Maria Canuti pittore (1626–1684)* (Rimini: Luisè Editore, 1988), 165–66.

2. Manuela B. Mena Marqués, *Museo del Prado: Catálogo de dibujos: VI. Dibujos italianos del siglo XVII* (Madrid: Ministerio de Cultura, 1983), 47, fig. 51.

25

ADRIAEN VAN DE VELDE
Amsterdam 1636–1672 Amsterdam
Standing Nude Woman with Upraised Arms, about 1670
Red chalk
11 ¾ x 7 in. (29.9 x 17.8 cm)

PROVENANCE

R. S. Davis; Robert M. Light, Boston; purchased by the museum in 1963

———

BIBLIOGRAPHY

Feinblatt, 1970, n.p.; Carlos van Hasselt, *Rembrandt and His Century: Dutch Drawings of the Seventeenth Century from the Collection of Fritz Lugt*, exh. cat. (New York: Pierpont Morgan Library, 1978), 163 n. 6

EXHIBITIONS

Feinblatt, 1976, 170, no. 203; Davis, 32, no. 76

———

Los Angeles County Fund, 63.29.4

———

Adriaen was the son and brother, respectively, of the marine specialists Willem van de Velde the Elder and the Younger. He studied with Jan Wijnants in Haarlem, where he was particularly influenced by the landscape painter Philips Wouwerman. Van de Velde specialized in landscapes of the Dutch countryside, especially coastal scenes, but was also notable for his meticulously rendered figures. He was employed by other landscape painters, including Jacob van Ruisdael, to provide staffage for their works.

William Robinson has identified four types of drawings made by Van de Velde: landscape studies made directly from nature, preliminary sketches of landscape compositions, finished drawings of landscape compositions, and chalk figure studies.[1] Carlos van Hasselt identified a number of studies in red chalk by Van de Velde, including this sheet, in which the artist used the same model, sometimes clothed and sometimes nude.[2] To this group can be added two drawings for the figure of Pomona in Van de Velde's painting *Vertumnus and Pomona* of 1670 in the Kunsthistorisches Museum, Vienna.[3] The connection—not previously made—of studies of this particular female model to a dated painting suggests the entire group, including the museum's drawing, is from the same period.

NOTES

1. William W. Robinson, "Preparatory Drawings by Adriaen van de Velde," *Master Drawings* 17, no. 1 (1979): 4.
2. Van Hasselt, *Rembrandt and His Century*, 162.
3. Robinson, "Preparatory Drawings," 22, nos. D.14–15, pls. 10–11.

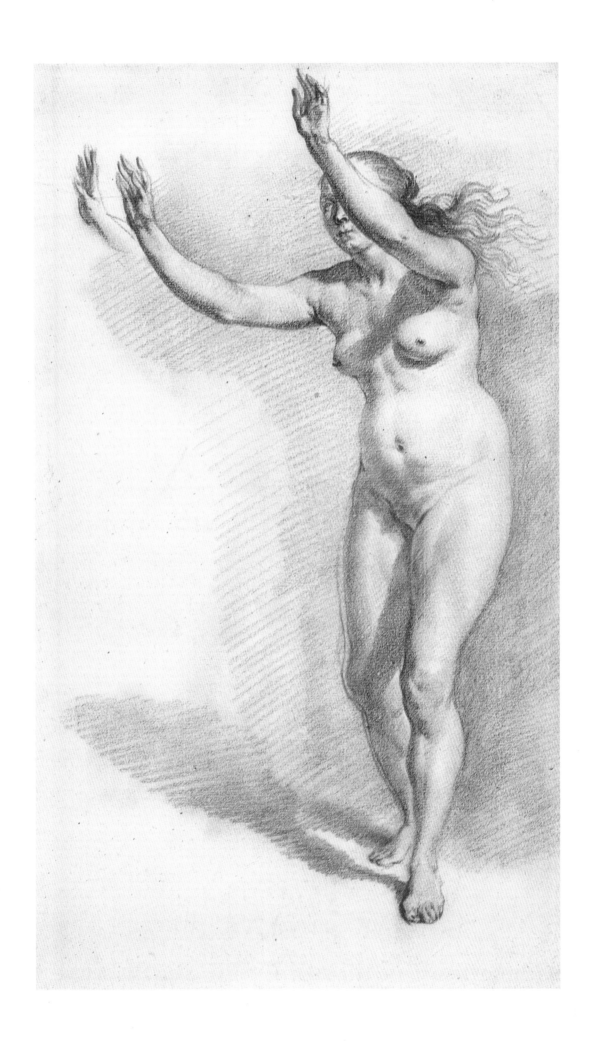

26

CARLO MARATTA
Camerano (Italy) 1625–1713 Rome
Study for an Allegorical Figure of Africa, about 1674–77
Red chalk, laid down
17 x 12⅜ in. (43.2 x 31.4 cm), spandrel shaped

PROVENANCE

John Barnard (Lugt 1420) [with his inscription on back of the mount: JB no. 4/17 x 12¼]; F. Abbott
(Lugt 970); Sotheby's, London, 7 December 1978, lot 56, purchased by the museum

BIBLIOGRAPHY

Ebria Feinblatt, "A Drawing by Carlo Maratta," *Los Angeles County Museum of Art Bulletin* 25 (1979):
7–21; Catherine Legrand and Domitilla d'Ormesson-Peugeot, *La Rome baroque de Maratti à Piranesi*,
exh. cat. (Paris: Musée du Louvre, 1990), 40–41, under nos. 23–24; Bert W. Meijer, ed., *Italian
Drawings from the Rijksmuseum Amsterdam*, exh. cat. (Florence: Centro Di, 1995), 167, under no. 80

EXHIBITION

Davis, 31–32, no. 46

Purchased in memory of Lorser Feitelson with funds provided by the Graphic Arts Council,
Dart Industries, Inc., and Ticor Corporation, M.79.10

Maratta went to Rome at the age of eleven and soon entered the studio of Andrea Sacchi, eventually becoming not only his prize pupil but his assistant and artistic heir. Maratta's career was highly successful, with numerous papal and princely commissions, including sensitive ones such as the restoration of Raphael's Vatican frescoes and Annibale Carracci's Galleria Farnese. He very effectively forged a compromise between Sacchi's classicism and Pietro da Cortona's baroque exuberance and was championed by Gian Pietro Bellori, the most influential and discerning critic and connoisseur of his time. In 1701 Maratta was named "president-for-life" of the Accademia di San Luca.

Unlike most notable Roman baroque painters, Maratta limited his activity as a frescoist to only a few projects. The most significant of these was the decoration in 1674–77 of the main audience hall in the Palazzo Altieri, the family home of Pope Clement X. The icono-graphic plan for the frescoes was devised by Bellori.[1] The central section of the vault was devoted to *An Allegory of Clemency*, a pointed reference to the pope's name. After painting this area, the rest of the ceiling remained blank, and Maratta planned to fill these architectural spaces of spandrels and lunettes with several allegorical personifications of Christian virtues, such as Religion, Divine Wisdom, Peace, and so on, as well as with representations of the four parts of the world. Maratta's project is documented extensively by drawings for these figures, ranging from rapid pen and ink sketches to highly finished works like the museum's drawing.[2] Some of the subjects were repeatedly explored, including *Virtue Crowned by Honor* and *Sacred and Christian Rome*. For *Africa*, however, only the museum's drawing and one other, in the collection of the Earl of Crawford and Balcarres in London,[3] are known.

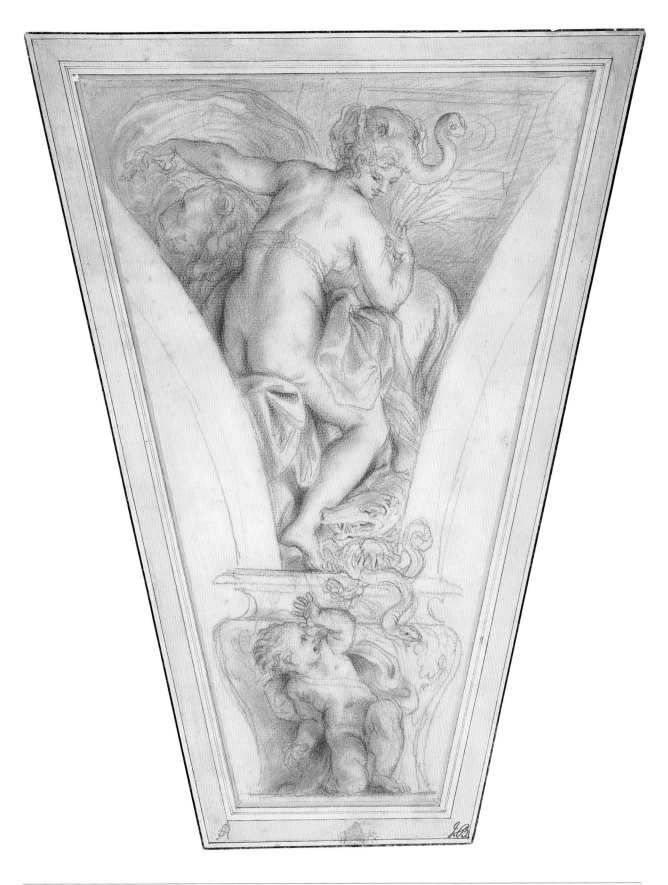

NOTES

1. Jennifer Montagu, "Bellori, Maratti, and the Palazzo Altieri," *Journal of the Warburg and Courtauld Institutes* 41 (1978): 334–42.

2. Ebria Feinblatt's article catalogues all the drawings for the unexecuted Altieri frescoes known at the time. Three more can be added to the group: a study for *Divine Wisdom* in the Louvre (published by Legrand and d'Ormesson-Peugeot); another study for *Divine Wisdom* in the Musée Wuyts-Van Campen-Caroly, Lier (*De Giorgione à Tiepolo: Dessins italiens du 15e au 18e siècle dans les collections privées et publiques de Belgique*, exh. cat. [Musée Communal d'Ixelles, 1993], no. 82); and a sketch for *Asia and America* in the Rijksmuseum (J. F. Heijbroek, "Carlo Maratta, De werelddelen Azië en Amerika, 1670–1676," *Bulletin van het Rijksmuseum* 37, no. 3 (1989): 235–37).

3. Feinblatt, "A Drawing by Carlo Maratta," 17, fig. 17.

27

CIRO FERRI
Rome 1634–1689 Rome

Saint John the Baptist Revealing Christ to Saints Peter and Andrew (recto);
Pagan Sacrifice (verso), about 1675–85

Red chalk, framed in brown ink

13 3/16 x 18 1/8 in. (33.5 x 46 cm)

INSCRIPTIONS

RECTO, UPPER LEFT: no. 27; RECTO, LOWER LEFT: Domenichino

———

PROVENANCE

Lorser Feitelson (purchased in the 1960s)

———

EXHIBITION

Alfred Moir, ed., *Old Master Drawings from the Feitelson Collection*, exh. cat.
(Santa Barbara: Art Galleries, University of California, 1983), no. 33

———

Gift of the Lorser Feitelson and Helen Lundeberg Arts Foundation, M.86.66

———

A native of Rome, Ferri was apprenticed at a young age to Pietro da Cortona, the major painter of the Roman High Baroque. Ferri became Cortona's principal assistant and his most faithful follower. Their styles of painting were so similar and compatible that Ferri was selected by Cortona to complete painted decorations that Cortona was unable to finish, most notably the frescoes in the Medici apartments in the Palazzo Pitti in Florence. As a result of the close working relationship between Cortona and Ferri and the pupil's conscious and sustained efforts to emulate his master, it has often been difficult to separate one artist's works from the other.[1] In addition to his Palazzo Pitti frescoes, Ferri also received significant commissions in Bergamo (in the church of Santa Maria Maggiore), Rome (in the church of Sant'Agnese), and Frascati (in the Villa Falconieri). The last two decades of his life were spent less on painting and more on designing decorative projects like mosaics in Saint Peter's, a set of tapestries illustrating the life of Pope Urban VIII, liturgical sculpture, and engravings. Ferri also directed the education of young Florentine artists at the Medici grandducal academy in Rome.

As noted by the inscription, the sheet was once attributed to Domenichino, presumably because of his well-known depiction of the subject in a fresco in the church of Sant'Andrea della Valle, Rome. The author suggested to Alfred Moir, editor of the Feitelson catalogue, the attribution of the drawing to Ferri. This sheet is unusual in Ferri's oeuvre because of the use of red chalk as its medium and the prominence of the landscape in the composition. Ferri generally preferred black chalk or pen and ink for compositional studies, and he executed few landscape drawings. The drawing's subject was treated by Ferri in a vertical composition that was made in 1684 as a presentation drawing for Cosimo III, grand duke of Tuscany.[2] In comparison with that design, the horizontal orientation and the smaller size of the figures in relation to the landscape in the museum's drawing make it appear relatively expansive and more lyrical in tone.

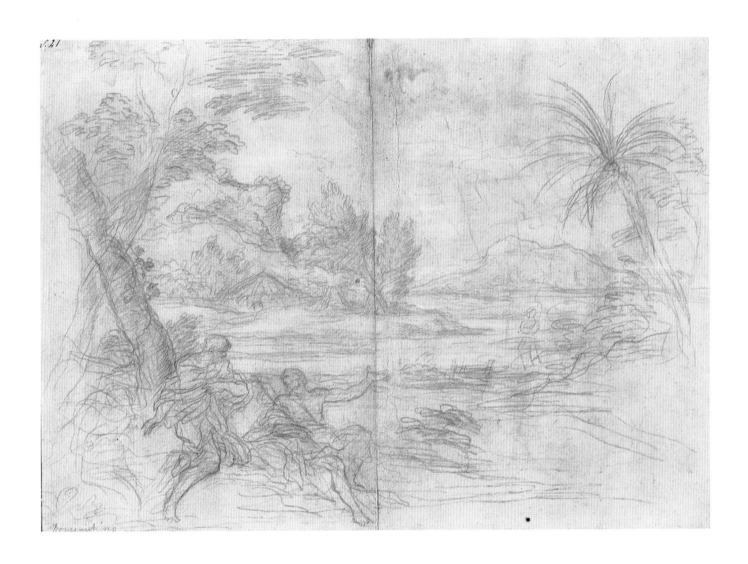

NOTES

1. The most complete study of Ferri's drawings and their relationship with Cortona's is Bruce Davis, *The Drawings of Ciro Ferri* (New York and London: Garland Publishing, Inc., 1986).

2. Ibid., 253, pl. 184.

28

DOMENICO PIOLA
Genoa 1627–1703 Genoa

The Pierides Transformed by the Muses into Magpies, about 1690–1700
Black chalk, brown ink, and gray wash, heightened with white
10 5/8 x 19 3/8 in. (27 x 49.2 cm), fan shaped

INSCRIPTION
LOWER CENTER: di Carlo Marati. Roma:

————

PROVENANCE
Adolph Loewi, Inc., Los Angeles; purchased by the museum in 1958

————

Los Angeles County Fund, 58.62.2

————

Domenico Piola initially studied painting with his older brother, Pellegro Piola. When the latter died prematurely in 1640, Domenico transferred to the studio of Pellegro's original teacher, Giovanni Domenico Cappellino. His most significant mentors, however, were Giovanni Benedetto Castiglione and Valerio Castello, under whose influences Piola developed a vigorously sweet and decorative style that dominated Genoese painting during the second half of the seventeenth century. He spent his career in Genoa except for a trip to Lombardy and Emilia in 1684–85, when Genoa was bombarded by the French. Piola was very prolific during his fifty-year career, and his altarpieces and frescoes are found in many Genoese churches and palaces. His drawings are also numerous and survive by the hundreds. Most of them, whether compositional sketches or studies for individual figures, are, like the Los Angeles sheet, executed in brown ink and carefully applied wash that defines the sculptural volumes of the forms.

This study was purchased in 1958 as by Carlo Maratta, undoubtedly based on the inscription; it was attributed to Piola by Ebria Feinblatt in 1971. Its fan-shaped format suggests that it is related to a decorative enterprise like a wall fresco over a door or window.

During the 1680s Piola collaborated with his son-in-law, the painter Gregorio de Ferrari, in the decorations in Genoa of the Villa Balbi allo Zerbino and the Palazzo Brignole-Sale, now the Palazzo Rosso. The mythological subjects of these frescoes revolved around themes of nature, such as representations of the seasons, Aurora, Apollo and his chariot of the sun, and the myth of Phaeton. The subject of the Los Angeles drawing is consistent with those themes: the metamorphosis of the daughters of Pierus (called the Pierides), who challenged the Muses to a musical contest and lost and were transformed into magpies (Ovid, *Metamorphoses*, 5.295–678). In 1666–67 Piola decorated a room in the palace of Francesco Maria Balbi with the subject of Apollo and the Muses;[1] but the format of the drawing does not correspond with the room's architecture, and the style of draftsmanship suggests a date twenty to thirty years later. Its scale and expansive composition can be compared to his late (1680s and 1690s) drawings *Saint Paul Preaching on the Areopagus* in Darmstadt[2] and *Saint Luke Preaching* in the Kunstbibliothek, Berlin.[3] A nearly identical drawing, apparently a copy, is in the Staatsgalerie Stuttgart, where it is catalogued as Florentine from about 1700.[4]

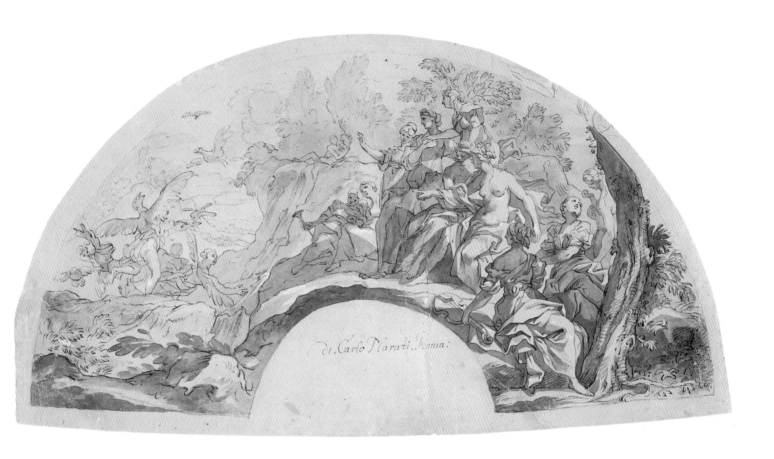

NOTES

1. Ezia Gavazza, *Lo spazio dipinto: Il grande affresco genovese nel '600* (Genoa: Sagep Editrice, 1989), 146, figs. 135–38.

2. Peter Marker, ed., *Genueser Zeichnungen des 16. bis 18. Jahrhunderts im Hessischen Landesmuseum Darmstadt,* exh. cat. (Darmstadt: Hessischen Landesmuseum Darmstadt, 1990), 124–25, no. 63.

3. Mary Newcome, *Genoese Baroque Drawings,* exh. cat. (Binghamton: University Art Gallery, State University of New York, 1972), no. 88.

4. Corinna Höper, *Italienische Zeichnungen, 1500–1800: Bestandskatalog, Teil II* (Stuttgart: Graphische Sammlung Staatsgalerie Stuttgart, 1992), 110, no. E 78.

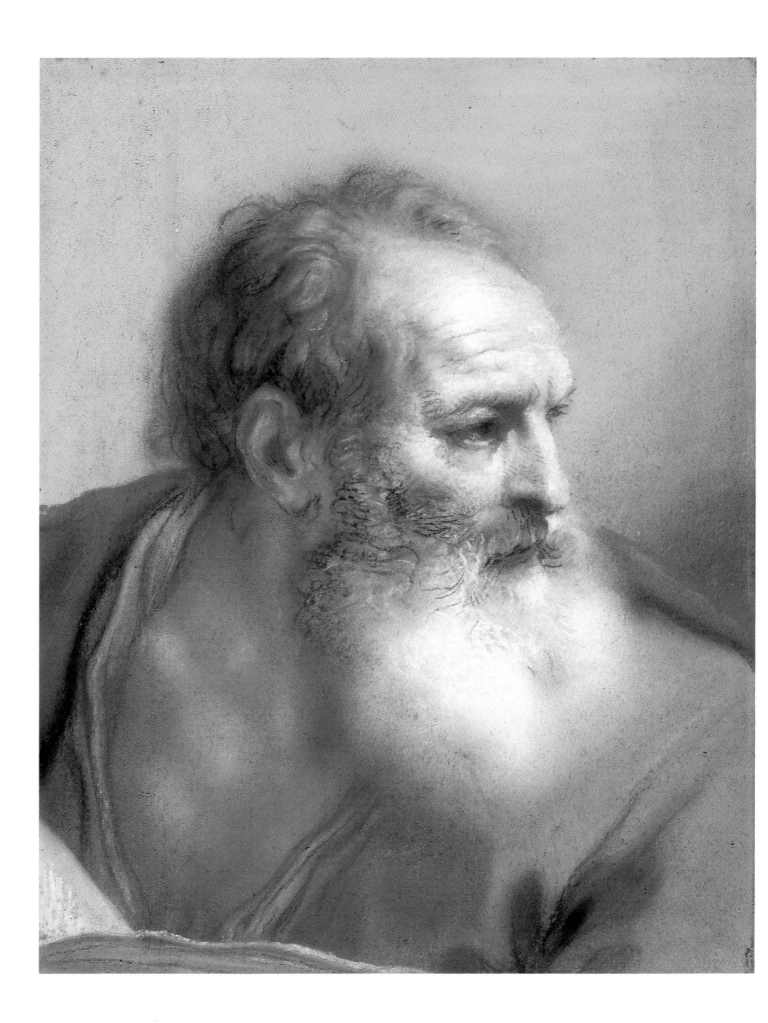

29

BENEDETTO LUTI

Florence 1666–1724 Rome

The Head of an Apostle, 1712

Pastel

16 ⅛ x 13 in. (41 x 33 cm)

INSCRIPTION

ON ORIGINAL BACKING BOARD: Roma 1712/Benedetto Luti fece

———

PROVENANCE

Sotheby's, New York, 14 January 1987, lot 122; purchased by P. and D. Colnaghi, New York, for Ian Woodner; his sale, Christie's, London, 2 July 1991, lot 115; Michael Curran, Houston; W. M. Brady, New York, and Thomas Williams, London (1995 cat., no. 31); purchased by the museum in 1996

———

Gift of the 1996 Collectors Committee, AC1996.29.1

⎯⎯⎯⎯⎯⎯

Luti was the most important painter in Rome during the first half of the eighteenth century. A native of Florence, he studied there initially with Anton Domenico Gabbiani. Luti moved to Rome in 1690 in order to study with Ciro Ferri, who had been Gabbiani's teacher and was head of the Medici grandducal academy in Rome. Unfortunately he was a year too late as Ferri had died in 1689. Luti became a member of the Accademia di San Luca in 1694 and was elected its president in 1720. He was not only a gifted artist but a great connoisseur and collector of drawings as well; when his collection was sold in 1762, it comprised 192 volumes of nearly fifteen thousand sheets.

He transformed the dramatic and sometimes heavy baroque style exemplified by Pietro da Cortona into the lighter, more decorative, and more playful manner of the Roman rococo, sometimes called *barochetto*. He was also significant for the popularization throughout Europe of the medium of pastel for the creation of drawings as independent works of art.[1] This drawing is from a set of twelve pastels representing the apostles. The male figures are not individually identifiable because Luti omitted the attributes traditionally associated with particular apostles. They are more like character studies than religious images. The museum's sheet is the most vigorous and dramatic drawing in the set, as several of the others are decidedly softer and sweeter in their characterizations. This head is also outstanding for Luti's virtuosic handling of the chalks, and especially the incredible effect of soft tactility in the rendering of the apostle's beard.

NOTE

1. For a general survey of Luti's pastels, see Edgar Peters Bowron, "Benedetto Luti's Pastels and Coloured Chalk Drawings," *Apollo* 111 (1980): 440–47.

30

FRANÇOIS BOUCHER
Paris 1703–1770 Paris
The Artist in His Studio, about 1733
Red chalk, heightened with white
14 ¼ x 10 ½ in. (36.2 x 26.7 cm)

PROVENANCE
Baron d'Ivry, Paris [?]; private collection, Paris; William H. Schab, New York;
purchased by the museum in 1959

BIBLIOGRAPHY
Ebria Feinblatt, "Boucher and Van Loo: Two Drawings," *Los Angeles County Museum Bulletin of the Art
Division* 11, no. 1 (1959): 3–7; Alexandre Ananoff, *L'oeuvre dessiné de François Boucher*
(Paris: F. DeNobele, 1966), 1: no. 10, fig. 22; Feinblatt, 1970, n.p.; Regina Shoolman Slatkin, "Portraits
of François Boucher," *Apollo* 94 (1971): 283, fig. 15; Alistair Laing et al., *François Boucher, 1703–1770*,
exh. cat. (New York: Metropolitan Museum of Art, 1986), 149–50, fig. 108

EXHIBITION
Davis, 32–33, no. 6

Los Angeles County Fund, 59.37.1

Boucher studied painting first with his father, Nicolas, and François Lemoine. Boucher won the Prix de Rome in 1723 and spent the years 1727–31 in Rome. He became *premier peintre* to King Louis XV in 1765 and took part in the decoration of many of the royal residences. He also designed theatrical sets, tapestries manufactured at Beauvais and Gobelins, and models for porcelains made at Vincennes and Sévres.

The attribution of this drawing to Boucher was rejected by Regina Slatkin but was accepted by Alistair Laing[1] as a study for a small oil on canvas, *The Landscape Painter* of 1733 in the Louvre.[2] The compositions of the painting and drawing correspond fairly closely, except for some details of various studio props. Like the canvas in the Louvre, it has traditionally been thought to be a self-portrait. In the painting the artist is working at his easel on a landscape that is identifiable as one by Boucher. But the age of the painter in the composition, apparently a rather young boy, does not correspond to Boucher's age

of about thirty at the time the drawing and painting were executed.

The drawing also differs from traditional representations of artists working in their studios, in which they sometimes portrayed themselves as well-dressed scholars rather than paint-splattered artisans. In a variation of the genre, students on occasion have been depicted working in a studio, but they are usually shown together with other students in the presence of their master rather than alone. In the Louvre painting the artist is working from a page in a sketchbook open next to the easel. Consequently, the painting on the easel is not based on the artist's direct observation of nature but is a product of his imagination. The works then may be interpreted as Boucher's tribute to his own artistry and creativity. The sketchbook is not present in the drawing, thus it appears that the painter is lost in thought as he stares blankly into space.

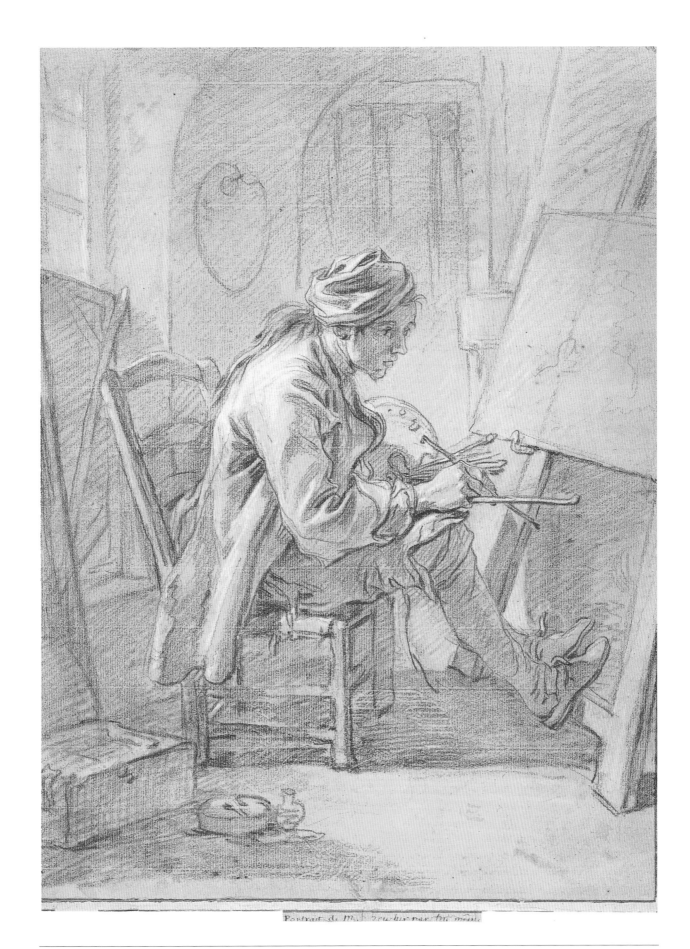

Portrait de M. Boucher par lui même

NOTES

1. Laing et al., *Boucher*, 149–50; and in a letter, departmental files.
2. Laing et al., *Boucher*, no. 22.

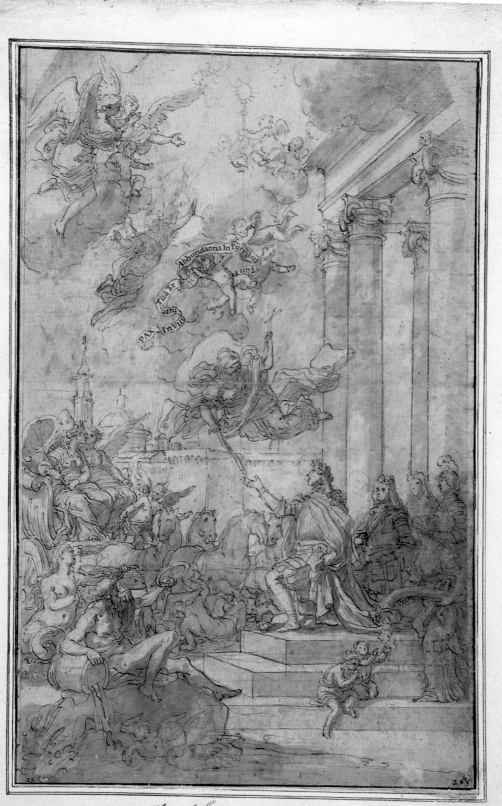

Abbundantia In Turribus

Tua Et

sint

PAX Invid

22 265

J.co Solimena

31

FRANCESCO SOLIMENA
Canale di Serino (Italy) 1657–1747 Barra
Allegory of the Entry of Charles Bourbon into Naples, about 1735
Brown ink and gray wash over black chalk
17 ½ x 11 ⅜ in. (44.5 x 28.9 cm)

INSCRIPTIONS
LOWER LEFT: 22; LOWER RIGHT: 265; ON OLD MOUNT: F.co Solimena

———

PROVENANCE
Hermann Voss, Berlin; purchased by the museum in 1954

———

EXHIBITION
Feinblatt, 1976, 102, no. 126

———

Los Angeles County Fund, 54.12.9

⌗

Solimena studied initially with his father, Angelo. In 1674 he went to Naples, where he absorbed the lessons of the decorative cycles painted there by Giovanni Lanfranco, Mattia Preti, and Luca Giordano and became one of the principal frescoists of the Late Baroque. He successfully combined the chiaroscuro and naturalism of Lanfranco and Preti with the robust theatricality of Giordano and Pietro da Cortona. He made a dramatic debut at the age of seventeen with his fresco in the chapel of Santa Anna in the Neapolitan church of the Gesù Nuovo. By the early eighteenth century Solimena was one of the most famous artists in Europe.

Stylistically similar to this drawing and in agreement with the proposed date of about 1735 is a sketch in the Uffizi for the painting *Deborah and Barach* in the Harrach collection, Vienna.[1] The subject of the museum's drawing has traditionally been identified simply as an allegory of victory. The title given here was suggested by Walter Vitzthum (note, departmental files). It may be an allegorical representation of the entry of Charles Bourbon into Naples with the Spanish army; he took control of the city from the Austrian Habsburgs and in 1735 was crowned king of the Two Sicilies.

NOTE

1. For the drawing and painting, see Ferdinando Bologna, *Francesco Solimena* (Naples: L'Arte Tipografica, 1958), 253, figs. 174–75. The painting is datable to after 1728.

32

CHARLES-ANDRÉ VAN LOO, CALLED CARLE VAN LOO

Nice 1705–1765 Paris

Portrait of an Unidentified Man [Self-Portrait?], about 1740–50

Red chalk

18 ¼ x 13 in. (46.4 x 33 cm)

PROVENANCE

Bordeaux-Groult collection, Paris; Elizabeth Royer, Paris;
purchased by the museum in 1996

———

Purchased with funds provided by the Austin and Irene Young Trust by
exchange and anonymously in memory of John Paul Passi, AC1996.55.1

———

Van Loo was the most illustrious member of a dynasty of painters—rivaled only by the Coypel family—in eighteenth-century France, whose members included his brother Jean-Baptiste and nephews Louis-Michel and Charles-Amedée. At the age of ten he traveled with his brother to Rome, where he studied with Benedetto Luti, the city's most notable artist of the time. Back in Paris he won the Prix de Rome in 1724; he returned to Italy in 1727 and stayed until 1734. In France he received numerous honors and was named *premier peintre* to King Louis XV in 1762, succeeding Charles-Antoine Coypel.

The extraordinary plasticity and sense of personality in this drawing, datable to about 1740–50, make it unique in Van Loo's oeuvre. The presence of a turban casually knotted around the sitter's head very likely identifies the subject as an artist or writer; while the identity of the man portrayed here remains uncertain, there are similarities to a self-portrait by Van Loo.[1] Although that work depicts an older person, the subject of both drawings has a straight nose with a blunt, broad tip, heavy eyebrows, a high forehead, a dimpled chin, heavy jowls, and a short, thick neck. The pensiveness and striking individuality in this drawing have few parallels among Van Loo's many portrait studies, although the artist's portrait of his wife is remarkably vivacious and brilliant.[2] The latter work is drawn with black and white chalks, as are most of Van Loo's portrait drawings, with a few notable exceptions, such as the portrait in red chalk of the painter Michel-François Dandré-Bardon.

—Victor Carlson

———

NOTES

1. Marie-Cathedral Sahut, *Carle Van Loo, premier peintre du roi*, exh. cat. (Nice: Musée Chéret, 1977), no. 395.
2. Ibid., no. 397.

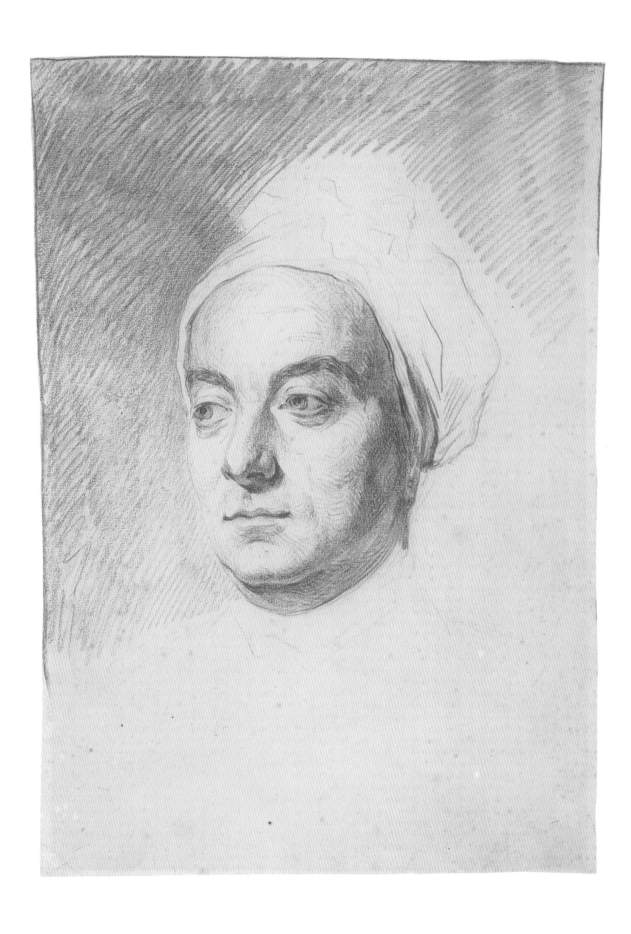

33

ANTONIO GUARDI

Vienna 1699–1761 Venice

Study of a Bishop Saint [Saint Nicholas of Bari?], about 1742

Brown ink and pinkish brown wash

10 ⅝ x 7 ½ in. (27 x 19.1 cm)

INSCRIPTION

VERSO, UPPER RIGHT: Missura estima de' beni di Pratepraito fatto l'anno 1616-Carte 11c

PROVENANCE

Unidentified collector's mark, lower right; Jo Ann and Julian Ganz Jr.

Gift of Jo Ann and Julian Ganz Jr., M.68.66.1

Guardi belonged to the imperial nobility and had ties through his father to Viennese artists; he was related by marriage to the painter Johann Michael Rottmayer. His sister Cecilia married Giovanni Battista Tiepolo. By 1730 he was in Venice, where in the last decade of his life he painted his extravagantly rococo masterpiece, the organ parapet in the church of the Angelo Raffaele. For years Guardi's figurative works have been confused with those of his better-known brother, Francesco.

Acquired by the museum as an anonymous Italian drawing, this vivacious sketch on what appears to be a page from an old account book (presumably from 1616 according to the inscription) may be ascribed to Guardi, an attribution confirmed by James Byam Shaw (letter, departmental files). Its draftsmanship, with its callig-raphic line and highly atmospheric washes, is particularly close stylistically to Guardi's *Madonna and Child with Saints* in a private collection in Milan.[1] The figure may be identified as Saint Nicholas of Bari because of its costume and its similarity in pose to the same subject in a sheet formerly in the collection of Duke Roberto Ferretti.[2] The drawings in the Milanese and ex-Ferretti collections have been associated with Guardi's altarpiece *Madonna and Child with Four Saints* of about 1742 in Vigo d'Anaunia.[3] Like those studies, as well as the painting, the Los Angeles drawing has the form of an altarpiece with its rounded upper section. It lacks, however, the figures of the Madonna and child and the other saints and proba-bly precedes the ex-Ferretti sketch.

NOTES

1. Antonio Morassi, *Guardi: Tutti i disegni di Antonio, Francesco e' Giacomo Guardi* (Venice: Alfieri, 1975), 81, no. 13, fig. 12.

2. David McTavish, *Italian Drawings from the Collection of Duke Roberto Ferretti*, exh. cat. (Toronto: Art Gallery of Ontario, 1985), 130, no. 60. Sold at Christie's, London, 7 July 1992, lot 208.

3. Antonio Morassi, *I Guardi: L'opera completa di Antonio e' Francesco Guardi* (Venice: Alfieri, 1973), 1: 38, no. 58; 3: figs. 60–61.

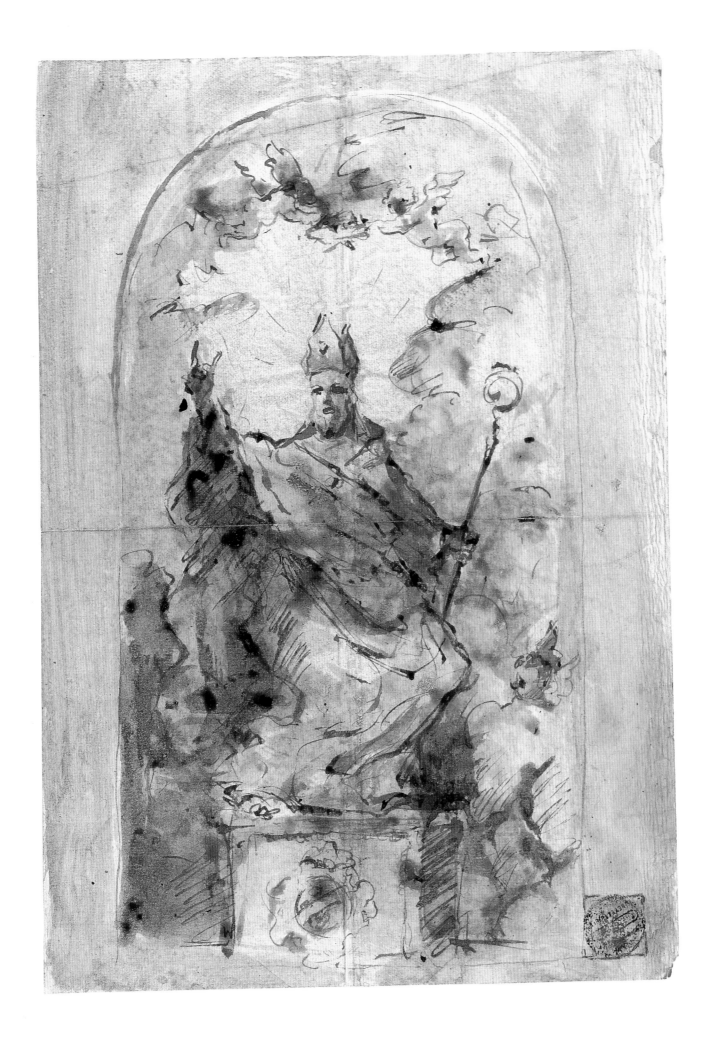

34

GIOVANNI BATTISTA TIEPOLO
Venice 1696–1770 Madrid
A Falling Figure, about 1752
Red and white chalk on faded blue paper
10 ½ x 12 ¼ in. (26.7 x 31.1 cm)

INSCRIPTIONS
VERSO, LOWER RIGHT: No. 76; No. 2042[?]

PROVENANCE
Bossi; Beyerlen; Wendland (1927); private collection, Rome; private collection,
Los Angeles; purchased by the museum in 1984

BIBLIOGRAPHY
George Knox, *Giambattista and Domenico Tiepolo: A Study and Catalogue Raisonné of the Chalk Drawings*
(Oxford: Clarendon Press, 1980), 1: 288, no. M.668

EXHIBITIONS
Feinblatt, 1976, 37, no. 61; Davis, 35, no. 75

Gift of the Graphic Arts Council in honor of Ebria Feinblatt, M.84.21

Tiepolo studied painting in the workshop of Gregorio Lazzarini, but his true mentors were Giovanni Battista Piazzetta, Sebastiano Ricci, and Paolo Veronese. He was the greatest decorative painter of the eighteenth century, with an astonishing succession of outstanding projects, beginning with the archbishop's palace at Udine and including the Palazzo Labia in Venice, the Villa Valmarana in Vicenza, and most notably the Residenz in Würzburg. He ended his career in Madrid, where he spent his last decade in the service of King Charles III.

Tiepolo made drawings in one of two media: ink and wash on white paper, and red or black chalk nearly always on blue paper. He used pen and ink not only for studies in preparation for his painting projects but also for independent series (like *Holy Family*, catalogue no. 35), landscapes, and caricatures. His style in these sketches is clearly distinct from that of his sons, Giovanni Domenico and Lorenzo. The attribution of chalk draw-

ings is more problematic. George Knox has estimated the Tiepolos made about 1,500 chalk drawings that mostly originated from four primary sources: the Beurdeley Album in the Hermitage, Saint Petersburg; the Quaderno Gatteri in the Museo Correr, Venice; four sketchbooks in the Martin von Wagner Museum, University of Würzburg; and a group of now-dismantled sketchbooks formerly belonging to the Bossi-Beyerlen family.[1] The museum's drawing came from the last source.

This sheet is a study for one of the falling figures in Tiepolo's altarpiece of 1752, *The Fall of the Rebel Angels* in the chapel of the Residenz at Würzburg, where he and his studio created one of the most splendid decorative ensembles in European art.[2] Although the blue paper has faded somewhat, the vigor of Tiepolo's rendition of the muscular torso remains as an example of his draftsmanship at its highest level.

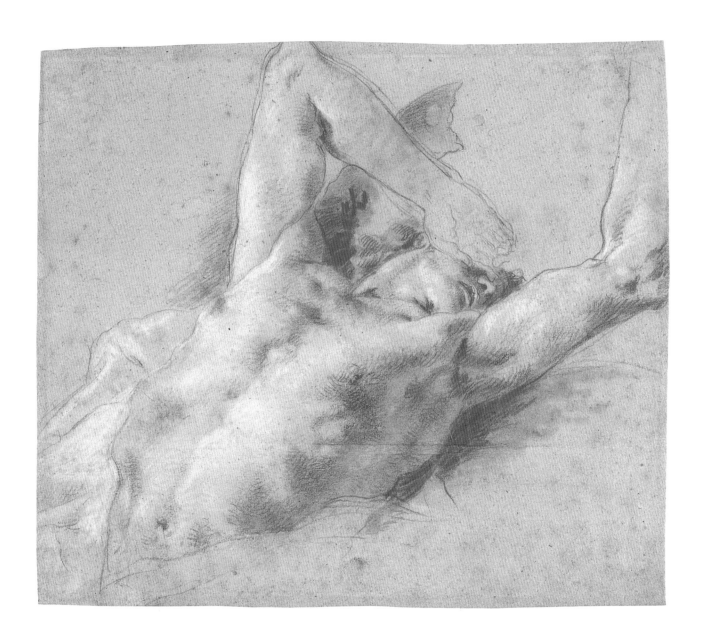

NOTES

1. Knox, *Giambattista and Domenico Tiepolo*, v.

2. For the painting, see Antonio Morassi, *A Complete Catalogue of the Paintings of G. B. Tiepolo* (Greenwich, Conn.: New York Graphic Society, 1962), 68–69, fig. 224.

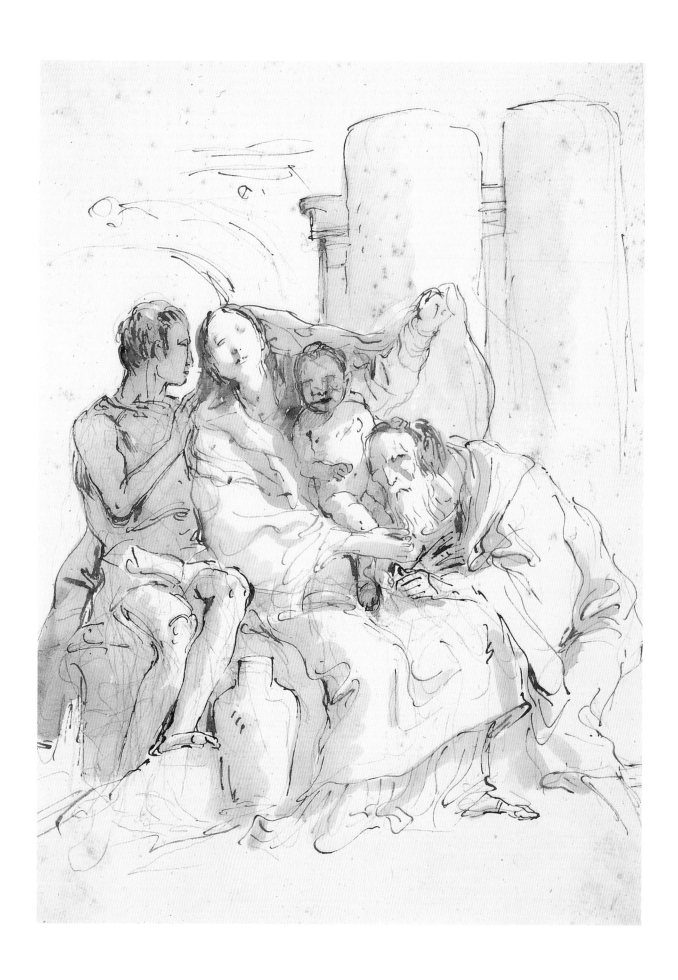

35

GIOVANNI BATTISTA TIEPOLO
Venice 1696–1770 Madrid
The Holy Family with Saint John (recto);
Sketches for "Sole figure vestite" (verso), about 1758
Brown ink and wash over black chalk (recto); black chalk and brown ink (verso)
11 ¾ x 8 ½ in. (29.9 x 21.6 cm)

PROVENANCE
Library of the Sommasco Convent (Santa Maria della Salute), Venice; Cicognara; Antonio Canova;
Francesco Pesaro; Edward Cheney (purchased 1842); his sale, Sotheby's, London, 29 April 1885,
part of lot 1024; Parsons; P. and D. Colnaghi; Richard Owen, Paris; Barbara Hutton
(purchased about 1943); Cary Grant

———

BIBLIOGRAPHY
Feinblatt, 1970, n.p.

———

EXHIBITION
A Decade of Collecting, 1965–1975, exh. cat.
(Los Angeles: Los Angeles County Museum of Art, 1975), no. 80

———

Gift of Cary Grant, M.69.14.2

———

One of two drawings by Tiepolo of this subject in the museum's collection, this composition comes from a series of about seventy variations by Tiepolo on the theme of the Holy Family.[1] As noted by George Knox, the sketches in the series "are the most magnificently sustained examples of Giambattista's graphic inventiveness." Tiepolo created several series of drawings, particularly in the 1750s, whose only purpose seems to have been as exercises of his powers of invention. The largest groups include those known as *sole figure vestite* (single draped figures) and *sole figure per soffiti* (single figures for ceilings) as well as albums of caricatures. Although probably made independently of any definable purpose as studies for particular projects, these sketches appear much more spontaneous than his son Giovanni Domenico's more finished "album drawings," such as the *Punchinello* series, the *Large Biblical* series, or the *Centaur, Faun, and Satyr* series (catalogue no. 36).

NOTE
1. For a discussion of the dating and provenance of the group, see George Knox, *Tiepolo: A Bicentenary Exhibition,* exh. cat. (Cambridge: Fogg Art Museum, Harvard University, 1970), under no. 89. Knox dates the museum's two drawings to about 1758 (letter, departmental files).

36

GIOVANNI DOMENICO TIEPOLO
Venice 1727–1804 Venice
Centaur Arrested in Flight, a Female Faun on His Back, about 1759–91
Brown ink and wash over black chalk
7 5/8 x 10 7/8 in. (19.4 x 27.6 cm)

INSCRIPTIONS
UPPER LEFT: 40 [or 41]; LOWER LEFT: Dom Tiepolo f

PROVENANCE
C. R. Rudolf; Paul Drey Gallery, New York; purchased by the museum in 1965

BIBLIOGRAPHY
James Byam Shaw, *The Drawings of Domenico Tiepolo* (Boston: Boston Book and Art Shop, 1962),
42 n. 2; Feinblatt, 1970, n.p.; Jean Cailleux, "Centaurs, Fauns, Female Fauns, and Satyrs among the
Drawings of Domenico Tiepolo," *Burlington Magazine* 116, advertising supplement by Galerie Cailleux
(June 1974): xix, no. 53, fig. 48; Annalia Delneri, "Un'Arcadia domestica: Fauni, satiri, centauri e
ninfe" in Dario Succi et al., *I Tiepolo: Virtuosismo e' ironia*, exh. cat. (Mirano: Barchessa Villa xxv aprile,
1988), 88, fig. 67; Adelheid M. Gealt and George Knox, *Giandomenico Tiepolo, Maestria e' Giocco: Disegni
dal mondo*, exh. cat. (Udine: Castello di Udine, 1996), 198, under no. 137

EXHIBITIONS
A Decade of Collecting, 1965–1975, exh. cat. (Los Angeles: Los Angeles County Museum of Art,
1975), no. 81; Feinblatt, 1976, 39, no. 73

Los Angeles County Fund, 65.17

Domenico was the principal assistant of his father, Giovanni Battista Tiepolo, though he was an exceptionally talented and prolific painter, draftsman, and printmaker in his own right, beginning with *The Stations of the Cross* of 1747 in the church of San Polo, Venice. He often reveals a distinctive eye for naturalism, especially in his series of scenes from contemporary Venetian life and from the life of Punchinello. His last years were spent decorating the family villa at Zianigo.

This drawing belongs to a series of over one hundred compositions representing centaurs, fauns, and/or satyrs. Cailleux has linked the museum's sheet to thirty-one others depicting scenes of the abduction of a female faun by a satyr.[1] The drawing is an especially important member of this group because it is clearly related to one of Domenico's frescoes in the Camerino dei Centauri in the family villa of Zianigo, now in the Ca' Rezzonico, Venice.[2] Only a few of the *Centaur and Satyr* series drawings can be associated with the Zianigo frescoes; one related to the same painting as the museum's study is in the Metropolitan Museum, another in the National Gallery of Victoria.[3] The date of the drawings is uncertain because the cycle of frescoes in the Camera dei Satiri is dated 1759, whereas that in the Camerino dei Centauri is dated 1791. Byam Shaw assumes, probably rightly, that the series was executed some time between those dates.[4]

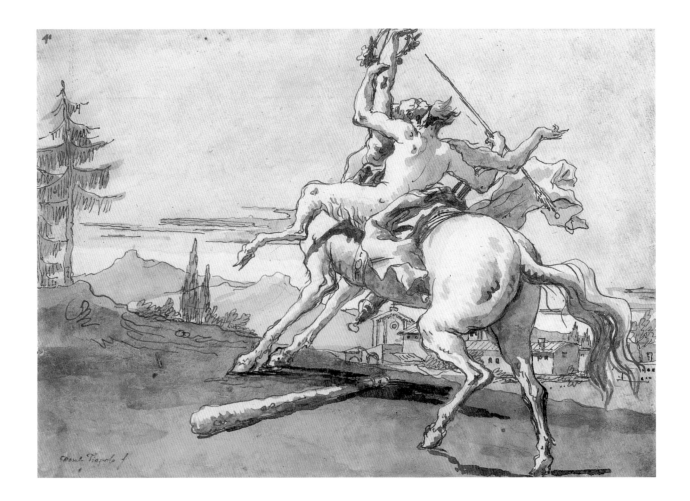

What also seems apparent is that the museum's drawing cannot be considered a preparatory study in the usual sense. Instead, this group of one hundred drawings was conceived as an independent series, and Domenico simply employed some of them for the Zianigo paintings of related themes. George Knox pointed out that the church seen in the center of the landscape in the background is Madonna delle Grazie in Udine and that the building also appears in Domenico's drawing *Peasant Family Walking to Church* in the National Academy of Design, New York.[5]

NOTES

1. Cailleux, "Centaurs," iii. These thirty-two drawings constitute the largest iconographic group in the series.

2. For the painting, see Adriano Mariuz, *Giandomenico Tiepolo* (Venice: Alfieri, 1971), 141, fig. 354.

3. Cailleux, "Centaurs," xviii, no. 51, fig. 44; and xix, no. 52, fig. 47.

4. Byam Shaw, *Domenico Tiepolo*, 42.

5. Gealt and Knox, *Giandomenico Tiepolo*, 1996.

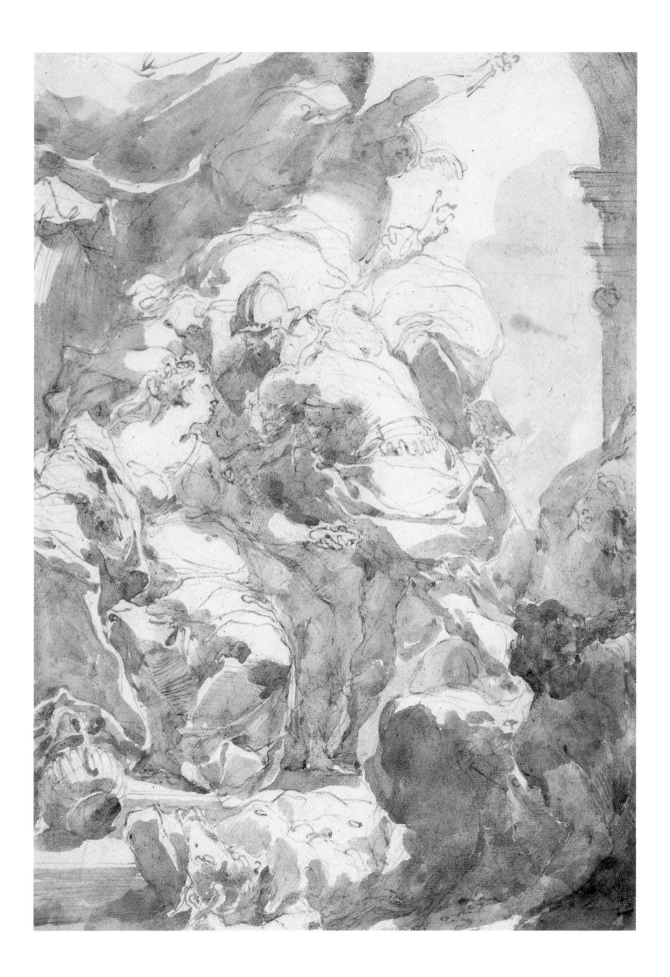

37

GAETANO GANDOLFI
San Matteo della Decima (Italy) 1734–1802 Bologna
Circe, Ulysses, and Mercury, about 1766
Brown ink and dark gray wash over traces of black chalk
10 ½ x 8 ⅛ in. (26.7 x 20.6 cm)

INSCRIPTION
ON OLD MOUNT: Pittoni or Amigoni/...Aeneas u. Dido

———

PROVENANCE
Hermann Voss, Berlin; purchased by the museum in 1954

———

Los Angeles County Fund, 54.12.13

———

Although this sheet bears an inscription attributing it to one of two Venetian painters, Giambattista Pittoni or Jacopo Amigoni, it may be assigned more accurately to a Bolognese artist, particularly Gaetano Gandolfi, the last significant master of that school. He attended the Accademia Clementina in Bologna, where, alongside his brother Ubaldo, he studied with Felice Torelli and Ercole Graziani. After a year in Venice in 1760 he returned to Bologna for good, except for a year in London in 1788. Gandolfi was remarkably prolific. His autobiography suggests that he received three or four major commissions each year during a career that spanned forty years. In the Bolognese tradition dating back to Parmigianino and Guercino, Gandolfi was also prolific as a draftsman.

This drawing's florid and curvilinear draftsmanship combined with flowing patches of gray wash are typical of the extraordinary fluidity of Gandolfi's drawings. Previously unrecognized is the fact that it is a study for a painting of the subject by Gandolfi, dated to 1766, in the Museo Civico, Piacenza.[1] The Los Angeles sheet can be compared stylistically to *Odysseus Receiving a Bag of Winds from Aeolus* of about 1766 in the Victoria and Albert Museum.[2] The Venetian-influenced character of Gandolfi's draftsmanship during this period renders understandable the old attribution of the Los Angeles sheet to Pittoni or Amigoni.

NOTES
1. Prisco Bagni, *I Gandolfi: Affreschi, dipinti, bozzetti, disegni* (Bologna: Nuova Alfa Editoriale, 1992), 238, no. 219.
2. Mimi Cazort Taylor, "The Pen and Wash Drawings of the Brothers Gandolfi," *Master Drawings* 14, 2 (1976): 159, pl. 29.

38

FRANCESCO GUARDI
Venice 1712–1793 Venice
Architectural Capriccio, about 1770–80
Brown ink and wash on dark gray paper
15 x 12¼ in. (38.1 x 31.1 cm)

PROVENANCE
E. V. Thaw, New York; Hans Schaeffer, New York; Paul Kantor Gallery, Beverly Hills;
purchased by the museum in 1957

———

BIBLIOGRAPHY
Ebria Feinblatt, "A Romantic Capriccio by Guardi," *Los Angeles County Museum
Bulletin of the Art Division* 9, no. 3 (1957): 3–5; Winslow Ames,
Drawings of the Masters: Italian Drawings from the Fifteenth to the Nineteenth Century (New York:
Shorewood Publishers, 1963), 126; *Los Angeles County Museum of Art Handbook*
(Los Angeles: Los Angeles County Museum of Art, 1965), 124; Feinblatt, 1970, n.p.; Antonio Morassi,
Guardi: Tutti i disegni di Antonio, Francesco e Giacomo Guardi
(Venice: Alfieri, 1975), 504, fig. 496; *Los Angeles County Museum of Art Handbook*
(Los Angeles: Los Angeles County Museum of Art, 1977), 97–98

———

EXHIBITIONS
Jurgen Schulz, *Master Drawings from California Collections*, exh. cat. (Berkeley: University Art Museum,
University of California, 1968), no. 38; Feinblatt, 1976, 38, no. 67; Davis, 34–35, no. 36

Los Angeles County Fund, 57.46

———

Guardi began as a figure painter with his brother Antonio, but by the late 1740s his principal subjects were landscapes. Like his older contemporary Canaletto, he painted Venetian views for the tourist trade as well as for local patrons; but whereas Canaletto's paintings are precise and exacting in their renditions of the Venetian topography, Guardi's are more fantastic and painterly. They are frequently, though erroneously, compared to later Venetian views by Claude Monet and James Abbott McNeill Whistler.

Antonio Morassi pointed out that this splendid late (about 1770–80) drawing by Guardi is preparatory for a painting in the Botto collection, Milan.[1] A related view of the same fountain, with the same two figures and birds in the water, can be seen in a smaller sheet in the Museo di Castelvecchio, Verona.[2] In spite of the popularity of Guardi's Venetian views with foreign tourists, particularly English and German, the genre represented by the museum's *capriccio* would have been more highly valued by eighteenth-century connoisseurs and academicians because it was more a product of the artist's imagination and inventiveness than a mere imitation of nature. In typical Venetian rococo fashion solidity of form is sacrificed in favor of a brilliantly decorative surface pattern of light and shade—the actual subject of the drawing.

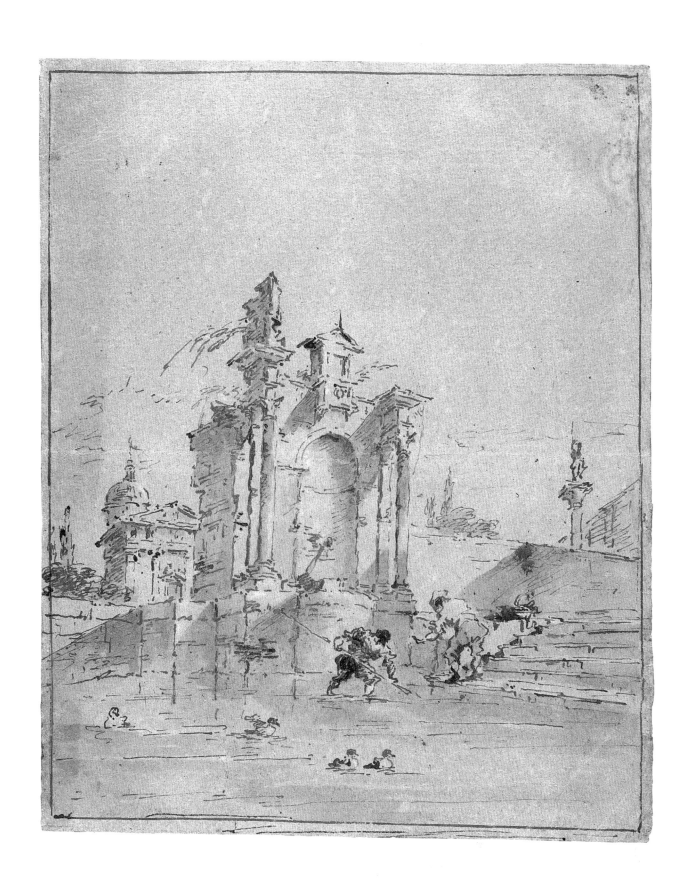

NOTES

1. For the painting, see Antonio Morassi, *Guardi: L'opera completa di Antonio e' Francesco Guardi* (Venice: Alfieri, 1973), 1: no. 739; 2: fig. 685.

2. Morassi, *Guardi: Tutti i disegni*, 167, no. 505, fig. 502.

39
HUBERT ROBERT
Paris 1733–1808 Paris
Landscape with Steps, 1770s
Red chalk
17 ½ x 12 ¹¹/₁₆ in. (44.5 x 32.2 cm)

PROVENANCE
Richard Owen, Paris; John Nicholas Brown; his estate; David Tunick, New York;
purchased by the museum in 1986

———

BIBLIOGRAPHY
Denys Sutton, *French Drawings of the Eighteenth Century* (London: Pleiades Books, 1949), pl. 4

———

EXHIBITIONS
Agnes Mongan, "French Drawings and Prints of the Eighteenth Century: A Loan Exhibition,"
exh. cat., *Bulletin of the Fogg Art Museum* 3, no. 2 (1934): no. 4; *Master Drawings*, exh. cat. (Buffalo:
Albright Art Gallery, 1935), no. 86; Agnes Mongan, *French Drawings from American Collections:
From Clouet to Matisse*, exh. cat. (New York: Metropolitan Museum of Art, 1959), no. 77;
Thomas J. McCormick, *Hubert Robert, 1733–1808: Paintings and Drawings*, exh. cat.
(Poughkeepsie: Art Gallery, Vassar College, 1962), no. 31; *France in the Eighteenth Century*, exh. cat.
(London: Royal Academy of Arts, 1968), no. 604; Victor Carlson, *Hubert Robert, Drawings and
Watercolors*, exh. cat. (Washington, D.C.: National Gallery of Art, 1978), no. 31

Gift of Anna Bing Arnold and purchased with funds provided by
Mr. and Mrs. Billy Wilder by exchange, 86.13

———

Best known for his views of ancient and modern Rome, Robert was one of the most significant landscape painters in France in the eighteenth century. Like his seventeenth-century compatriot Claude Lorrain, Robert played a major historical role in elevating landscape as a viable subject for an artist. In 1765 he returned to Paris after having spent eleven years in Rome as a student. He was deeply impressed by the grandeur of the ancient and modern monuments and continued to employ these elements in his art after his return to France. During the 1770s, when this drawing was created, Robert was also working as a landscape architect and was particularly noted for his picturesque and fanciful garden designs in what is known as the English or Chinese taste. In contrast to the more formal and symmetrical style of French landscape design, this more naturalistic approach was strongly influenced by Robert's Italian experiences at such sites as the Villa d'Este in Tivoli and the Villa Pamphili and Villa Medici in Rome. This sheet shows a flight of steps leading to a terrace set among towering trees. The trunks and branches form graceful natural arches delineated in Robert's favorite medium of red chalk, as the varied densities of foliage create the illusion of light and atmospheric nuances.

40

JEAN-JACQUES LAGRENÉE THE YOUNGER
Paris 1739–1821 Paris
The Baptism of Clorinda by Tancred, 1770s–80s
Brown ink and wash, heightened with white gouache, on blue prepared paper
17 1/4 x 12 7/8 in. (43.8 x 32.7 cm)

PROVENANCE
W. M. Brady and Co., New York (cat. 1988, no. 7); purchased by the museum in 1989

———

EXHIBITION
Campbell and Carlson, no. 25

———

Graphic Arts Council Curatorial Discretionary Fund and Donor Members, M.89.75

———

In 1760 Lagrenée won second prize in the competition for the Prix de Rome. That year he traveled to Saint Petersburg with his older brother, who had been his teacher and had been named *premier peintre* to the empress Catherine the Great. In 1765 Lagrenée paid his own expenses in Rome, studying at the Académie de France, and in 1769 he was back in Paris, where he exhibited at the Salons from 1771 to 1804.

The subject of this drawing is taken from Torquato Tasso's epic sixteenth-century poem, *Gerusalemme liberata*, a sprawling romantic tale of the First Crusade and a popular source of subjects for artists throughout the seventeenth and eighteenth centuries. In this particu-

lar scene, rarely depicted by artists, Lagrenée shows the Christian knight Tancred baptizing his beloved, the infidel Saracen Clorinda, after he has mistakenly wounded her mortally. Although the compositions are very different, Lagrenée was familiar with his brother's interpretation of the subject, painted in 1760–62, when the two artists were in Saint Petersburg. Victor Carlson, however, suggests a date of the 1770s or early 1780s for the drawing. The technique of this highly finished chiaroscuro drawing was popular in the eighteenth century, demonstrated by examples by Jean-Baptiste Oudry and Charles-Joseph Natoire. Drawings like these would have been framed and hung as independent works of art.

41

JEAN-PIERRE SAINT-OURS
Geneva 1752–1809 Geneva

Titus Quincticus Flaminius Granting Liberty to Greece at the Isthmian Games, 1780

Brown ink and wash, heightened with white ink, over black chalk on yellow-tan paper

13 15/16 x 28 5/16 in. (35.4 x 71.9 cm)

INSCRIPTION
LOWER CENTER: a Paris St. Ours ft/1780

———

PROVENANCE
Private collection, Paris; V. C. Sainty, London; Stair Sainty Matthiesen,
New York (cat. 1985, 11); Mr. and Mrs. Guy Stair Sainty

———

EXHIBITION
Campbell and Carlson, no. 104

———

Gift of Mr. and Mrs. Guy Stair Sainty, M.86.65

———

Saint-Ours was a pupil of Joseph-Marie Vien at the Académie in Paris at the same time as Jacques-Louis David. Although he won the Prix de Rome in 1780, he could not accept the royal pension accompanying it because he was a foreigner and a Protestant. Nevertheless, he went to Rome that year, financing the trip through his own resources. He exhibited at the Salon de la Liberté in 1791 but returned to his native Geneva the following year, where he became established as a portraitist.

This large and impressive sheet may be the second of two versions by Saint-Ours, the other being in the Musée d'Art et d'Histoire, Geneva. It is essentially a baroque design, with the figures arranged theatrically in a classicizing setting that resembles the proscenium of a stage. The drawing was executed in Paris just prior to the artist's departure for Italy. The subject is taken from Plutarch's *Lives* and depicts the Roman general Titus Quincticus Flaminius restoring liberty to the vanquished Greeks after the Romans had defeated them at the battle of Cynoscephalae. It is the sort of subject, with its theme emphasizing a ruler's magnanimity and virtue, that was quite popular in the period just prior to the French Revolution.

42

GUILLAUME-GUILLON LETHIÈRE
Sainte-Anne (Guadeloupe) 1760–1832 Paris
The Condemned Metellus Spared by Augustus, about 1791
Brown ink and gray wash
18 x 24 ⅝ in. (45.7 x 62.6 cm)

INSCRIPTION
LOWER RIGHT: Lethiere

PROVENANCE
Drouot-Richelieu, Paris, 14 March 1990, lot 89; Sotheby's, New York,
14 June 1992, lot 149, purchased by the museum

EXHIBITION
Campbell and Carlson, no. 52

General Acquisition Fund, AC1992.30.1

⸻

Born in the West Indies, Lethière was trained first in Rouen, then in Paris in the studio of Gabriel-François Doyen. Although he did not win the Prix de Rome, he was a *pensionnaire* at the French Academy in Rome from 1786 to 1791. In 1807 he was named director of the academy, which he headed until 1816, and upon his return to Paris was named a professor at the École des Beaux-Arts.

The subject of this drawing, from Roman history, is encountered rarely in art, an exception being a painting by Nicolas-Guy Brenet, exhibited at the Salon in 1779. As noted by Victor Carlson, the figures of Augustus in each work are identical and both may have been inspired by the Roman sculpture of Menander then in the Museo Pio-Clementino in the Vatican. Carlson also notes the relieflike character of the composition, and the resemblance of the draftsmanship executed in pen and brush to sheets by Jacques-Louis David. He proposes a date of about 1791, shortly after Lethière returned to Paris from Rome.

43

JEAN-JOSEPH TAILLASSON
Bordeaux (France) 1745–1809 Paris

Hero Discovering the Body of Leander on the Seashore, about 1798
Black and white chalk on gray paper
14 ¼ x 19 ⅞ in. (36.2 x 50.5 cm)

PROVENANCE
Henri Baderou, Paris; Frederick J. Cummings, Detroit; P. and D. Colnaghi,
New York; purchased by the museum in 1985

BIBLIOGRAPHY
Jean Lacambre, *French Painting 1774–1830: The Age of Revolution*, exh. cat.
(Detroit: Detroit Institute of Arts, 1974), 626, under no. 172; Jean-Pierre Mouilleseaux,
"Léandre et Héro de Taillasson, à propos d'un thème iconographique et littéraire," *Revue du Louvre* 24,
no. 6 (1974): 412; *Le port des lumières: La peinture à Bordeaux*, exh. cat.
(Bordeaux: Musée des Beaux-Arts, 1989), 319

EXHIBITIONS
Alumni Who Collect: I. Drawings from the Sixteenth Century to the Present, exh. cat. (Chicago: David and
Alfred Smart Gallery, University of Chicago, 1982), no. 28; Campbell and Carlson, no. 33

Purchased with funds provided by Museum Associates Acquisition Fund
and the Garrett Corporation, M.85.191

Taillasson studied with Joseph-Marie Vien at the Académie in Paris, where three times he attempted to win the Prix de Rome but achieved only third place. He traveled to Italy anyway, paying his own expenses, and stayed there from 1773 to 1777. He became an academician in 1784 and exhibited regularly at the Salon.

This drawing is a study for Taillasson's painting of Hero and Leander, exhibited in 1798 at the Salon, where it won a prize awarded by the French Republic, and now in the Musée d'Art et d'Histoire in Blaye.[1] The effect of a moonlit night is achieved by his use of black and white chalks on gray paper. He attains a sense of purity and clarity that would appear to belie the high-pitched emotionalism of the narrative. Hero and Leander were illicit lovers, as Leander nightly swam the Hellespont to reach Hero, who guided him by a lamp shining from her tower. One night a storm blew out the lamp; Leander lost his way and drowned. Upon Hero's discovery of her lover's body the next morning, she committed suicide.

Taillasson's composition is remarkably similar to a seventeenth-century Dutch painting, *Pyramus and Thisbe* by Abraham Hondius in the Museum Boymans-van Beuningen, Rotterdam.[2] Both subjects feature a woman hysterically lamenting her dead lover, her arms outspread as she is about to throw herself on the body. It is impossible to suggest how Taillasson could have seen Hondius's painting, as its provenance in the eighteenth century is unknown. They may have shared a common prototype for the grouping.

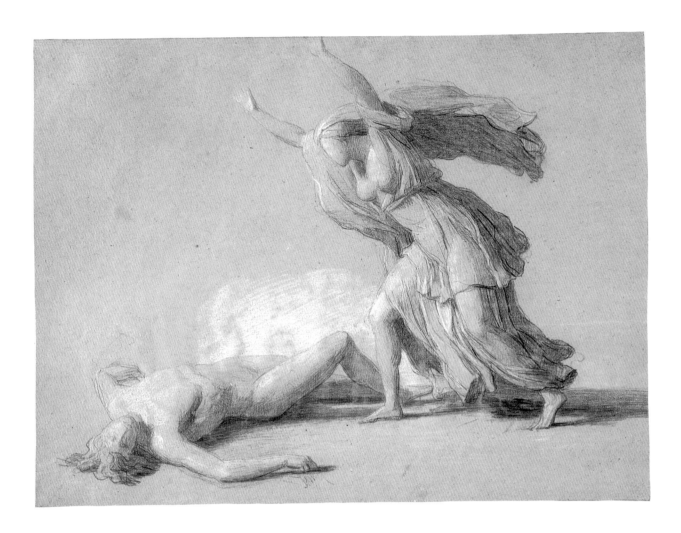

NOTES

1. Lacambre, *French Painting 1774–1830*, no. 172.

2. Vitale Bloch, "Pyramus und Thisbe von Abraham Hondius," *Bulletin Museum Boymans-Van Beuningen* 18, no. 1 (1967): 94–97, fig. 2.

44
JEAN-VICTOR BERTIN
Paris 1767–1842 Paris
Study of a Tree, about 1800–1805
Gouache
19 7/8 x 15 5/8 in. (50.5 x 39.7 cm)

PROVENANCE

Private collection, Paris; Galeries Brame-Lorenceau, Paris, Kate de Rothschild, London, and Didier
Aaron, New York (1996 cat., no. 45); purchased by the museum in 1997

———

Wallis Foundation Fund in memory of Hal B. Wallis and Graphic Arts Council Fund, AC1997.12.1

———

Bertin was accepted to the Académie in 1785 as a student of Gabriel-François Doyen. In 1788 he became the pupil of Pierre-Henri de Valenciennes, the leading French neoclassical landscape painter, who in 1800 published his influential treatise *Réfléxions et conseils à un élève sur la peinture et particulièrement sur le genre du paysage.* In the essay Valenciennes sought to elevate the stature of what he termed the *paysage historique* (historical landscape) to the same level as history painting; his success is attested by the establishment in 1817 of a Prix de Rome for historical landscape. But Valenciennes's even more significant contribution was his argument for the importance of the artist's direct study of nature,[1] not simply sketching but actually painting in the open air. Bertin absorbed these lessons and passed them on to his pupil Jean-Baptiste-Camille Corot and through him to the impressionists.

Study of a Tree demonstrates—with remarkable clarity and freshness in its color and the evocation of the warm, clear light of a summer's day—these precepts for sketching directly from nature. It can be argued, however, that it was not produced in the open air but in Bertin's studio. Its size (nearly 20 x 16 inches) is considerably larger than most oil-on-paper studies made outdoors by artists at this time. It is also more meticulously detailed than contemporary examples made directly from nature, particularly in the rendition of the foliage. Because the treatment of the foliage contrasts with the more broadly applied strokes of gouache for the ground and wash, possibly it was started as a sketch from nature but brought to a higher degree of finish in the studio.[2]

Study of a Tree is related to a slightly smaller work, an oil on canvas in the Phoenix Art Museum, *Landscape with a Cart in the Distance.*[3] Gutwirth dates the Phoenix work to Bertin's late period, about 1830–42, whereas the author of the catalogue cited in the provenance dates it to the first years of the nineteenth century, about 1800–1805. Because of its anomaly of scale, the museum's drawing was likely made by Bertin as a work of art in its own right, subsequent to the execution of the Phoenix painting rather than as a study for it. There was growing interest in the nineteenth century in collecting finished drawings to be framed and exhibited, and Bertin's sheet may have been made for that market.

NOTES

1. For recent assessments of Valenciennes, see Peter Galassi, "The Nineteenth Century: Valenciennes to Corot," in Alan Wintermute, ed., *Claude to Corot: The Development of Landscape Painting in France,* exh. cat. (New York: Colnaghi, 1990); and Jeremy Strick, "Nature Studied and Nature Remembered: The Oil Sketch in the Theory of Pierre-Henri de Valenciennes," in Philip Conisbee et al., *In the Light of Italy: Corot and Early Open-Air Painting,* exh. cat. (Washington, D.C.: National Gallery of Art, 1996), 79–87.
2. For other examples of this practice, see Vincent Pomarède, "Realism and Recollection," in Conisbee et al., *In the Light of Italy,* 95–98.
3. Suzanne Gutwirth, "Jean-Victor Bertin, un paysagiste néo-classique (1767–1842)," *Gazette des Beaux-Arts* 6 pér., 83 (1974): 357, no. 135.

45
NICOLAS-ANTOINE TAUNAY
Paris 1755–1830 Paris
Landscape with an Aqueduct, about 1810
Black ink and gray wash
9 ¾ x 13 ¹⁄₁₆ in. (24.8 x 33.2 cm)

PROVENANCE

Bourgarel; his sale, Paris, 13–15 November 1922, lot 145; Galerie Cailleux, Paris;
purchased by the museum in 1990

———

BIBLIOGRAPHY

Suzanne Gutwirth, "A Pre-Romantic Painting by Nicolas-Antoine Taunay," *Los Angeles County
Museum of Art Bulletin* 25 (1979): 34, fig. 2 (as location unknown)

———

EXHIBITION

Artistes en voyage au XVIIIe siècle, exh. cat. (Paris: Galerie Cailleux, 1986), no. 61

———

Graphic Arts Council Fund, M.90.170

Upon the sudden death of another student in 1784, Taunay was recommended by Joseph-Marie Vien and Jean-Baptist Marie Pierre for a pension at the French Academy in Rome. Under the influence of neoclassic artists, Taunay achieved a sense of balance and equilibrium in his compositions, executed with a light and smooth touch. Upon his return to Paris, he exhibited at the Salon regularly from 1787 until his death. Taunay flourished as an artist during the period of the Empire. He was a founding member of the Institut de France in 1795.

This highly finished drawing repeats the composition of a painting exhibited in the Salon of 1810 and now in the Los Angeles County Museum of Art. Because of the correlation of details to the painting, the drawing may have been made as a record of the exhibited canvas rather than as a study for it. The evocation of the poetic and pastoral Italianate landscape places the work clearly in the tradition of seventeenth-century Roman landscapes by Claude Lorrain and Gaspard Dughet as well as works by eighteenth-century Italian painter Jan Frans van Bloemen (called Orrizzonte). The stormy sky, however, suggests the turbulent and emotional works of the French romantic artists.

46
PIERRE-PAUL PRUD'HON
Cluny (France) 1758–1823 Paris
Study of a Man, about 1810–20
Black and white chalk on blue paper
22 ¾ x 13 ¼ in. (57.8 x 33.7 cm)

PROVENANCE

François Martial Marcille; Eudoxe Marcille; Mme Jahan; Mme Chevrier; Meissonnier;
Wildenstein and Co., New York; purchased by the museum in 1989

———

BIBLIOGRAPHY

Jean Guiffrey, *L'oeuvre de P.-P. Prud'hon* (Paris: Librairie Armand Colin, 1924), 447, no. 1190;
Roberta J. M. Olson, "Selected Drawings at Wildenstein," *Arts* 48, no. 6 (1974): 74;
Helen Weston, "London: Prud'hon at Wildenstein's and the Heim Gallery," *Burlington Magazine* 123,
no. 941 (1981): 501; John Elderfield, *The Language of the Body: Drawings by Pierre-Paul Prud'hon*
(New York: Harry N. Abrams, Inc., 1996), 152–53, pl. 30

———

EXHIBITIONS

Exposition des oeuvres de Prud'hon au profit de sa fille, exh. cat. (Paris: École des Beaux-Arts, 1874),
no. 432; *Prud'hon*, exh. cat. (Paris: Musée Jacquemart-André, 1958), no. 212;
Collecting the Masters, exh. cat. (Milwaukee: Milwaukee Art Museum, 1977), 170–71;
Exposition Rococo: Poésie et rêve de la peinture française au XVIIIe siècle, exh. cat.
(Nishinomiya: Otani Museum of Fine Arts, 1978), no. 46; Georges Bernier, *Consulat, Empire,
Restauration: Art in Early Nineteenth-Century France*, exh. cat. (London: Wildenstein Galleries, 1981;
New York: Wildenstein Galleries, 1982), 26; Campbell and Carlson, no. 49

———

Graphic Arts Council Fund and Museum Acquisition Fund, M.89.48

———

Prud'hon was awarded the Prix de Rome in 1784, and while in Italy he was influenced by the masters of the Italian Renaissance as well as by his contemporaries Antonio Canova, Angelika Kauffmann, and Anton Raphael Mengs. After returning to Paris, he began to exhibit in the Salon in 1791. With his painting *The Triumph of Bonaparte* in 1801 he received many commissions from the Napoleonic court. After the fall of Napoleon, however, patronage for Prud'hon declined.

Prud'hon was intensely interested in mastering an understanding of the human form and made finished studies from live models throughout his career; it was not an activity limited to his student days but was viewed by the artist as a means of perfecting his art. He became one of the most renowned artists of his time and was one of Napoleon's favorite painters. His use of unstable pigments, however, has rendered many of his paintings unviewable. Consequently, he is best known for his figure drawings. This superb example may in fact date from the later part of his career. The sheet exemplifies Prud'hon's interest in the formal elements of classical sculpture, its principal model probably being the famous *Apollo Belvedere*, then as now in the Vatican. Prud'hon's sensitive draftsmanship and highly atmospheric chiaroscuro, created through his distinctive use of black and white chalk on blue paper, transform the icy marble surface of the ancient statue into a highly sensuous form. He further brings it to life by including the props used by a model for posing in the studio; namely the rope suspended from the ceiling and held in the figure's left hand and the box on which his right hand rests.

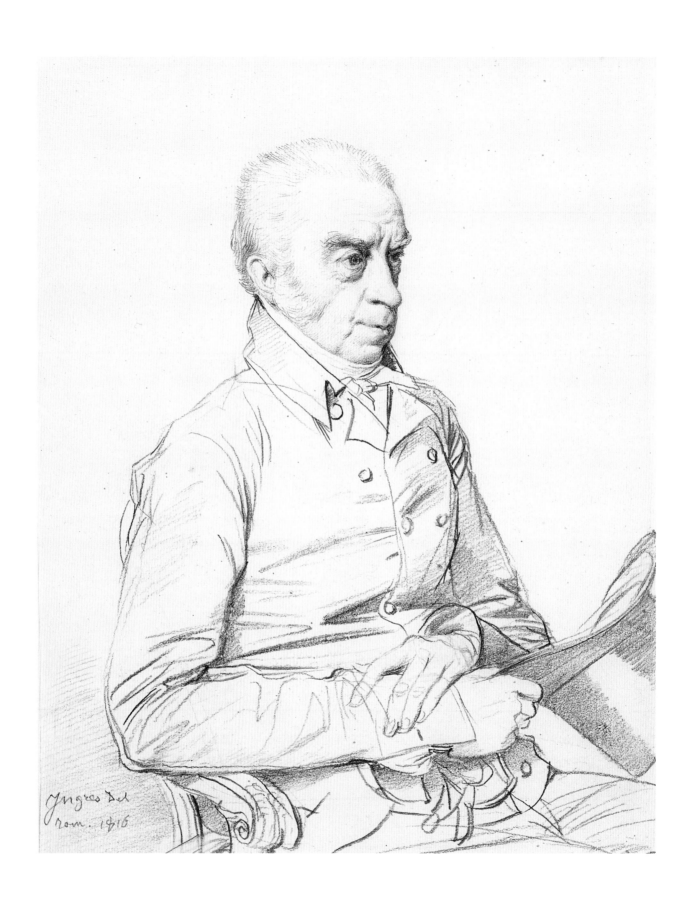

47

JEAN-AUGUSTE-DOMINIQUE INGRES
Montauban (France) 1780–1867 Paris
Portrait of Thomas Church, 1816
Graphite
7 15/16 x 6 1/4 in. (20.2 x 15.9 cm)

INSCRIPTION

LOWER LEFT: Ingres Del/Rom. 1816

———

PROVENANCE

Church family; Rev. Robert Longe, Spixworth; Robert Bacon Longe; his sale, Spixworth Park, 19 March
1912, part of lot 198; Adele Emily Anna Hamilton; David C. Wilson, Sheffield (and on loan to Tate
Gallery, London, 1939–48); his sale, Sotheby's, London, 1 December 1966, lot 74; Walter
Feilchenfeldt, Zurich; purchased by the museum in 1967

———

BIBLIOGRAPHY

Frederick Duleep Singh, *Portraits in Norfolk Houses* (Norwich: Jarrold, 1928), 2: 307, no. 14;
Brinsley Ford, "Ingres' Portrait Drawings of English People at Rome, 1806–1820," *Burlington
Magazine* 75 (July 1939): 9, pl. III; Hans Naef, "L'Ingrisme dans le monde," *Bulletin du Musée Ingres* 22
(December 1967): 31; Ebria Feinblatt, "An Ingres Drawing for Los Angeles,"
Connoisseur 170 (1969): 262–65; Marianne Feilchenfeldt, *25 Jahre Feilchenfeldt in Zurich, 1948–1973*
(Zurich: Walter Feilchenfeldt, 1972), no. 1; *Los Angeles County Museum of Art Handbook*
(Los Angeles County Museum of Art, 1977), 105–6; Hans Naef,
Die Bildniszeichnungen von J.-A.-D. Ingres (Bern: Bentelli Verlag, 1977), 2: 73–78; 4: 338–39, no. 183

———

EXHIBITIONS

A Decade of Collecting, 1965–1975, exh. cat.
(Los Angeles: Los Angeles County Museum of Art, 1975), no. 85;
Patricia Condon, Marjorie Cohn, and Agnes Mongan, *In Pursuit of Perfection: The Art of J.-A.-D. Ingres*,
exh. cat. (Louisville: J. B. Speed Art Museum, 1983), no. 65; Davis, 37, no. 41

———

Purchased with funds provided by the Loula D. Lasker Bequest and
Museum Associates Acquisition Fund, M.67.62

———

Ingres won the Prix de Rome in 1801, although he did not actually go to Rome until 1806; after four years of study there, he remained in Italy until 1820. He produced several major paintings during his stay in Italy, including the masterpieces *Portrait of Granet*, *The Bather of Valpinçon*, *Oedipus and the Sphinx*, and *La grande' odalisque*. During his years in Florence and Rome Ingres supported himself principally by making portrait drawings of foreign visitors. The sitters were usually French, until the fall of Napoleon in 1815, when many of them left Italy. From 1815 to 1817 Ingres used principally English patrons who had been unable to travel to Italy during the French occupation. Thomas Church (1758–1821) was a fifty-eight-year-old English surgeon when Ingres drew his portrait. At the same time Ingres also drew a pendant portrait of Church's younger brother, the Reverend Joseph Church (1766–1830); that drawing is in the Virginia Museum of Fine Arts.

Ingres assumed his self-appointed role as the guardian of the classical tradition of draftsmanship that originated with Raphael. His portrait drawings are among his most sublime expressions of the power of linear definition. In *Portrait of Thomas Church* he used a finely sharpened pencil to incisively capture the sitter's face and personality, while broader and more loosely applied strokes were used for rendering the rest of the figure. The three-quarters view of the sitter, also used for Joseph Church, though facing left, is very unusual among Ingres's drawings, in which the subjects are usually presented frontally.

A copy of the museum's drawing—by an unknown artist—was sold in 1990.[1] Apart from weaknesses in draftsmanship, such as the disproportionate relationship between head and body, the copy shows the back of the chair behind Church's right shoulder.

NOTE

1. Weschler's, Washington, D.C., 8 December 1990, lot 20.

48

EUGÈNE DELACROIX

Charenton-Saint-Maurice (France) 1798–1863 Paris

Strolling Players, 1833

Watercolor

9 ¾ x 7 ¼ in. (24.8 x 18.4 cm)

INSCRIPTION

LOWER LEFT: Eug. Delacroix

PROVENANCE

Count Charles de Mornay; his estate sale, Paris, 29 March 1877, lot 20; L. Gauchez; Baron Henri de
Rothschild; Kraushaar Gallery, New York; Autumn Sims, New York; private collection, France;
John and Paul Herring, New York; purchased by the museum in 1985

BIBLIOGRAPHY

Adolphe Moreau, *Eugène Delacroix et son oeuvre* (Paris: Librairie des Bibliophiles, 1873), 184, 202;
Alfred Robaut, *L'oeuvre complet de Eugène Delacroix* (Paris: Charvay Frères, 1885), 136, no. 511;
Lorna Price, *Masterpieces from the Los Angeles County Museum of Art Collection*
(Los Angeles: Los Angeles County Museum of Art, 1988), 128; Maurice Sérullaz et al.,
Delacroix in Morocco, exh. cat. (Paris: Institut du Monde Arabe; Flammarion, 1994), 178

EXHIBITION

Eugène Delacroix, exh. cat. (New York: Wildenstein Galleries, 1944), no. 71; Margaret Stuffmann,
Eugène Delacroix: Themen und Variationen, Arbeiten auf Papier, exh. cat.
(Frankfurt: Städtische Galerie im Städelschen Kunstinstitut, 1987), 158-59, no. H.25

Art Museum Council Fund, M.85.126

In 1832 King Louis-Philippe sent a delegation led by Count Charles de Mornay to Morocco in order to establish diplomatic relations with the sultan. At the last minute de Mornay invited Delacroix to accompany the mission with the charge of artistically recording events. The journey was a turning point in Delacroix's career, as he responded with vivid enthusiasm to the people, customs, and landscape of Morocco. During his six-month sojourn Delacroix filled journals and notebooks with his reactions to North Africa. When the delegation returned to France in 1833, it was quarantined in the port of Toulon because of an outbreak of cholera. During this time Delacroix decided to memorialize his trip and

express his gratitude to de Mornay with an album of eighteen watercolors. The album remained intact until 1877, when the works were sold at de Mornay's estate sale. Of the eighteen watercolors, only eleven (including this sheet) can now be traced.

The scene illustrates the importance of the oral tradition in the Arab world, where audiences gathered in and outside of villages to listen to traveling musicians, storytellers, and other entertainers. The two principal figures in the composition were later used by Delacroix in his 1848 painting *Arab Players*, now in the Musée des Beaux-Arts, Tours.[1]

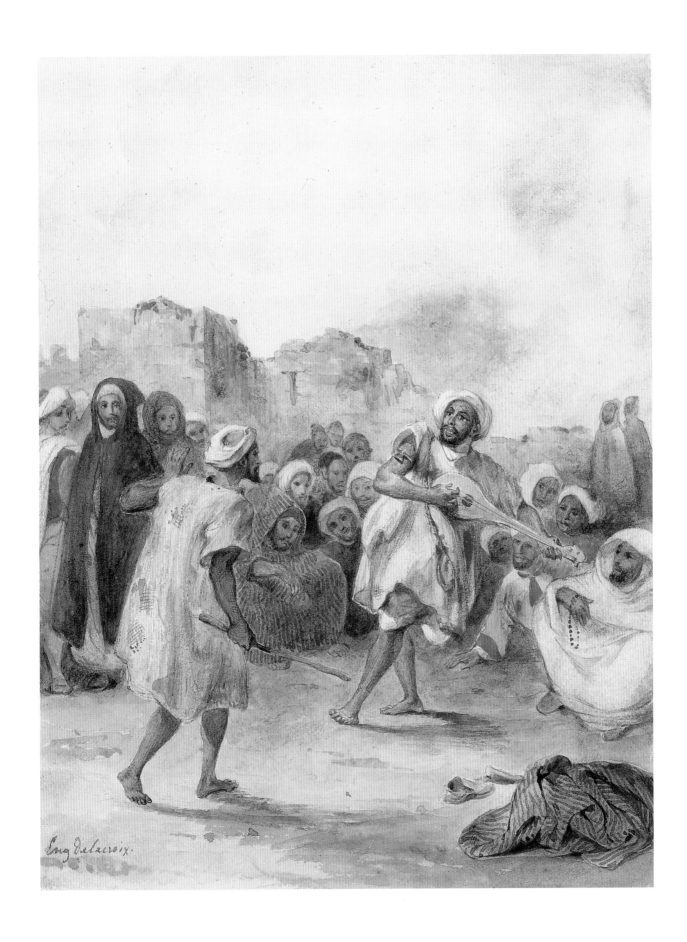

NOTE

1. Sérullaz et al., *Delacroix*, 80–81, pl. 16.

49

THÉODORE CHASSÉRIAU
Santa Barbara de Samaná (Dominican Republic) 1819–1856 Paris
Arab Woman and Girl with a Gazelle, 1851
Brown ink and brown wash
5 ½ x 7 ⅞ in. (14 x 20 cm)

INSCRIPTIONS
LOWER LEFT: Th. Chasseriau; LOWER RIGHT: 1851

———

PROVENANCE
Galerie Brame-Lorenceau, Paris; purchased by the museum in 1993

———

BIBLIOGRAPHY
Marc Sandoz, *Théodore Chassériau 1819–1856: Catalogue raisonné des peintures et estampes*
(Paris: Arts et Métiers Graphiques, 1974), 276, under no. 138, pl. 128a; Louis-Antoine Prat,
Théodore Chassériau 1819–1856: Dessins conservés en dehors du Louvre, Cahiers du Dessin
Français, no. 5 (Paris: Galerie de Bayser, 1989), 25, no. 175

———

Purchased with funds provided by George Cukor by exchange, AC1993.12.1

———

As an artist, Chassériau seems to fall midway between the aesthetic poles represented in nineteenth-century French painting by the classicism of Jean-Auguste-Dominique Ingres and the romanticism of Eugène Delacroix. On the one hand, Chassériau worked briefly as a student in Ingres's studio at the age of fifteen, where he likely absorbed Ingres's interest in the conception and articulation of forms. The drawing's character of sharply delineated forms viewed in clear light can be attributed to Ingres's influence. On the other hand, the subject of this drawing, an Arab woman and girl seated in an exotic interior against a patterned screen, reflects the nineteenth-century romantic fascination with "orientalism" and the allure of exotic cultures. In this regard Chassériau follows

Delacroix's interest in the extraordinary colors and sensations to be witnessed in North Africa. Chassériau visited Morocco in 1846, a little more than a decade after Delacroix's journey there in 1832 (see Delacroix's watercolor *Strolling Players*, catalogue no. 48). Chassériau first employed this composition in 1849 in a small painting exhibited in the Salon of 1850–51, now in the Museum of Fine Arts, Houston.[1] In 1851 he repeated this composition in a soft-ground etching, *Two Young Moorish Women*, which appeared in the periodical *L'Artiste*.[2] Because of the similar manner of delineation, the museum's drawing may have been made in preparation for the etching, though both are in reverse of the painting.

NOTES
1. Sandoz, *Chassériau*, 276, no. 138.
2. Ibid., 436, no. 292, pl. 257.

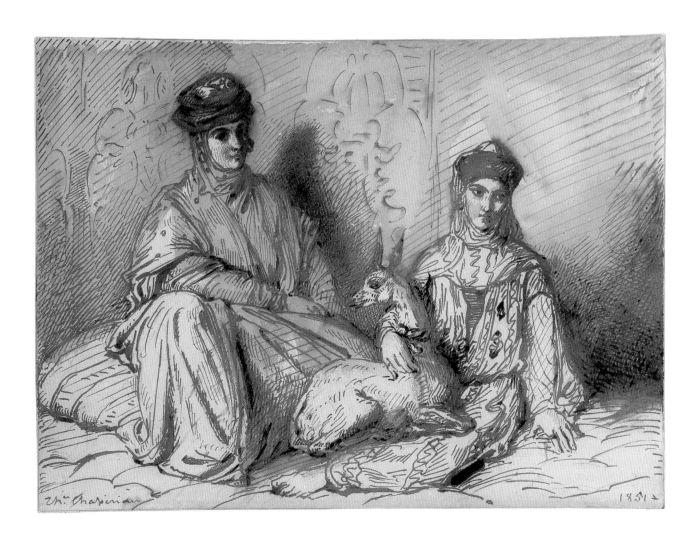

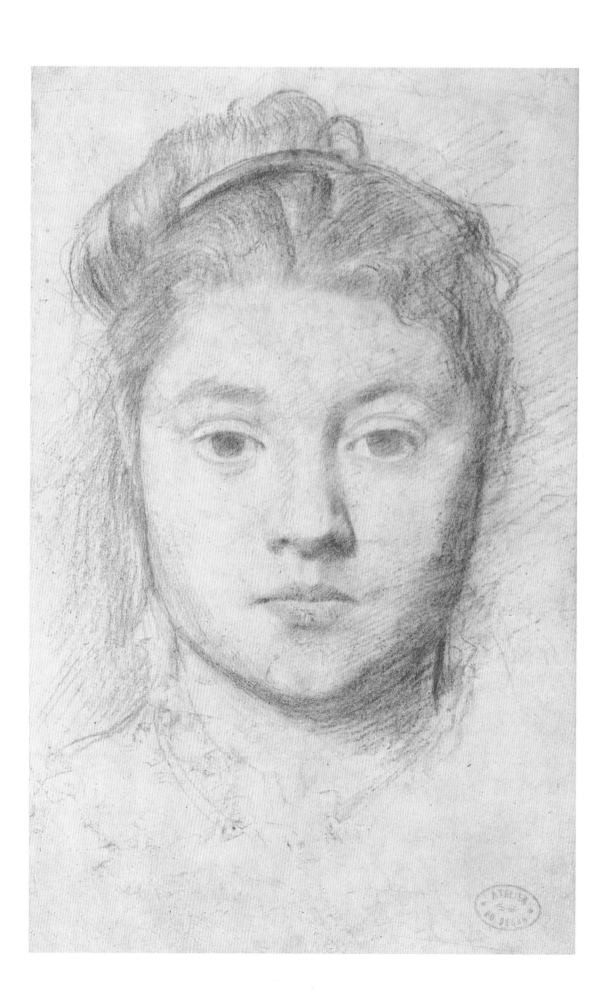

50

EDGAR DEGAS

Paris 1834–1917 Paris

Head of a Woman, about 1866

Red chalk

11 x 6 7/8 in. (27.9 x 17.5 cm)

INSCRIPTION

VERSO: Heureux mon cher ami, de vous/remettre ce souvenir de mon frère/René De Gas 11.2.1920

———

PROVENANCE

The artist (Lugt 657); René De Gas; private collection, Nantes; Talandier et Couton, Nantes, 17
October 1992, lot unnumbered [p. 7]; Galerie Berès, Paris; purchased by the museum in 1996

———

BIBLIOGRAPHY

P. A. Lemoisne, *Degas et son oeuvre* (Paris: Arts et Métiers Graphiques, 1946), 2: 176, under no. 336
(no location cited); "Americans in Paris," *Art and Auction* 19 (September 1996): 100–101

Wallis Foundation Fund in memory of Hal B. Wallis, AC1996.51.1

———⊗∞⊗———

Unlike the majority of impressionists with whom he exhibited, Degas was devoted to the human figure as the basis of his art. After studying at the École des Beaux-Arts, he went to Italy and worked at the Villa Medici in Rome. After returning to Paris, he met the circle of impressionist artists and exhibited with them every year from 1874 to 1886. Through these contacts Degas developed, particularly under the influence of Édouard Manet, from depicting historical subjects to recording scenes from modern life. Degas was perhaps the finest draftsman of the impressionists, the artistic descendant of Jacques-Louis David and Jean-Auguste-Dominique Ingres and the artistic ancestor of Henri de Toulouse-Lautrec and Pablo Picasso.

This superb portrait is a study for Degas's painting *Girl in a Red Peignoir* of about 1866 in the National Gallery of Art, Washington, D.C.[1] Jean Sutherland Boggs identified the model for that painting as Victorine Meurent, most famous as Manet's model for his painting *Olympia* of 1863.[2] Theodore Reff sees her as one of Degas's models, Emma Dobigny.[3] According to the auctioneer at the time of the drawing's sale in 1992, the subject may be Degas's niece Odile Degas or another female relative. The only citation to it in art historical literature is a passing reference by Lemoisne.

This drawing was in Degas's studio at the time of his death and was recorded photographically by his dealer, Durand-Ruel (Archive no. 1744). It was to be included in the fifth sale of Degas's estate, but the sale did not take place. It passed in 1920 from Degas's brother, René De Gas, to an unknown friend and reappeared again only recently.

NOTES

1. Lemoisne, *Degas*, 2: 176, no. 336.

2. Jean Sutherland Boggs, *Portraits by Degas* (Berkeley and Los Angeles: University of California Press, 1962), 124, pl. 49.

3. For Dobigny, see Jean Sutherland Boggs, ed., *Degas*, exh. cat. (New York: Metropolitan Museum of Art, 1988), no. 86.

51

JEAN-FRANÇOIS MILLET

Gruchy (France) 1814–1875 Barbizon

Panoramic Landscape: The Village of Gruchy, about 1866–71

Brown ink and watercolor

13 x 18 in. (33 x 45.7 cm)

INSCRIPTIONS

RECTO, UPPER RIGHT: 207; VERSO, LOWER RIGHT: Vente Millet [stamped]

———

PROVENANCE

The artist (Lugt 1460); Léon Suzor, Paris; Drouot, Paris, 15 December 1983, lot 18; Hazlitt, Gooden,
and Fox, London; Walter Feilchenfeldt, Zurich; purchased by the museum in 1986

———

EXHIBITION

Nineteenth-Century French Drawings, exh. cat. (London: Hazlitt, Gooden, and Fox, 1984), no. 15

———

Purchased with funds provided by Mr. and Mrs. Billy Wilder and
Mr. and Mrs. William Preston Harrison Collection by exchange, 86.9

———⊗⊗⊗———

Millet's parents were peasants, and that social back-ground informed his art throughout his career. After studying in Paris with the academic painter Paul Delaroche, Millet achieved initial fame in the Salon of 1850–51 with his painting *The Sower*, now in the Museum of Fine Arts, Boston. Beginning in 1849 he lived in the village of Barbizon outside Paris, becoming the central figure in the school of landscape painters that developed there, including Charles-François Daubigny, Charles Jaques, Théodore Rousseau, and Constant Troyon. Their unidealized views of nature and the peas-antry marked a desire to reaffirm the ethical values of an earlier time.

This remarkably spare and simple view represents Millet's birthplace, the village of Gruchy on the Normandy coast. Robert L. Herbert has provided addi-tional information on this sheet (letter, departmental files):

The watercolor is a fine and typical Millet, albeit unfinished. Because of the inscription on the verso, it seems fair to assume that it was no. 58 in Millet's death sale of 1875 (Drouot, Paris, 10–11 May 1875), 'Hameau de Gruchy,' there dated 1854. However, the date can't be that early, and is either 1866, when Millet was in Gruchy-Greville for a while, or 1870–71, when he spent a long period there. The executors were seldom wrong about dates, and that gives me pause, but no surviving drawing or watercolor from 1853–54 looks like this. I know nothing of the collector Suzor, and can't correlate the numbers on the drawing with any known sale. However, it is possible that this work was no. 184 in the famous Marmontel sale, 25–26 January 1883, 'Le Village. Aquarelle.' That catalogue, like the studio sale, lists no dimen-sions for the watercolors.

52

JOZEF ISRAËLS
Groningen (Holland) 1824–1911 The Hague
Farm Girl Resting, date unknown
Watercolor over traces of graphite
10 1/2 x 14 5/16 in. (26.7 x 36.4 cm)

INSCRIPTION
LOWER LEFT: Jozef Israels

———

PROVENANCE
Mr. and Mrs. Bernard F. Herman

———

Gift of Mr. and Mrs. Bernard F. Herman, M.64.36

———⁂———

Israëls initially studied painting and drawing in Groningen and Amsterdam. In 1845 he went to Paris, where in the mornings he worked in the studio of François Édouard Picot and in the evenings at the École des Beaux-Arts with James Pradier, Horace Vernet, and Paul Delaroche. Most significant for his development, however, was his visit in 1853 to Jean-François Millet in Barbizon. Under Millet's considerable influence, Israëls's subject matter was transformed from historical pictures to genre scenes, particularly with rural themes. He settled in The Hague in 1871 and became the leader of The Hague school.[1]

Rural French peasants, at work or at rest, were Millet's preferred subjects in his paintings, pastels, drawings, and prints and the ones that brought him international renown. Along with other mid-nineteenth-century followers of Millet, such as Jules Breton and Leon Lhermitte, Israëls adopted these subjects. Like many of Millet's paintings and pastels, this watercolor features an overall cool tonality suggestive of a bosky Barbizon evening.[2] Like Millet, Israëls was much-admired by Vincent van Gogh, indicated by Van Gogh's frequent references to him in his letters.[3] In his description of "the soul of modern civilization" in a letter from 1883 to his brother, Théo, Van Gogh described "the eternal quality in the greatest of the great: simplicity and truth." He then proceeded to include Israëls in a list with painters Jules Dupré, Charles-François Daubigny, Jean-Baptise-Camille Corot, and Millet, and writers Jules Michelet, Victor Hugo, Émile Zola, and Honoré de Balzac.[4]

NOTES

1. See Ronald de Leeuw, John Sillevis, and Charles Dumas, eds., *The Hague School: Dutch Masters of the Nineteenth Century*, exh. cat. (London: Royal Academy of Arts, 1983), 187–99.

2. For numerous excellent color plates of Millet's works, see Alexandra R. Murphy, *Jean-François Millet*, exh. cat. (Boston: Museum of Fine Arts, 1984).

3. Seventy-six references to Israëls can be found in the index of *The Complete Letters of Vincent van Gogh* (Greenwich, Conn.: New York Graphic Society, 1958), 3: 612.

4. Ibid., 2: 206.

53

GUSTAVE DORÉ

Strasbourg (France) 1832–1883 Paris

Derby Day, 1873

Black, gray, and white ink over black crayon

38 ½ x 28 ½ in. (97.8 x 72.4 cm)

INSCRIPTION

LOWER LEFT: G. Dore/Londres 1873

———

PROVENANCE

Allen Frumkin Gallery, New York; purchased by the donor in 1960

———

Gift of Mr. and Mrs. Vincent Price in honor of Anna Bing Arnold, M.86.285

———

Doré was self-taught as an artist. In 1847 he moved to Paris and the following year began working for the publisher Philippon, providing lithographs for the weekly *Journal pour rire*. He became the most prolific and successful illustrator in the second half of the nineteenth century; his designs adorned literary works by François Rabelais, Honoré de Balzac, John Milton, Dante, and many others. In the 1870s he abandoned book illustration and took up painting and etching.

Derby Day was executed in 1873 in London and is related to the illustrations Doré made for his friend Blanchard Jerrold's *London, A Pilgrimage* (London: Grant and Co., 1872), a documentation of Doré's and Jerrold's explorations of Victorian London.[1] With its calligraphic swirls and painterly washes, it is considerably more vibrant than another large, compositionally similar, and more detailed and finished Derby subject, *Courses d'Epsom: Les tribunes* (The races at Epsom: The grandstand).[2] Another *Derby Day* is in Harvard College Library, Department of Printing and Graphic Arts.[3] Doré assembled these large drawings into an album of London subjects and hoped to sell them as a group but was unsuccessful.

NOTES

1. For an extensive account, see Blanchard Jerrold, *Life of Gustave Doré* (London: W. H. Allen and Co., 1891), 150–86.

2. Samuel F. Clapp, *Gustave Doré, 1832–1883*, exh. cat. (London: Hazlitt, Gooden, and Fox, 1983), 52, no. 43, pl. 46.

3. Eleanor M. Garvey, *The Artist and the Book, 1860–1960, in Western Europe and the United States* (Boston: Museum of Fine Arts, 1961), 67.

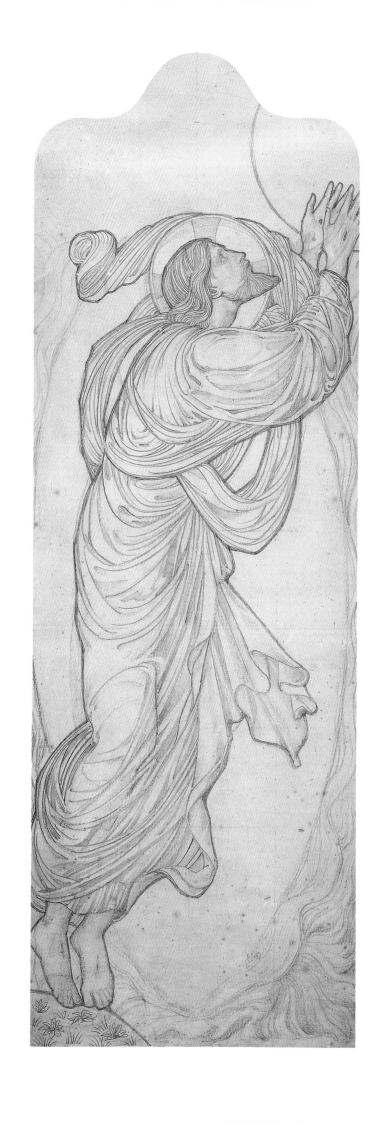

54

EDWARD BURNE-JONES
Birmingham (England) 1833–1898 London
Study of Christ for "The Ascension," 1874
Charcoal, framed in black ink, squared for transfer
44 3/16 x 16 1/2 in. (112.2 x 41.9 cm)

INSCRIPTIONS
UPPER LEFT: Arcangels [?]/Christ Ascending; UPPER RIGHT: S.P. 161

————

PROVENANCE
Harold Rathbone; Paul Rodman Mabury

————

BIBLIOGRAPHY
Martin Harrison and Bill Waters, *Burne-Jones* (New York: G. P. Putnam's Sons, 1973), 192

————

EXHIBITION
The Pre-Raphaelites, exh. cat. (Indianapolis: Herron Museum of Art, 1964), no. 36

————

The Paul Rodman Mabury Collection, M.39.3.57

————

The Pre-Raphaelite Brotherhood was founded in 1848 by seven young artists at the Royal Academy, including William Holman Hunt, John Everett Millais, and Dante Gabriel Rossetti. This group of artists was drawn especially to what it considered the "sincerity" of Quattrocento Italian art; that is, before Raphael. Burne-Jones was the most significant of the next generation of Pre-Raphaelites. He studied from 1853 to 1856 at Exeter College, Oxford, where he met William Morris and Rossetti. In 1857 he designed his first stained-glass window, produced by the Whitefriars Glass Factory. After 1861 windows designed by Burne-Jones were executed by Morris, Marshall, Faulkner and Company, of which he was one of the founders. After 1874 the company was reformulated as Morris and Company, for which Burne-Jones was the sole designer of stained glass. His exhibition in 1877 of eight paintings at the opening of the Grosvenor Gallery made him famous, though he was

undoubtedly overshadowed by the lawsuit that arose between John Ruskin and James Abbott McNeill Whistler over the latter's *Nocturne in Black and Gold— The Falling Rocket*, which was in the same show; Ruskin had described Whistler as "flinging a pot of paint in the public's face."

This drawing was used in 1874 for making a stained-glass window, now badly damaged, in the parish church at Brown Edge, Staffordshire. It was reused in 1878 for the east window at Christ Church, Tunbridge Wells, Kent. Harrison and Waters provide conflicting information on this drawing. In discussing the drawing they state it was used in 1874 for the window at Ruskington, Lincolnshire.[1] In the chronological list of Burne-Jones's windows, however, they mention windows of *The Ascension* in Staffordshire and Kent, but not Lincolnshire.[2]

NOTES
1. Harrison and Waters, *Burne-Jones*, 192.
2. Ibid., 189.

55

CAMILLE PISSARRO
Saint-Thomas (West Indies) 1830–1903 Paris
Peasant Girl Seated on the Ground, early 1880s
Pastel
23 5/8 x 17 1/2 in. (60 x 44.5 cm)

PROVENANCE
The artist's studio (Lugt Suppl. 613b); Lucien Pissarro; Galerie Cottereau, Paris;
purchased by the donor in 1926

———

BIBLIOGRAPHY
Harrison, 1929, 38, no. 64; Ludovic-Rodo Pissarro and Lionello Venturi, *Camille Pissarro,
son art, son oeuvre* (Paris: Paul Rosenberg, 1939), 1: 295, no. 1560; 2: pl. 299, no. 1560;
Feinblatt, 1970, n.p.; Françoise Cachin et al., *Camille Pissarro 1830–1903*, exh. cat.
(Paris: Galeries Nationales du Grand Palais, 1981), 119, under no. 47;
Impressionist and Modern Paintings, Watercolours, and Sculpture
(London: Christie's, 27 June 1994), 31, under no. 10

———

EXHIBITION
The Development of Impressionism, exh. cat.
(Los Angeles: Los Angeles County Museum of History, Science, and Art, 1940), no. 53

———

Mr. and Mrs. William Preston Harrison Collection, 26.7.11

———

Pissarro was born in the West Indies though educated in France. He settled permanently in Paris in 1855, studying at the École des Beaux-Arts and the Académie Suisse. He exhibited at the Salon des Refusées in 1863 and at the first impressionist exhibition in 1874. He was one of the key impressionist painters as well as the one most interested in printmaking. He worked with Paul Cézanne in the town of Pontoise outside Paris and later adopted briefly the pointillist methods of the neoimpressionists.

The year 1882 was Pissarro's last in Pontoise, where this pastel drawing was executed. It is closely related to the central figure in one of Pissarro's boldest and most audacious compositions, the 1882 painting *Peasants Guarding Cows, Pontoise* in Mrs. Paul Mellon's collection.[1] The early 1880s was a period when Pissarro was intensely interested in figures rather than pure landscape.[2] Two very similar pastel drawings by Pissarro of the same seated girl have appeared on the market recently. One was with JPL Fine Arts, London, in 1993,[3] the other sold at auction in 1994.[4]

NOTES

1. Pissarro and Venturi, *Pissarro*, 1: 161, no. 567; 2: pl. 117, no. 567; and Cachin et al., *Camille Pissarro 1830–1903*, no. 57.

2. For this aspect of Pissarro's art, see "Figures, Harvests, Market Scenes" in Joachim Pissarro, *Camille Pissarro* (New York: Harry N. Abrams, Inc., 1993), 152–211; and "Representing the Peasant," in Richard Thomson, *Camille Pissarro: Impressionism, Landscape, and Rural Labour*, exh. cat. (London: South Bank Centre, 1990), 46–58.

3. See "London: Summer Exhibitions," *Burlington Magazine* 135 (August 1993): 576–77, fig. 50.

4. Christie's, London, 27 June 1994, lot 10.

56

CAMILLE PISSARRO

Saint-Thomas (West Indies) 1830–1903 Paris

Shepherds in the Fields with Rainbow, 1885

Gouache and pastel on silk

11 5/8 x 24 3/4 in. (29.5 x 62.9 cm), fan shaped

INSCRIPTION

LOWER LEFT: C. Pissarro 1885

———

PROVENANCE

Mme Paulin, Neuilly; Arnold S. Kirkeby

———

BIBLIOGRAPHY

Ludovic-Rodo Pissarro and Lionello Venturi, *Camille Pissarro, son art, son oeuvre*

(Paris: Paul Rosenberg, 1939), 1: 304, no. 1628; 2: pl. 308, no. 1628

———

EXHIBITION

L'oeuvre de C. Pissarro, exh. cat. (Paris: Galerie Durand-Ruel, 1904), no. 151

———

Gift of Arnold S. Kirkeby, 57.64

———

Pissarro moved in 1884 to Eragny, a small village about sixty miles outside Paris on the Epte River, where over a twenty-year period he executed two hundred paintings and hundreds of drawings and watercolors. Although the site is not specified, the view of the grainstack with the distant row of trees is identical to the view in his *Grainstack, Eragny* of 1885 (location unknown).[1] In 1885 Pissarro met Georges Seurat and Paul Signac and entered a brief phase of experimentation with pointillism, or neoimpressionism. Even though executed that year, *Shepherds in the Fields with Rainbow* is not rendered with the fractured brushwork characteristic of pointillism. It is one of a group of over fifty fan-shaped paintings by Pissarro dating from 1878 to 1898.[2] Interest by Pissarro and the impressionists in the format of the fan was sparked by the widespread influence of Japanese art on French art during the second half of the nineteenth century.

NOTES

1. Pissarro and Venturi, *Pissarro*, 1: 177, no. 686; 2: pl. 142, no. 686.

2. Ibid., 1: 302–9, nos. 1609–64.

Degas
1886

57

EDGAR DEGAS
Paris 1834–1917 Paris
Portrait of Mlle Hélène Rouart, 1886
Pastel and charcoal
19 ¼ x 12 ½ in. (48.9 x 31.8 cm)

INSCRIPTION

LOWER RIGHT: Degas/1886

———

PROVENANCE

Vente Degas, Galerie Georges Petit, Paris, 1918, 2: lot 329; Galerie Durand-Ruel, Paris;
Galerie Bernheim-Jeune, Paris; Mr. and Mrs. William Preston Harrison

———

BIBLIOGRAPHY

Harrison, 1929, 37, no. 57; P. A. Lemoisne, *Degas et son oeuvre* (Paris: Arts et Métiers Graphiques,
1946), 3: 500, no. 866; Jean Sutherland Boggs, "Mme Henri Rouart et Hélène by Edgar Degas,"
Los Angeles County Museum Bulletin of the Art Division 8, no. 2 (1956): 15, fig. 3;
Jean Sutherland Boggs, *Portraits by Degas* (Berkeley and Los Angeles: University of California Press,
1962), 67, 128; Stephen Longstreet, *The Drawings of Degas*
(Alhambra, Calif.: Borden Publishing Co., 1964), n.p.; Feinblatt, 1970, n.p.;
Franco Russoli and Fiorella Minervino, *L'opera completa di Degas* (Milan: Rizzoli Editore, 1970),
116–17, no. 654; Charles W. Millard, *The Sculpture of Edgar Degas*
(Princeton: Princeton University Press, 1976), fig. 57; Götz Adriani, *Degas: Pastelle, Ölskizzen,
Zeichnungen*, exh. cat. (Tübingen: Kunsthalle, 1984), 381; Jean Sutherland Boggs et al.,
Degas, exh. cat. (New York: Metropolitan Museum of Art, 1988), 384;
Degas Images of Women, exh. cat. (Liverpool: Tate Gallery, 1989), 19;
Felix Baumann and Marianne Karabelnik, eds., *Degas Portraits*, exh. cat.
(Zurich: Kunsthaus; London: Merrell Holberton Publishers, 1994), 74–75, 95

———

EXHIBITIONS

Jean Sutherland Boggs, *Edgar-Hilaire-Germain Degas*, exh. cat. (Los Angeles: Los Angeles County
Museum of History, Science, and Art, 1958), no. 53; *The Nineteenth Century:
One Hundred and Twenty-Five Master Drawings*, exh. cat. (Minneapolis: University Gallery, University
of Minnesota, 1962), no. 30; Jean Sutherland Boggs, *Drawings by Degas*, exh. cat.
(Saint Louis: City Art Museum, 1966), no. 125; Katherine H. Mead, ed., *The Impressionists and the
Salon (1874–1886)*, exh. cat. (Los Angeles: Los Angeles County Museum of Art, 1974), no. 17;
Nancy Mowll Mathews, *Mary Cassatt and Edgar Degas*, exh. cat.
(San Jose: San Jose Museum of Art, 1981), no. 61; Dillian Gordon, *Acquisition in Focus: Edgar Degas,
"Hélène Rouart in Her Father's Study,"* exh. cat. (London: National Gallery, 1984), 8, 18, fig. 7

———

Mr. and Mrs. William Preston Harrison Collection, 35.18.2

———

Henri Rouart, an old childhood friend of Degas, was a collector and amateur painter who displayed his landscapes alongside the impressionists in their exhibitions. The museum's drawing is one of several from the mid-1880s of members of the Rouart family, including Henri, his wife Hélène, and their children, Hélène (the subject of this drawing), Alexis, Ernest, and Louis. In 1884 Degas portrayed Mme Rouart seated in an armchair next to a Greek terra-cotta Tanagra figurine in a pastel drawing now in the Staatliche Kunsthalle, Karlsruhe.[1] Tanagra figures are terra-cotta sculptures of the third and second centuries B.C. which were discovered in the nineteenth century in cemeteries in the ancient city of Tanagra in Boeotia. The female figures are notable for being completely wrapped in thin drapery and became extremely popular among collectors during the late nineteenth century. Degas has depicted Mlle Hélène in the museum's drawing in this guise.

Two pencil studies by Degas show Hélène in a pose similar to the museum's drawing, one in a private collection[2] and the other recently on the art market.[3] In 1886, the same year as the museum's pastel drawing, Degas painted a woman wrapped in a red shawl (sometimes, though probably erroneously, identified as Mlle Hélène).[4] Although Mlle Hélène was a close family friend, Degas's adoption of the Tanagra pose suggests a peculiar distancing between artist and subject.

NOTES

1. Lemoisne, *Degas*, 3: 434 bis, no. 766 bis; Baumann and Karabelnik, *Degas Portraits*, 223, no. 169.
2. Ibid., 74.
3. Phillips, New York, 15 November 1988, lot 11.
4. Baumann and Karabelnik, *Degas Portraits*, 249, no. 173.

58

EDGAR DEGAS
Paris 1834–1917 Paris
Woman Drying Herself, after 1888
Pastel
24 ¾ x 18 ½ in. (62.9 x 47 cm)

PROVENANCE

Vente Degas, Galerie Georges Petit, Paris, 1918, 1: lot 234; Pellet, Paris; Felix Vallotton;
Morren, Brussels (by 1935); private collection, Bern; Wildenstein and Co., New York;
purchased by the donor in 1959

BIBLIOGRAPHY

P. A. Lemoisne, *Degas et son oeuvre* (Paris: Arts et Métiers Graphiques, 1946), 3: 550,
no. 948; Franco Russoli and Fiorella Minervino, *L'opera completa di Degas*
(Milan: Rizzoli Editore, 1970), 128, under no. 933

EXHIBITIONS

L'impressionisme, exh. cat. (Brussels: Palais des Beaux-Arts, 1935), no. 22; *Degas*, exh. cat.
(Bern: Kunstmuseum, 1951), no. 44A; Nancy Mowll Mathews, *Mary Cassatt and Edgar Degas*, exh. cat.
(San Jose: San Jose Museum of Art, 1981), no. 67

Gift of Jerome K. Ohrbach, M.61.58

※

In 1886 Degas showed a suite of ten nudes in the eighth and final impressionist exhibition. In writing about Degas's art of the 1880s, Gary Tinterow stated, "Toward the mid-1880s, Degas markedly shifted the course of his art. He simplified his compositions, made the depicted space more shallow, brought his viewpoint down to near eye-level, and focused his attention on a single figure or figural group.... Degas's new classicizing style is most evident in the series of large pastel nudes."[1] The museum's drawing is a finished and complete study for a larger pastel by Degas formerly in the collection of Georges Viau, Paris.[2] The woman is depicted kneeling on an armchair and balancing herself on a folding screen. The final work shows two panels of the folding screen, but the compositions are basically identical. The museum's drawing was preceded by a pastel study in the Le Garrec collection, Paris.[3] This initial drawing is roughly the same

height as the museum's but is extended on the sides to a horizontal composition. Degas then compressed the scene to a vertical orientation in the museum's piece and raised the position of the woman's right arm so that the line of her back continues unbroken into the line of her arm.

Lemoisne dated this group of pastels to about 1888. They have not been discussed critically in the recent literature and exhibition catalogues on Degas, but a revision to a few years later is suggested here. The loose and gestural application of the pastel and the eccentric placement of the figure in space is related to works such as *Woman Stepping into a Bath* of about 1890 in the Metropolitan Museum, New York,[4] and *After the Bath, Woman Drying Herself* of about 1895–1900 in the Courtauld Institute Galleries, London.[5]

NOTES

1. Gary Tinterow, "The 1880s: Synthesis and Change," in Jean Sutherland Boggs, ed., *Degas*, exh. cat. (New York: Metropolitan Museum of Art, 1988), 366.

2. Lemoisne, *Degas*, 3: 550, no. 947.

3. Ibid., 3: 550, no. 949.

4. Boggs, no. 288.

5. Richard Kendall, *Degas: Beyond Impressionism*, exh. cat. (London: National Gallery, 1996), no. 61.

59

VINCENT VAN GOGH
Zundert (Holland) 1853–1890 Auvers-sur-Oise (France)
The Bridge at Langlois, 1888
Brown ink over traces of black chalk
9 5/8 x 12 9/16 in. (24.5 x 31.9 cm)

PROVENANCE

Émile Bernard; Mrs. J. van Gogh-Bonger, Amsterdam; Paul Cassirer Art Gallery, Berlin;
Mrs. Tilla Durieux-Cassirer, Berlin; Mrs. Paret, Berlin; Jacques Seligmann and Co., New York,
(1935–38); purchased by the donor in 1938

———

BIBLIOGRAPHY

William R. Valentiner, *The Mr. and Mrs. George Gard De Sylva Collection of*
French Impressionist and Modern Paintings and Sculpture (Los Angeles: Los Angeles County Museum of
History, Science, and Art, 1950), 53, no. 21; J.-B. de la Faille, *The Works of Vincent van Gogh,*
His Paintings and Drawings (Amsterdam: Reynal and Co., 1970), 512, no. F1471; Feinblatt, 1970, n.p.

———

EXHIBITIONS

Vincent van Gogh, exh. cat. (Berlin: Paul Cassirer Art Gallery, 1914), no. 72; *Vincent van Gogh*
(Berlin: Otto Wacker Art Gallery, 1927), in exh. but not in cat.; *Meisterzeichnungen französischer*
Künstler von Ingres bis Cézanne, exh. cat. (Basel: Kunsthalle, 1935), no. 241; *Vincent van Gogh,*
exh. cat. (New York: Museum of Modern Art, 1935), no. 115;
Nineteenth-Century French Drawings, exh. cat. (San Francisco: California Palace of the Legion of Honor,
1947), no. 134; *Vincent van Gogh*, exh. cat. (Houston: Contemporary Arts Museum, 1951), no. 13;
Vincent van Gogh, Loan Exhibition of Paintings and Drawings, exh. cat.
(Los Angeles: Municipal Art Gallery, 1957), no. 37; Ronald Pickvance, *Van Gogh in Arles*, exh. cat.
(New York: Metropolitan Museum of Art, 1984), no. 24; *Van Gogh et Arles*, exh. cat.
(Arles: Ancien Hôpital Van Gogh, 1989), no. 6

———

The George Gard De Sylva Collection, M.49.17.2

———

The son of a pastor, Van Gogh worked as an evangelist among the Belgian miners in Wasmes. The experiences informed his early, nearly monochromatic paintings depicting poor peasants. In 1886 Van Gogh and his brother, Théo, an art dealer, moved to Paris, where they encountered the works of the impressionists. Their brilliantly colored canvases inspired Van Gogh to radically change his palette. In 1888 began his most creatively productive period when he moved to Arles in southern France, where his health deteriorated but not his creativity. He spent time in an asylum in Saint-Remy and was later under the care of Dr. Paul Gachet in Auvers. In 1890 he committed suicide. Along with Paul Cézanne, Paul Gauguin, and Georges Seurat, Van Gogh is considered one of the most significant postimpressionist painters.

The subject of this drawing was built about 1820–30 over one of the canals that linked Arles with

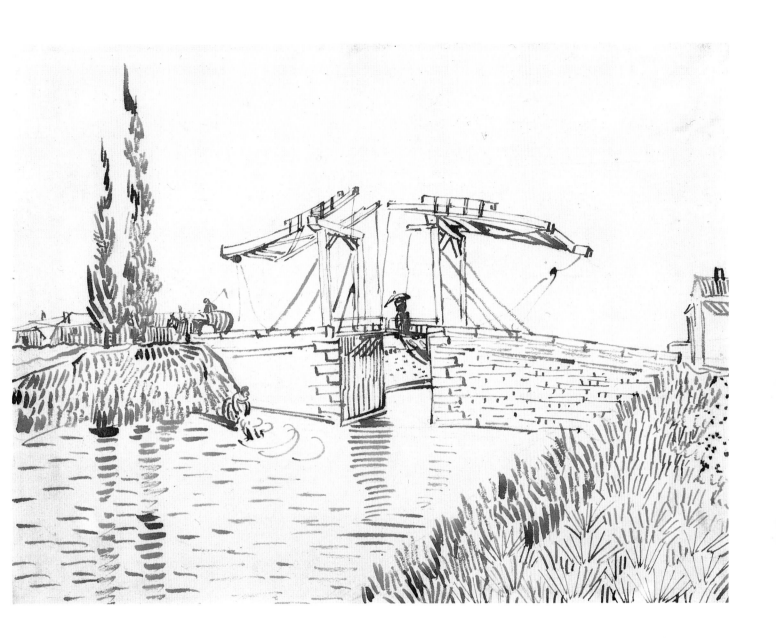

the Mediterranean. It was one of Van Gogh's favorite motifs, the subject of five paintings, three drawings, and a watercolor. This sheet was part of a group of fifteen drawings that Van Gogh made in July 1888, copied from his own freshly painted canvases as they were drying in his studio in the Maison Jaune in Arles; he then sent the drawings to his young protégé in Brittany, Émile Bernard. The canvas on which this sheet is based is in Wallraf-Richartz Museum, Cologne.[1]

NOTE

1. De la Faille, *Van Gogh*, no. F570.

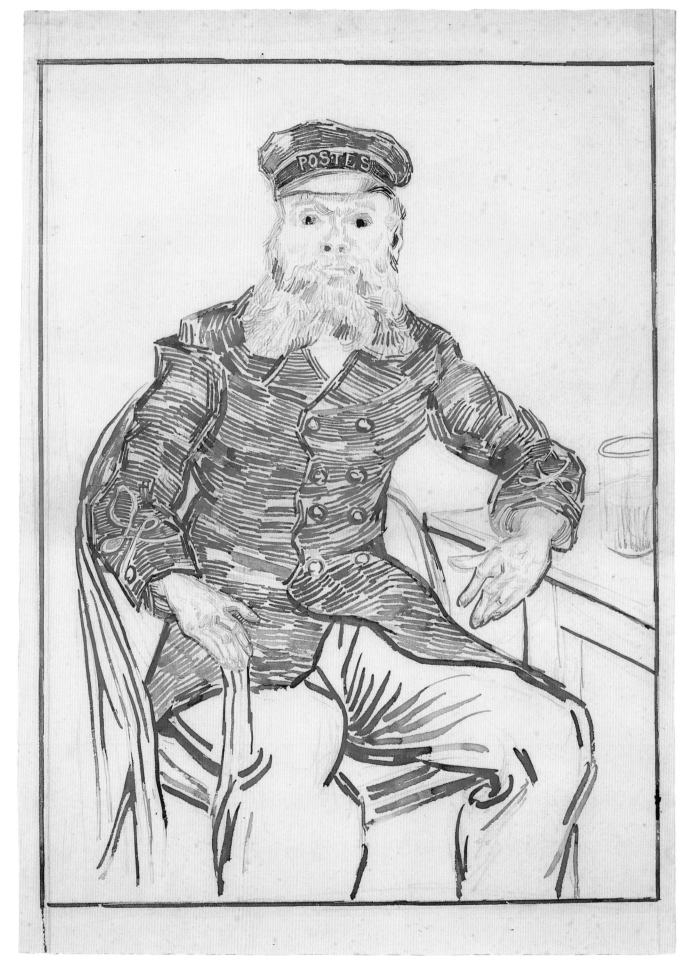

60

VINCENT VAN GOGH

Zundert (Holland) 1853–1890 Auvers-sur-Oise (France)
The Postman Joseph Roulin, 1888
Brown ink over black chalk
20 1/4 x 16 5/8 in. (51.4 x 42.2 cm)

PROVENANCE

Mrs. J. van Gogh-Bonger, Amsterdam; Paul Cassirer Art Gallery, Berlin; H. Freudenberg,
Nikolassee; Jacques Seligmann and Co., New York; purchased by the donor in 1937

———

BIBLIOGRAPHY

Kurt Pfister, *Vincent van Gogh* (Potsdam: G. Kiepenheuer, 1922), 34; Julius Meier-Graefe,
Vincent van Gogh der Zeichner (Berlin: O. Wacker, 1928), pl. 29; Aline B. Louchheim,
"Today's Collectors. Buddy De Sylva: Gift to Hollywood," *Art News* 45, no. 7 (September 1946): 32;
Regina Shoolman and Charles E. Slatkin, *Six Centuries of French Master Drawings in America*
(New York: Oxford University Press, 1950), 218, pl. 123; William R. Valentiner,
*The Mr. and Mrs. George Gard De Sylva Collection of French Impressionist and Modern Paintings and
Sculpture* (Los Angeles: Los Angeles County Museum of History, Science, and Art, 1950),
55, no. 22; *Los Angeles County Museum of Art Illustrated Handbook*
(Los Angeles: Los Angeles County Museum of Art, 1965), 126; J.-B. de la Faille,
The Works of Vincent van Gogh, His Paintings and Drawings
(Amsterdam: Reynal and Co., 1970), 510, no. F1459; Feinblatt, 1970, n.p.;
Los Angeles County Museum of Art Handbook (Los Angeles: Los Angeles County Museum of Art,
1977), 110; Evert van Uitert and Louis van Tilborgh,
Vincent van Gogh: Paintings, exh. cat. (Amsterdam: Rijksmuseum Vincent van Gogh;
Otterlo: Rijksmuseum Kroller-Muller, 1990), 136, 138

———

EXHIBITIONS

Vincent van Gogh, exh. cat. (Amsterdam: Stedelijk Museum, 1905), no. 415;
Van Gogh-Matisse, exh. cat. (Berlin: Kronprinzenpalais, Nationalgalerie, 1921), no. 64;
Vincent van Gogh (Berlin: Otto Wacker Art Gallery, 1927), in exh. but not in cat.;
French Nineteenth-Century Paintings and Drawings (Buffalo: Fine Arts Academy, 1932), in exh.
but not in cat.; *Vincent van Gogh*, exh. cat. (New York: Museum of Modern Art, 1935), no. 117A;
Vincent van Gogh et son oeuvre, exh. cat. (Paris: Nouveaux Musées, Quai de Tokio, 1937), no. 70;
Nineteenth-Century French Drawings, exh. cat. (San Francisco: California Palace of
the Legion of Honor, 1947), no. 133; *Vincent van Gogh*, exh. cat.
(Cleveland: Cleveland Museum of Art, 1948), no. 46; *De David à Toulouse-Lautrec,
chefs d'oeuvre des collections americaines*, exh. cat. (Paris: Musée de l'Orangerie, 1955), no. 78;

Vincent van Gogh, Loan Exhibition of Paintings and Drawings, exh. cat.
(Los Angeles: Municipal Art Gallery, 1957), no. 36;
Nineteenth-Century Master Drawings, exh. cat. (Newark: Newark Museum, 1961), no. 55;
The Nineteenth Century: One Hundred and Twenty-Five Master Drawings, exh. cat.
(Minneapolis: University Art Gallery, University of Minnesota, 1962), no. 120; *International
Ausstellung Documenta III*, exh. cat. (Kassel: Alte Galerie, 1964), no. 7; Ronald Pickvance,
Van Gogh in Arles, exh. cat. (New York: Metropolitan Museum of Art, 1984), no. 92;
Vincent van Gogh Exhibition, exh. cat. (Tokyo: National Museum of Western Art, 1985), no. 20;
Johannes van der Wolk, Ronald Pickvance, and E. B. F. Pey,
Vincent van Gogh: Drawings, exh. cat. (Amsterdam: Rijksmuseum Vincent van Gogh;
Otterlo: Rijksmuseum Kroller-Muller, 1990), 233, no. 202

———

The George Gard De Sylva Collection, M.49.17.1

———

This large drawing is Van Gogh's autograph replica of his painting in the Museum of Fine Arts, Boston.[1] Van Gogh made a number of paintings and drawings of Roulin (1841–1903), a postal worker in Arles. This drawing differs in scale from the other drawn replicas that Van Gogh made in 1888 and sent to his brother, Théo, and Émile Bernard, executed on a sheet of paper twice the usual size. That this drawing is not a slavish copy of the Boston canvas is evident from the pentimenti over underdrawing in pencil as well as some differences in details. Most notable is the addition of the glass on the table, placing this drawing within the nineteenth-century tradition of solitary drinkers, which includes paintings by Édouard Manet, Henri de Toulouse-Lautrec, Edgar Degas, and others. Van Gogh commented on Roulin's predilection for drinking in a letter to his brother.[2]

NOTES

1. De la Faille, *Van Gogh*, no. F432.
2. Noted in Van der Wolk, Pickvance, and Pey, *Van Gogh: Drawings*, 233.

61

JEAN-JACQUES HENNER

Berviller (France) 1829–1905 Paris

Saint Sebastian Attended by Saint Irene, about 1889

Black and white chalk

24 ¼ x 18 ½ in. (61.6 x 47 cm)

INSCRIPTION

LOWER RIGHT: H Henner

———

PROVENANCE

Shepherd Gallery, New York (cat. 1981–82, no. 114); Paul Magriel, New York (1981–90);
Jill Newhouse, New York; purchased by the museum in 1991

———

BIBLIOGRAPHY

Victor Carlson, "Forum: 'St. Sebastian Attended by St. Irene' by Jean-Jacques Henner,"
Drawing 13, no. 4 (1991): 80–81

———

Gift of the 1991 Collectors Committee, M.91.63

———

Jean-Jacques Henner was one of the most highly regarded artists working in Paris during the last quarter of the nineteenth century. His early interest in drawing found support within his family, and by 1846 he was able to study in Paris with Michel-Martin Drolling. For twelve years Henner attempted to win the Prix de Rome but encountered only disappointment. Finally, he did achieve the coveted prize in 1858, which sent him to the Villa Medici in Rome for six years, where he was inspired by the works of such masters as Titian, Giorgione, and Correggio. When Henner returned to Paris, his paintings were regularly shown at the Salons. In 1878 he was made an officer of the Légion d'Honneur, and in 1889 he was elected to the Institut de France. That year Henner's painting *Saint Sebastian Attended by Saint Irene* was exhibited to favorable acclaim in Paris at the Universal Exhibition. The canvas was bought by the French state for the Musée de Luxembourg; today the painting is in the Musée Henner, Paris.

The painting received critical accolades when first exhibited, but the artist's mastery is now difficult to discern because the pigments have darkened, making the figures of Irene and her attendant almost invisible. By comparison, Henner's chalk drawing is the most faithful statement of his intentions. Most likely the artist made this highly finished drawing as a replica of his canvas, perhaps with the intention of selling it to a collector, an increasingly common practice during the late nineteenth century. This sheet brilliantly exploits the white pallor of the paper to represent the body of the saint. The dense blacks of the attendant figures in a nocturnal landscape were drawn using heavier layers of fabricated chalk, with highlights created by erasures. When the drawing was finished, it was sprayed with a fixative, which had the dual advantage of preserving the fragile surface of the tonal drawing as well as giving a pronounced tint to the overall surface.

—Victor Carlson

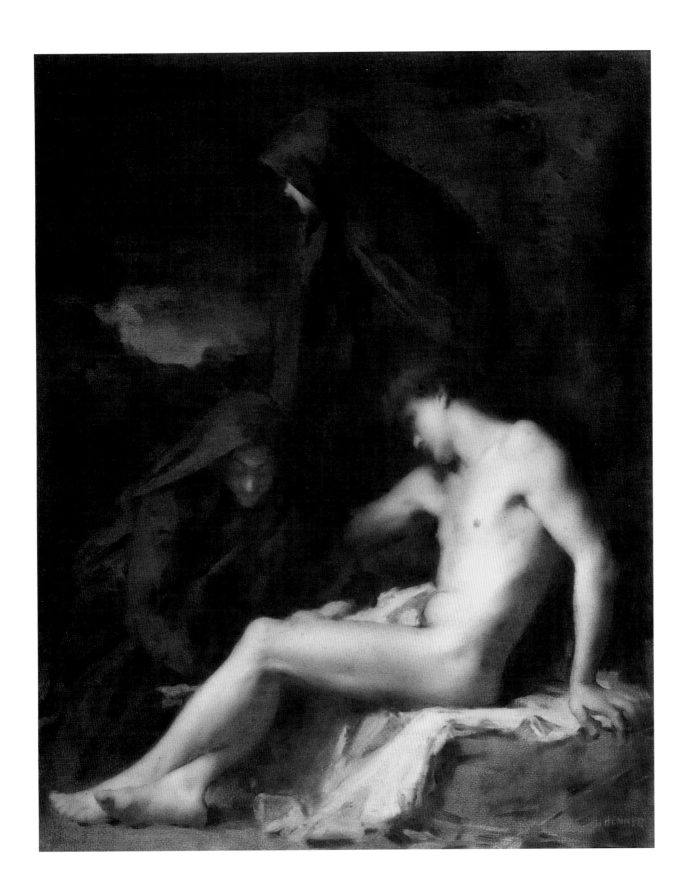

62

JOSEPH PENNELL
Philadelphia 1857–1926 New York
Blue Night, London, about 1890
Watercolor on light blue paper
10 ¼ x 13 ¹³/₁₆ in. (26 x 35.1 cm)

INSCRIPTION
LOWER RIGHT: Pennell

———

PROVENANCE
Purchased by the donor in 1924

———

BIBLIOGRAPHY
Harrison, 1934, 66; Fort and Quick, 439

———

EXHIBITION
Exhibition by Childe Hassam, Joseph Pennell, Maurice Sterne, exh. cat.
(Los Angeles: Los Angeles Museum of History, Science, and Art, 1924), no. 50;
Larry Curry, *American Pastels and Watercolors: Selections from the Mr. and Mrs. William Preston Harrison
Collection*, exh. cat. (Los Angeles: Los Angeles County Museum of Art, 1969), no. 13

———

Mr. and Mrs. William Preston Harrison Collection, 31.12.18

———

Pennell was the most significant follower of James Abbott McNeill Whistler, whose influence is evident in this nocturnal view of London and the Thames. Whistler's nocturnes were notorious in their day because of the artist's lawsuit against John Ruskin for his comments on them. Pennell's approach to the landscape in this watercolor was very similar to Whistler's. Despite the monochromatic coloration, Pennell achieved a remarkable variety of tonal effects. The night scene is broken by flickering lights along the banks of the Thames, with spots of yellow watercolor introduced into the general blue tonality. *Blue Night, London* is particularly similar in this regard to two of Whistler's paintings, *Nocturne in Blue and Silver* of 1872–78 in a private collection[1] and *Nocturne in Blue and Silver: The Lagoon, Venice* of 1879–80 in the Museum of Fine Arts, Boston,[2] and to two lithotints of the Thames, *Nocturne: The River at Battersea* of 1878[3] and *The Thames* of 1896.[4] Pennell made several etchings and aquatints of Thames views at night, with effects of flickering lights punctuating the nocturnal darkness, which may provide a chronological framework for *Blue Night, London*; especially similar to the watercolor are *Lion Brewery* of 1887[5] and *Cleopatra's Needle* of 1894.[6]

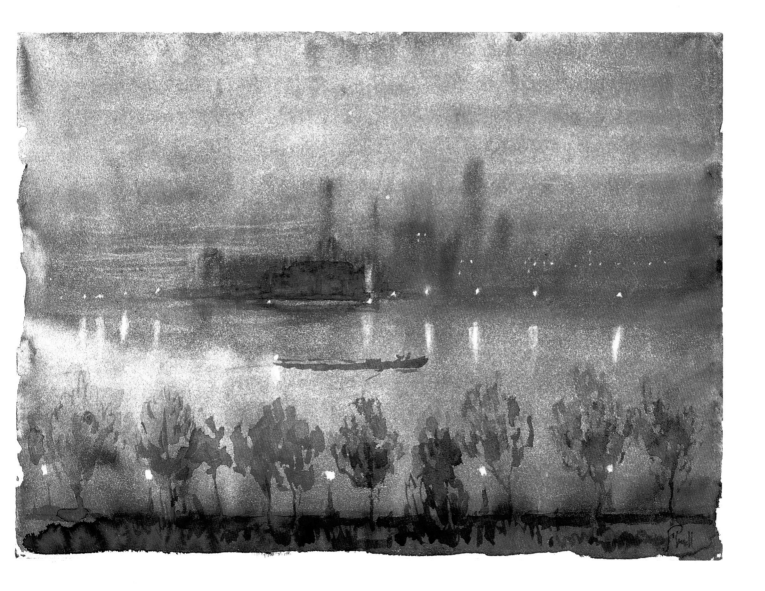

NOTES

1. Andrew McLaren Young, Margaret MacDonald, and Robin Spencer, *The Paintings of James McNeill Whistler* (New Haven and London: Yale University Press, 1980), 1: 89–90, no. 151, 2: pl. 150.

2. Ibid., 1: 123, no. 212; 2: pl. 151.

3. Mervyn Levy, *Whistler Lithographs: An Illustrated Catalogue Raisonné* (London: Jupiter Books, 1975), no. 11. A related monochromatic watercolor by Whistler, *Battersea*, is in the British Museum. See Margaret F. MacDonald, *James McNeill Whistler: Drawings, Pastels, and Watercolors, a Catalogue Raisonné* (New Haven and London: Yale University Press, 1995), 216, no. 588.

4. Levy, *Whistler Lithographs*, no. 178. From the same year is Whistler's similarly monochromatic watercolor, *Westminster from the Savoy*, in the Hunterian Art Gallery, University of Glasgow. See MacDonald, *Whistler: Drawings*, 528, no. 1471.

5. Louis A. Wuerth, *Catalogue of the Etchings of Joseph Pennell* (1928; reprint, San Francisco: Alan Wofsy Fine Arts, 1988), 48, no. 140.

6. Ibid., 74, no. 213.

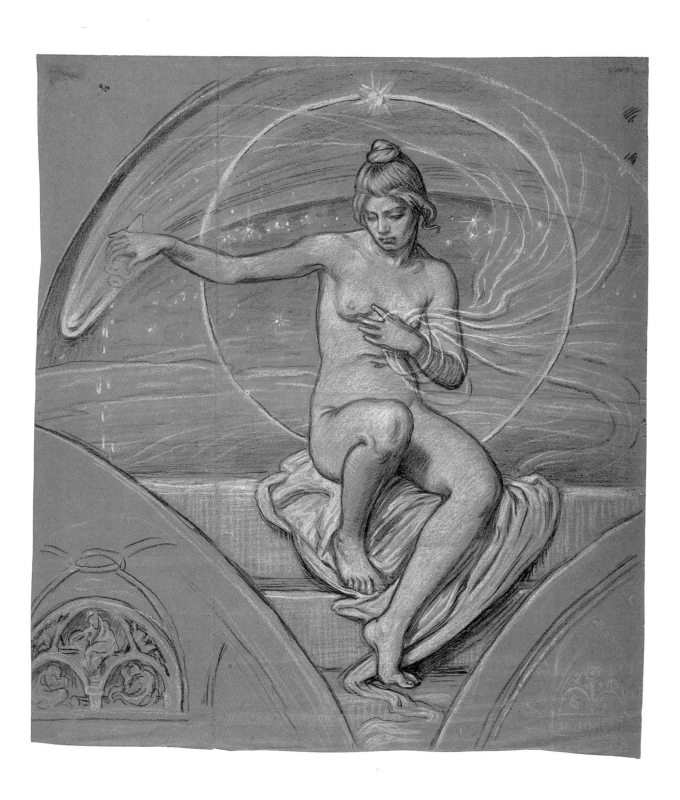

63

ELIHU VEDDER

New York 1836–1923 Rome

Study for "Stella Funesta" ("The Evil Star"), about 1892

Charcoal and pastel on blue paper

17 ½ x 15 ⅞ in. (44.5 x 40.3 cm)

PROVENANCE

Estate of the artist; Victor D. Spark, New York; purchased by the museum in 1969

———

EXHIBITION

Regina Soria, *Perceptions and Evocations: The Art of Elihu Vedder,* exh. cat.
(Washington, D.C.: National Collection of Fine Arts, 1979), 196–97, fig. 246

———

Art Museum Council Fund, M.69.66

Vedder initially studied in New York but went to Paris in 1856 and to Florence in 1857. Although he returned frequently to the United States, he was mostly an expatriate artist living in Rome and later Capri. In 1881 he began a career in the decorative arts, providing designs for greeting cards, book illustrations, stained-glass windows, mosaics, and mural decorations. He was closely associated with McKim, Mead, and White, the leading American architectural firm of the late nineteenth century.

In 1892 he visited the United States in hopes of obtaining decorative commissions from that architectural firm, which was also the principal organizer of the World's Columbian Exposition in Chicago in 1893. During this trip Vedder executed a series of proposals for mural decorations with allegorical themes that he hoped could be shown in Chicago. Five different astrological subjects are known, some of which, like *Stella Funesta,* reflect a gloomy philosophical outlook.[1] Another study for *Stella Funesta* is in the Hudson River Museum, Yonkers, New York.[2]

NOTES

1. For the drawings, see Soria, *The Art of Elihu Vedder,* 195–97, figs. 244–49.
2. Regina Soria, *Elihu Vedder: American Visionary Artist in Rome (1836–1923)* (Rutherford, N.J.: Fairleigh Dickinson University Press, 1970), 375, no. D 455.

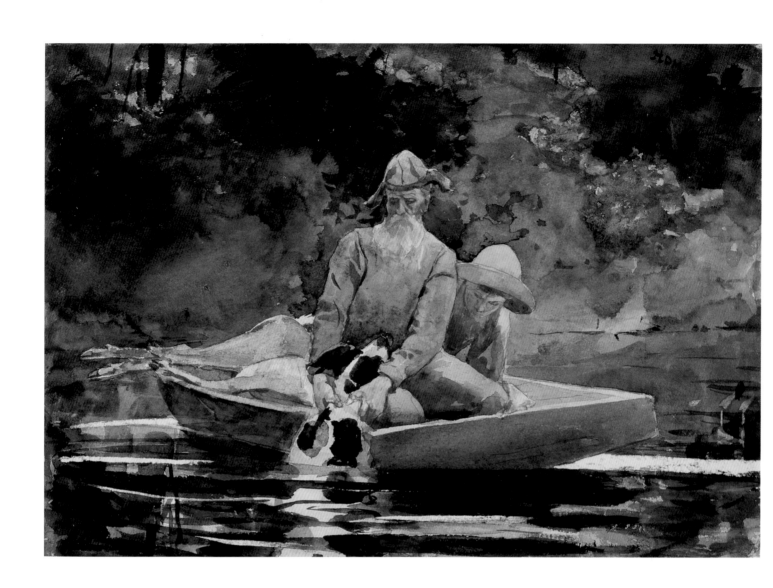

64

WINSLOW HOMER

Boston 1836–1910 Prout's Neck (Maine)

After the Hunt, 1892

Watercolor, gouache, and graphite

13 15/16 x 19 15/16 in. (35.4 x 50.6 cm)

INSCRIPTION

UPPER RIGHT: Homer/1892

———

PROVENANCE

The artist (1892–1900); Doll and Richards, Boston (1900–1902);
George (or Gustav) H. Buek, Brooklyn (1902–11); Moulton and Ricketts Galleries,
Chicago and New York (1911–16); purchased by the donor in 1916

———

BIBLIOGRAPHY

James William Pattison, "Buek Collection of Water Colors: Historic, Artistic, Complete,"
Fine Arts Journal 24 (1911): 369; *The Paul Rodman Mabury Collection of Paintings*
(Los Angeles: Los Angeles County Museum of History, Science, and Art, n.d. [about 1940]), 22;
Forbes Watson, *Winslow Homer* (New York: Crown, 1942), 36; Lloyd Goodrich, *Winslow Homer*
(New York: Whitney Museum of American Art; Macmillan, 1944), pl. 33; Ashton Sanborn,
"Winslow Homer's Adirondack Guide," *Bulletin of the Museum of Fine Arts* 46 (June 1948): 49, fig. 4;
Alexander Eliot, *Three Hundred Years of American Painting* (New York: Time, 1957), 300;
Winslow Homer in the Adirondacks, exh. cat. (Blue Mountain Lake, N. Y.:
Adirondack Museum, 1959), 25; Albert Ten Eyck Gardner, *Winslow Homer, American Artist:
His World and Work* (New York: Potter, 1961), 187; Winifred Haines Higgins,
"Art Collecting in the Los Angeles Area, 1910–1960" (Ph.D. diss., University of California,
Los Angeles, 1963), 127, no. 11; Philip C. Beam, *Winslow Homer at Prout's Neck*
(Boston: Little, Brown, 1966), 106, 259; *Los Angeles County Museum of Art Handbook*
(Los Angeles: Los Angeles County Museum of Art, 1977), 142; Lorna Price,
Masterpieces from the Los Angeles County Museum of Art Collection
(Los Angeles: Los Angeles County Museum of Art, 1988), 131; David Tatham,
"Trapper, Hunter, and Woodsman: Winslow Homer's Adirondack Figures,"
American Art Journal 22, no. 4 (1990): 48–50, fig. 7; Fort and Quick, 437–39

———

EXHIBITIONS

*An Historical Collection of Pictures in Water Color by American Artists,
Assembled by George H. Buek, Esq., of Brooklyn, N.Y., and by Him Lent for Exhibition*, exh. cat.
(Saint Louis: City Art Museum, 1909), no. 68; *A Collection of Paintings in Water Color
by American Artists Lent by Gustav H. Buek of Brooklyn, New York*

(Chicago: Art Institute of Chicago, 1910), no. 77; *Catalogue of the Inaugural Exhibition*,
exh. cat. (Muskegon, Mich.: Hackley Art Gallery, 1912), no. 31;
Summer Exhibition of Paintings (Los Angeles: Los Angeles Museum of History, Science, and Art, 1919),
no. 22; *Temporary Installation and Catalogue of the Paul Rodman Mabury Collection*, exh. cat.
(Los Angeles: Los Angeles County Museum of History, Science, and Art, 1939), no. 12;
American Painting of the Eighteenth and Nineteenth Centuries, exh. cat.
(Los Angeles: Fisher Gallery of Fine Arts, University of Southern California, 1940), no. 16;
Painting in the U.S.A. 1721–1953, exh. cat. (Pomona: Los Angeles County Fair Association, 1953),
no. 69; *Sport in Art*, exh. cat. (New York: American Federation of Arts, 1955), no. 51;
Winslow Homer: A Retrospective Exhibition (Washington, D.C.: National Gallery of Art, 1959),
no. 147; *Yankee Painter: A Retrospective Exhibition of Oils, Water Colors, and
Graphics by Winslow Homer*, exh. cat. (Tucson: Art Gallery, University of Arizona, 1963),
entries unnumbered, illus. on cover; Larry Curry, *Eight American Masters of Watercolor*, exh. cat.
(Los Angeles: Los Angeles County Museum of Art, 1968), no. 6;
Winslow Homer, exh. cat. (New York: Whitney Museum of American Art, 1973), no. 124;
Five American Masters of Watercolor, exh. cat. (Evanston: Terra Museum of American Art, 1981), 7;
Helen A. Cooper, *Winslow Homer Watercolors*, exh. cat.
(Washington, D.C.: National Gallery of Art, 1986), 177–79, fig. 168;
Nicolai Cikovsky Jr. and Franklin Kelly, *Winslow Homer*, exh. cat.
(Washington, D.C.: National Gallery of Art;
New Haven and London: Yale University Press, 1995), no. 162

————

Paul Rodman Mabury Collection, 39.12.11

———⊗∞⊗———

Homer was one of the finest American artists of the nineteenth century and certainly the greatest watercolorist of his age. His use of transparent washes of color to suggest the ever-changing reflective character of water is one of his trademark contributions to the art of the medium. In 1884 he moved to Prout's Neck, Maine, but often summered in the Adirondacks in upstate New York. Homer's watercolors based on the scenery and activities in the Adirondacks are considered among his most majestic and successful essays in the medium. *After the Hunt* illustrates well Homer's mastery in its evocation of the cool light and its reflections in the water of the lake. It is one of over thirty watercolors Homer executed in the Adirondacks during the summer and fall of 1892. He was a charter member since 1886 of the North Woods Club, a private preserve near Minerva, New York. *After the Hunt* shows a pair of guides in a boat after a particular form of deer hunting in which hounds would drive their quarry into a lake, where it would drown. This drawing, with its large figures arranged in a pyramidal composition, is among the noblest of the entire series. The two men have been variously identified as Adirondacks locals; the young man being possibly Michael "Farmer" Flynn or Wiley Gatchell while the bearded gentleman could be Orson Phelps, Rufus Wallace, or Harvey Holt.[1]

NOTE

1. Tatham, in "Trapper, Hunter, and Woodsman," suggests that the older guide may be a composite characterization, based on Rusty Wallace and Homer's Prout's Neck neighbor John Gatchell, whereas Cikovsky and Kelly, in *Winslow Homer*, identify the old mountaineer as Orson Phelps.

65

AUBREY BEARDSLEY
Brighton (England) 1872–1898 Menton
Enter Herodias, about 1893
Black ink
9 1/8 x 6 11/16 in. (23.2 x 17 cm)

PROVENANCE
John Lane, London; Baillie Gallery, London (1909); Else P. Hutchinson,
Schloss Weisstenstein; Hauswedell and Nolte, Hamburg, 8 June 1972, lot 132;
Robert M. Light, Boston; purchased by the museum in 1973

———

BIBLIOGRAPHY
Brian Reade, "Enter Herodias: Or, What Really Happened?"
Los Angeles County Museum of Art Bulletin 22 (1976), 58–65; Simon Wilson,
Beardsley (Oxford: Phaidon, 1976), 11, pl. 17;
Los Angeles County Museum of Art Handbook (Los Angeles: Los Angeles County Museum of Art,
1977), 110–11; Michael Gibson, *Le symbolisme* (Cologne: Taschen, 1994), 67

———

EXHIBITIONS
A Decade of Collecting, exh. cat. (Los Angeles: Los Angeles County Museum of Art, 1975), no. 96;
Late Nineteenth-Century Symbolism, exh. cat. (San Bernardino: Art Gallery of California
State College, 1980), 5 (illus.), no. 4; *Aubrey Beardsley, 1872–1898*, exh. cat.
(Tokyo: Isetan Museum of Art, 1983), no. 42; Davis, 39, no. 2

———

Graphic Arts Council Fund, M.73.49

———

Beardsley's career lasted only six years, as he died of consumption at the age of twenty-six. Nevertheless, he was one of the most gifted and original artists of the fin de siècle decadent movement. He was most prolific as a draftsman and illustrator, beginning in 1893 with *Morte d'Arthur*. His flat and highly decorative manner of drawing was indebted particularly to ancient Greek vase painting and Japanese prints.

This drawing was used in 1893 as the design for plate 5 in Beardsley's line-block illustrations to Oscar Wilde's play *Salome*, published by John Lane in London in 1894; Wilde is portrayed in the guise of a jester at the lower right, holding his manuscript. In the drawing's original form the male attendant standing at the right was depicted without the fig leaf covering his genitals. Proofs were printed of this illustration (of which two survive), but Lane rejected the image as too scandalous. Some time shortly thereafter Beardsley scraped off the offending detail and added the fig leaf. Reade's article on the drawing in the museum's *Bulletin* outlines the complicated history of this sheet.

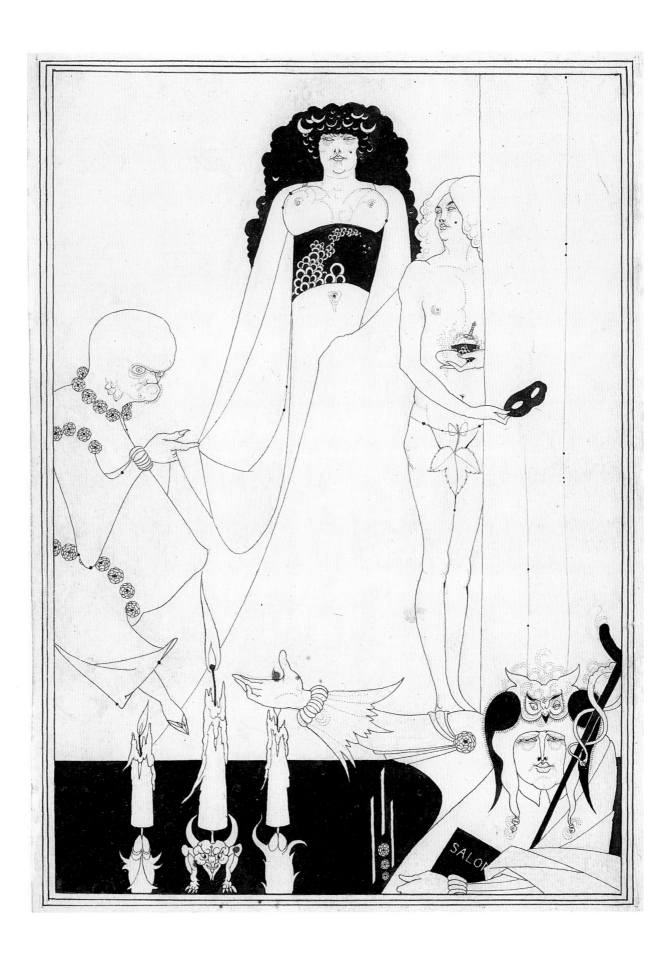

66

MARY CASSATT

Allegheny City (Pennsylvania) 1844–1926 Mesnil-Théibus (France)

Portrait of a Woman, about 1893

Graphite

11 ¼ x 8 ⅜ in. (28.6 x 21.3 cm)

PROVENANCE

Mary Cassatt/Mathilde X (Lugt Suppl. 2665a); purchased by the donor in the 1920s

BIBLIOGRAPHY

Adelyn Dohme Breeskin, *Mary Cassatt: A Catalogue Raisonné of the*
Oils, Pastels, Watercolors, and Drawings
(Washington, D.C.: Smithsonian Institution Press, 1970), 277,
no. 824; Feinblatt, 1970, n.p.

EXHIBITIONS

Galerie A.-M. Reitlinger, Paris, 1931, no. 77; *Mary Cassatt and Her Parisian Friends*, exh. cat.
(Pasadena: Pasadena Art Institute, 1951), no. 18;
Katherine Harper Mead, ed., *The Impressionists and the Salon (1874–1886)*, exh. cat.
(Riverside: Art Gallery, University of California, 1974), no. 12

Mr. and Mrs. William Preston Harrison Collection, 39.9.5

At the invitation in 1879 of her friend and mentor Edgar Degas, Cassatt was the only American painter included in the impressionist exhibitions. Unlike many other impressionists, Cassatt, like Degas, eschewed landscape as a subject in favor of the human figure. The intimacy and domesticity of mother and child was her favored theme.

This drawing, dated by Breeskin to about 1893, is not related to a painting by Cassatt. Whether or not this sketch is a portrait of a particular sitter or a drawing of a model from life is debatable, as Cassatt frequently made studies of unidentified figures in preparation for her paintings and pastels. Cassatt's focus on the face, with details of the torso delineated only sketchily, is typical and can be compared to her approach in many of her drypoints, such as *Portrait Sketch of Mme M...* of 1889, in which the figure wears a comparable black choker and a topknot of hair on her head and is depicted with a similar treatment of the bulbous tip of the nose.[1] The atmospheric and suggestive rendition of the figure is achieved by Cassatt's use of soft black chalk.

NOTE

1. Adelyn Dohme Breeskin, *Mary Cassatt: A Catalogue Raisonné of the Graphic Work* (Washington, D.C.: Smithsonian Institution Press, 1979), no. 114.

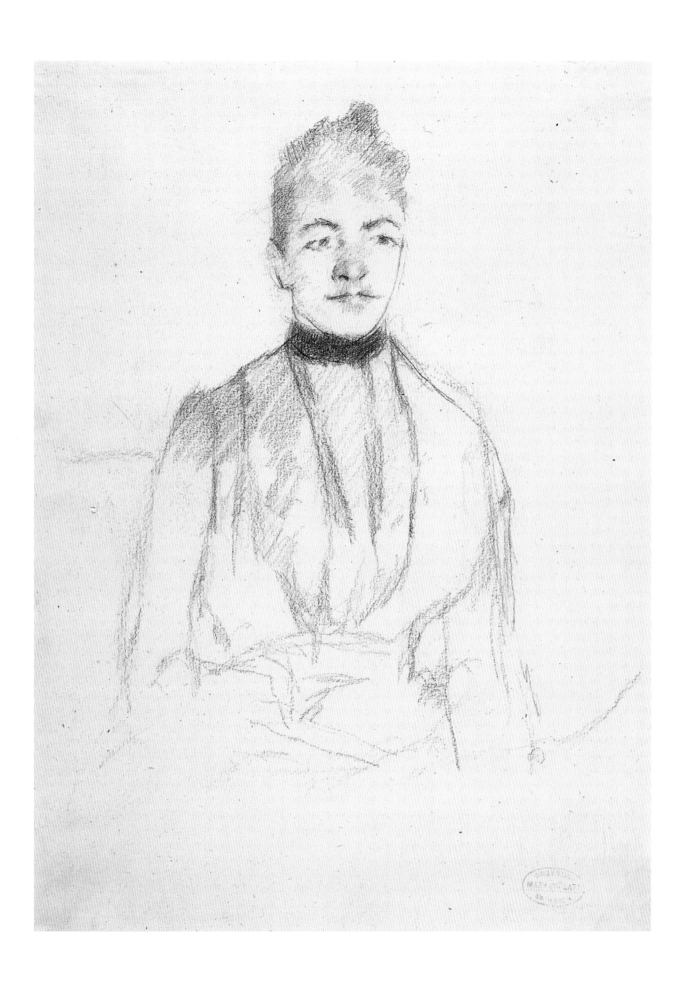

67

PAUL SIGNAC
Paris 1863–1935 Paris
Saint-Tropez: Evening Sun, 1894
Watercolor over traces of graphite
10 ⅝ x 8 ¼ in. (27 x 21 cm)

INSCRIPTION
LOWER RIGHT: PS/94

PROVENANCE
Galerie Henri Cottereau, Paris; Mr. and Mrs. William Preston Harrison

BIBLIOGRAPHY
Harrison, 1929, 36, no. 43; Peter A. Wick, "Some Drawings Related to Signac Prints,"
in Carl Zigrosser, ed., *Prints: Thirteen Illustrated Essays on the Art of the Print*
(New York: Holt, Rinehart and Winston, 1962), 90, fig. 8

EXHIBITIONS
Ebria Feinblatt, *Paul Signac: Watercolors and Paintings*, exh. cat.
(Los Angeles: Los Angeles County Museum of History, Science, and Art, 1954), no. 16; Peter A. Wick,
"Paul Signac Exhibition," *Bulletin of the Museum of Fine Arts, Boston* 52, no. 289 (1954): 70, no. 1;
From Delacroix to Cézanne: French Watercolor Landscapes of the Nineteenth Century, exh. cat.
(College Park: Art Gallery, University of Maryland, 1977), no. 69

Mr. and Mrs. William Preston Harrison Collection, 26.7.14

One of the principal results of the innovations of the impressionist painters in France was the movement known as neoimpressionism, also known as divisionism or pointillism because of the artists' scientific and systematic reduction of the rendition of their compositions to patterns of regularly applied dots and strokes of paint. Together with Georges Seurat, Signac was the leader of the neoimpressionists.

Saint-Tropez: Evening Sun is compositionally similar to three prints by Signac, two etchings of about 1896 and a color lithograph of about 1897–98.[1] In the lithograph Signac exploits the character of the medium through his use of the color separations to layer and superimpose the individual dabs of color. These spots of color are accumulated to define the forms, without much use of drawing.

The overall coloristic effect in the lithograph is soft and pastel-like. In Signac's drawing the colors are much stronger, with brilliant blues, oranges, and reds dominating the composition. The forms are also defined with staccato strokes applied with a reed pen, a technique Signac may have picked up from Vincent van Gogh, whom Signac visited in Arles in 1889. The museum's drawing is comparable in this manner of draftsmanship to an earlier color lithograph by Signac (executed the same year as the drawing), *Saint-Tropez II*,[2] particularly in the rendition of the reflective water in the foreground of the drawing and the grass and shadows in the foreground of the lithograph, as well as to another watercolor view of the harbor at Saint-Tropez dated 1895.[3]

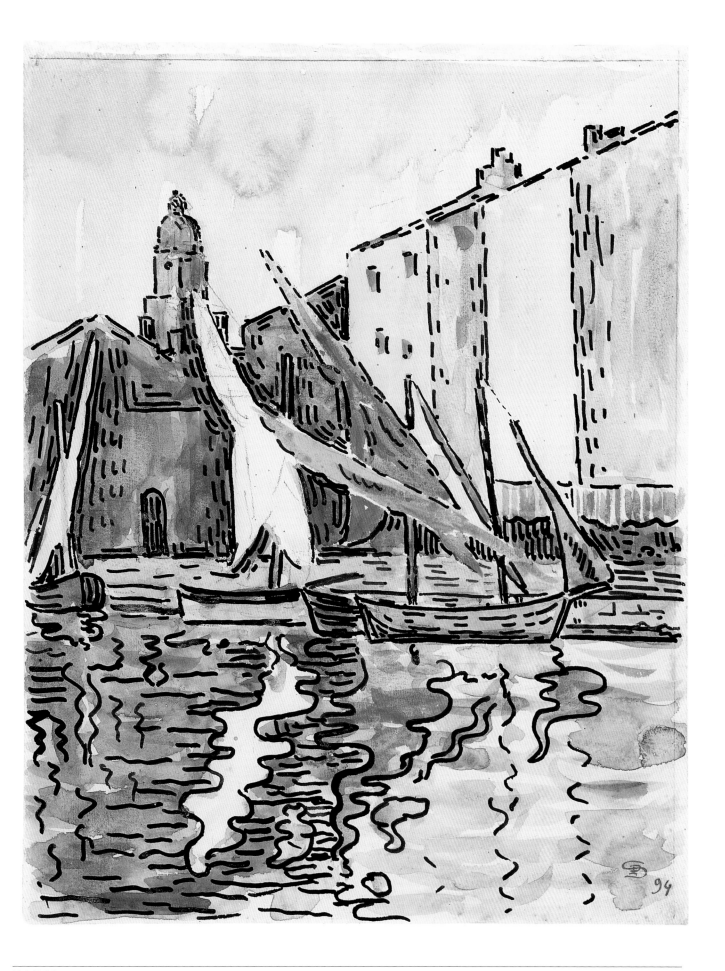

NOTES

1. E. W. Kornfeld and P. A. Wick, *Catalogue raisonné de l'oeuvre gravé et lithographié de Paul Signac* (Bern: Éditions Kornfeld et Klipstein, 1974), nos. 17–19.

2. Ibid., no. 6.

3. George Besson, *Signac dessins* (Paris: Les Éditions Braun et Cie, 1950), pl. 1.

PABLO PICASSO

Malaga (Spain) 1881–1973 Mougins (France)
Café-Concert, about 1901
Varnished pastel
8 3/8 x 10 3/8 in. (21.3 x 26.4 cm)

INSCRIPTION
LOWER LEFT: P Ruiz Picasso

———

PROVENANCE
M. Knoedler and Co., New York; Diane Esmond, Paris; William Beadleston, New York;
Fernando Garcia, Guerata, Mexico; purchased by the donor in 1981

———

BIBLIOGRAPHY
Alexandre Cirici, *Picasso antes de'Picasso* (Barcelona: Iberia, 1946), pl. 23; Christian Zervos,
Pablo Picasso (Paris: Cahiers d'Art, 1954), 6: 41, pl. 337; Pierre Daix and Georges Boudaille,
Picasso: The Blue and Rose Periods. A Catalogue Raisonné of the Paintings, 1900–1906
(Greenwich, Conn.: New York Graphic Society, 1967), 342, no. A.9

———

EXHIBITIONS
Picasso: Dessins et aquarelles 1899–1965, exh. cat. (Paris: Galerie Knoedler, 1966), no. 9;
Maurice Tuchman, *The Wolper Picassos*, exh. cat.
(Los Angeles: Los Angeles County Museum of Art, 1984), no. 34

———

Gift of Mr. and Mrs. David L. Wolper, M.83.204.1

———

Picasso is generally considered the most influential artist of the twentieth century; he was certainly one of the most prolific, producing thousands of paintings, drawings, prints, and sculptures in a dazzling variety of styles. A child prodigy, Picasso was accepted at the School of Fine Arts in Barcelona at the age of fourteen; he moved permanently to France in 1904. He is probably most closely associated with cubism, which he developed together with Georges Braque. He went through a number of stylistic phases thereafter, including neoclassicism, surrealism, and expressionism.

Picasso left Spain in 1900 for Paris, where he spent the year frequenting cafés and dance halls. After a few months he was back in Spain by 1901. While Picasso was in Paris, he was particularly struck by the same air of decadent pleasure that inhabits Henri de Toulouse-Lautrec's pictures of Parisian nightlife. One of Picasso's best works from this period is *The'Moulin de'la Galette* of 1900 in the Guggenheim Museum, New York.[1] *Café-Concert* is in the same vein, though it was executed after Picasso's return to Spain, in either Malaga or Madrid. The sad specter of the couple huddled over their drinks is in the tradition of well-known Parisian scenes by Edgar Degas (*L'absinthe* of about 1876, Musée d'Orsay, Paris) and Toulouse-Lautrec (*À la mie* of 1891, Museum of Fine Arts, Boston). The scene is similar to another pastel by Picasso executed in 1901 in Madrid, *In the Café* in the Masoliver collection, Barcelona.[2] In the right background of both pastels one can see an empty chair and a guitar, presumably where the musical entertainment took place.

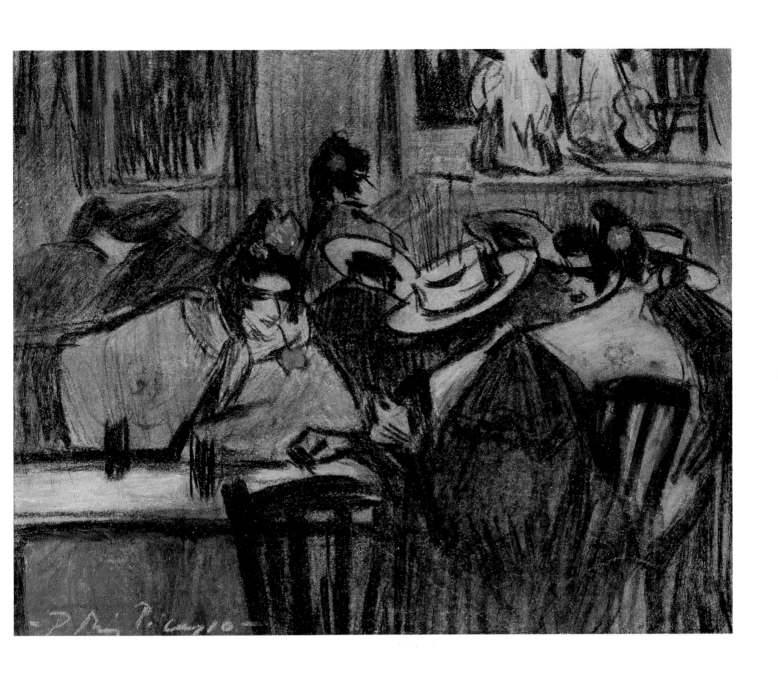

NOTES

1. Daix and Boudaille, *Picasso*, no. II.10 (illus. in color, p. 29).

2. Ibid., 137, no. D.III.7.

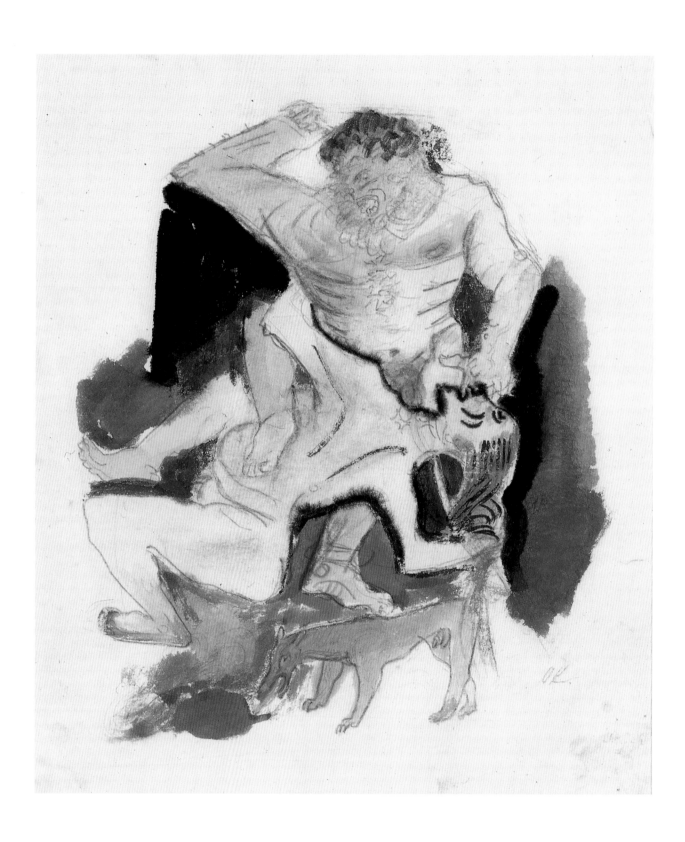

69

OSKAR KOKOSCHKA
Pöchlarn (Austria) 1886–1980 Villeneuve (Switzerland)
Illustration to "Mörder, Hoffnung der Frauen" ("Murderer, hope of women"), about 1908–9
Graphite, ink, and watercolor
12 ⅛ x 10 ⅛ in. (30.8 x 25.7 cm)

INSCRIPTION

LOWER RIGHT: OK

———

PROVENANCE

Karl and Faber, Munich, 12 November 1980, lot 1456, purchased by Robert Gore Rifkind

———

BIBLIOGRAPHY

Ernest Rathenau, *Oskar Kokoschka: Handzeichnungen, 1906–1969*
(New York: Ernest Rathenau, 1971), 13, pl. 23; Ivan Fenjö, *OK: Die frühe Graphik*
(Vienna: Euroart, 1976), 57, pl. 36; Robert Gore Rifkind, "A Conversation with Kokoschka
at Ninety-Two" in *German Expressionist Prints and Drawings: The Robert Gore Rifkind
Center for German Expressionist Studies. Volume One: Essays*
(Los Angeles: Los Angeles County Museum of Art; Munich: Prestel-Verlag, 1989),
169, fig. 223; Bruce Davis, *German Expressionist Prints and Drawings:
The Robert Gore Rifkind Center for German Expressionist Studies. Volume Two:
Catalogue of the Collection* (Los Angeles: Los Angeles County Museum of Art;
Munich: Prestel-Verlag, 1989), 436, no. 1559

———

EXHIBITIONS

Herschel B. Chipp, *The Human Image in German Expressionist Graphic Art
from the Robert Gore Rifkind Foundation*, exh. cat.
(Berkeley: University Art Museum, University of California, 1981), no. 70;
Peter Vergo, *Vienna 1900*, exh. cat.
(Edinburgh: National Museum of Antiquities of Scotland, 1983), no. 3.65, pl. 24;
Richard Calvocoressi, *Oskar Kokoschka, 1886–1980*, exh. cat.
(New York: Solomon R. Guggenheim Museum, 1986), no. 104;
Kirk Varnedoe, *Vienna 1900: Art, Architecture, and Design*, exh. cat.
(New York: Museum of Modern Art, 1986), 214; Alice Strobl and Alfred Weidinger,
Oskar Kokoschka. Das Frühwerk 1898–1917. Zeichnungen und Aquarell, exh. cat.
(Vienna: Graphische Sammlung Albertina, 1994), 20, no. 66

———

The Robert Gore Rifkind Center for German Expressionist Studies, M.82.287.85

Kokoschka received his earliest training in 1905 at the Kunstgewerbeschule in Vienna, where he studied with Berthold Löffler and Carl Otto Czeschka and was immersed in the Jugendstil manner associated with the Wiener Werkstätte. He was in Berlin from 1910 to 1911 at the invitation of Herwarth Walden, owner of the art gallery Der Sturm. During World War 1 he enlisted in the army but was badly injured and released; he then moved to Dresden where he taught at the Akademie. From 1910 to 1931 he received an annual salary from Berlin gallery owner Paul Cassirer. After the rise of the Nazis, he fled to London in 1938 and became a British citizen. In 1953 he moved to Geneva.

Apart from his career as a painter and graphic artist, Kokoschka was also a significant contributor to the development of expressionist theater. About 1907 Kokoschka wrote the play *Mörder, Hoffnung der Frauen*, for which this drawing is an illustration. Using archetypal characters named Man and Woman, the play explored Kokoschka's own tempestuous relations with women, illustrated by the brutal violence of this composition; its horrific character is epitomized by Kokoschka's suggestion of blood through the use of red watercolor, at which the small dog appears to be lapping. The drawing has been dated to about 1908–9, predating the illustrations drawn in black ink which were reproduced in the periodical *Der Sturm* in 1910.[1]

NOTE

1. The drawing illustrating this scene of Man stabbing Woman is in the Staatsgalerie Stuttgart. For it and others reproduced in *Der Sturm*, see Strobl and Weidinger, *Kokoschka*, nos. 88–91.

70

JOHN SINGER SARGENT
Florence 1856–1925 London
RoseᴗMarieᴗ Ormond Reading in a Cashmereᴗ Shawl, about 1908–12
Watercolor, gouache, and charcoal
14 ¹⁄₁₆ x 20 ¹⁄₁₆ in. (35.7 x 51 cm)

INSCRIPTION
UPPER RIGHT: To my friend Pegram—John S. Sargent

———

PROVENANCE
Henry Alfred Pegram, London (to 1937); P. G. Browne, London, by descent;
his sale, Sotheby's, London, 26 April 1972, lot 20; M. R. Schweitzer Gallery, New York;
purchased by the museum in 1972

———

BIBLIOGRAPHY
"Recent Accessions of American and Canadian Museums,"
Art Quarterly 36 (1973): 128; "Recent Acquisitions, Fall 1969–Spring 1973,"
Los Angeles County Museum of Art Bulletin 19, no. 2 (1973): 42, fig. 19; "La chronique des arts,"
Gazetteᴗdes Beaux Arts 6th ser., 81 (February 1973): fig. 576, suppl. 164; "Permanent Collection,"
Los Angeles County Museum of Art Report 1969–1973 (as *Los Angeles County Museum of Art Bulletin*
20, no. 1 [1974]: 19); Donelson F. Hoopes, *American Watercolor Painting* (New York: Watson-Guptill,
1977), 66, 122, pl. 26; *John Singer Sargent, His Own Work*, exh. cat.
(New York: Coe Kerr Gallery; Wittenborn, 1980), n.p.; Fort and Quick, 446–47

———

EXHIBITION
Exhibition of Works by the LateᴗJohn Singer Sargent, R.A., exh. cat.
(London: Royal Academy of Arts, 1926), no. 112

———

Gift of the Art Museum Council, M.72.52

———

Sargent was born to American parents from Philadelphia but spent most of his life in Europe. He was trained in 1873–74 at the Accademia di Belle Arti in Florence, and until the end of World War I he spent much of his career in Italy, traveling to Capri, Rome, Florence, Siena, and especially Venice.[1] He spent his last decade on commissions for murals; he did not travel to Italy again.

Sargent was a virtuoso as both a painter and a watercolorist. He frequently turned to the creation of watercolors as a break from the more grand and studied flavor of his oil paintings (portraits, landscapes, and genre scenes), even though the themes often overlapped. The presentation of the watercolors, however, tends to be more informal, spontaneous, and intimate. In this portrait Sargent achieves an astonishingly rich visual interplay through the overlay of different degrees of opacity in the watercolor and gouache, allowing the white of the paper to serve as a middle tone. The creamy colors of the fabric are contrasted with the angular and brilliant accents of the cashmere shawl. This kind of informal and intimate portraiture was a favorite form of expression for Sargent after 1907, when he tired of his career as the pre-

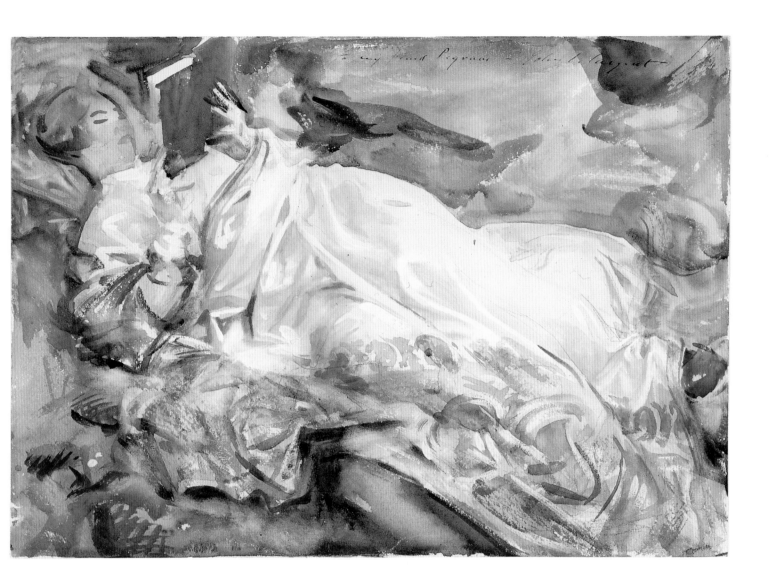

mier portraitist of the age; the museum's drawing has been dated to about 1908–12.

The subject is Rose-Marie Ormond, daughter of Sargent's sister Violet. During these years Sargent traveled frequently to Switzerland with his sister and her family. Rose-Marie is the subject of many works, includ-

ing the famous painting *Repose* in the National Gallery of Art, in which she is likewise portrayed in a casual and sensuous pose, wrapped in a colorful shawl and dressed in flowing white garment.[2] Another watercolor portrait of Rose-Marie dressed in similar garments is in the Museum of Fine Arts, Boston.[3]

NOTES

1. For Sargent in Italy, see Theodore E. Stebbins Jr., *The Lure of Italy: American Artists and the Italian Experience, 1760–1914*, exh. cat. (Boston: Museum of Fine Arts, 1992), passim.

2. Trevor Fairbrother, *John Singer Sargent* (New York: Harry N. Abrams, Inc., 1994), 103.

3. Sue Welsh Reed and Carol Troyen, *Awash in Color: Homer, Sargent, and the Great American Watercolor*, exh. cat. (Boston: Museum of Fine Arts, 1993), no. 81.

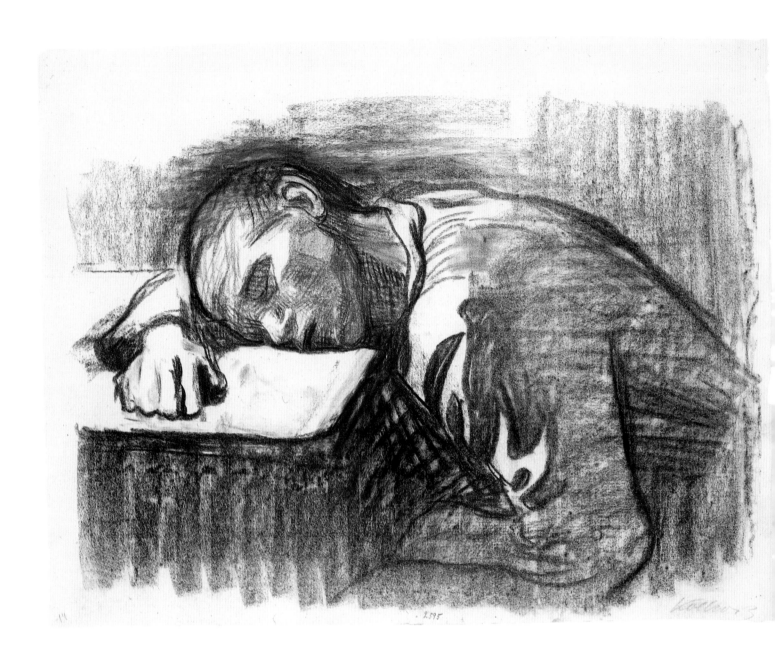

71

KÄTHE KOLLWITZ

Königsberg (Germany) 1867–1945 Moritzburg

Home Worker, Asleep at the Table, 1909

Charcoal

16 x 22 in. (40.6 x 55.9 cm)

INSCRIPTIONS

LOWER LEFT: 14; LOWER RIGHT: Kollwitz

PROVENANCE

Paul Cassirer Gallery, Berlin (1917); Helen Täubler, Berlin and New York (1917–40);
Galerie St. Etienne, New York; Shapiro collection, New York; A. C. Schnee (1946);
Dr. Thelma Moss, Los Angeles, by descent; purchased by the museum in 1969

BIBLIOGRAPHY

Der Weltspiegel, no. 32 (1917): 2; Otto Nagel, *Käthe Kollwitz: Die Handzeichnungen*
(Berlin: Henschelverlag Kunst und Gesellschaft, 1972), 284, no. 499; Joseph A. Gatto,
Emphasis: A Design Principle (Worcester: Davis Publishing, 1975), 23;
Los Angeles County Museum of Art Handbook (Los Angeles: Los Angeles County Museum of Art,
1977), 115–16; Nathan Goldstein, *The Art of Responsive Drawing*, 3d ed. (Englewood Cliffs, N.J.:
Prentice-Hall, 1984), 288, fig. 9.32; Elizabeth Prelinger, *Käthe Kollwitz*, exh. cat.
(Washington, D.C.: National Gallery of Art, 1992), 128, fig. 14, 135 n. 49

EXHIBITIONS

Paul Cassirer, *Käthe Kollwitz: Sonder-Ausstellung zu ihrem 50. Geburtstag*, exh. cat. (Berlin: Paul Cassirer
Gallery, 1917), no. 111; Ann Sutherland Harris and Linda Nochlin, *Women Artists, 1550–1950*,
exh. cat. (Los Angeles: Los Angeles County Museum of Art, 1976), no. 106

Graphic Arts Council Fund, M.69.69

Kollwitz's tragic life and its reflection in the deeply felt humanity of her art have made her one of the most revered artists of the twentieth century. She first studied art in 1881–82 with the engraver Rudolf Maurer and later with Karl Stauffer-Bern. Her first graphic cycle was *A Weavers' Rebellion* of 1893–98. Its socially conscious theme was followed in 1902–8 with the series *Peasants' War*. Other notable sets included *War* (1923) and *Death* (1937). Their themes reflected Kollwitz's personal tragedies—her son was killed in World War I and her grandson in World War II. In 1928 she became head of the graphic arts division at the Prussian Academy of Art,

a position from which the Nazis forced her to resign in 1933.

Because of the success of the *Weavers* and *Peasants* cycles, Kollwitz was commissioned by the Munich periodical *Simplicissimus* to provide drawings for reproduction. Between 1903 and 1911 Kollwitz made several drawings of workers entitled *Portraits of Misery*. *Home Worker* depicts a woman who has collapsed from exhaustion in the midst of her sewing job. It is a final study for the finished drawing now in the Kunsthalle in Bremen, reproduced in *Simplicissimus*, November 1, 1909.

72

GEORGES BRAQUE

Argenteuil-sur-Seine (France) 1882–1963 Paris

Glass and Playing Cards, about 1912

Charcoal and *papier collé*

11 5/8 x 18 1/8 in. (29.5 x 46 cm)

INSCRIPTION

LOWER LEFT: G Braque

———

PROVENANCE

Henry Kahnweiler, Paris; his sale, Hôtel Drouot, Paris, 7–8 May 1923, lot 19;

André Lhote, Paris; Galerie Pierre, Paris; purchased by the donor in 1926

———

BIBLIOGRAPHY

Harrison, 1929, 38, no. 66; Henry Radford Hope, *Georges Braque,* exh. cat.

(New York: Museum of Modern Art, 1949), 62–64; Janet Flanner, *Men and Monuments*

(New York: Harper, 1957), 148; Harriet Janis and Rudi Blesh, *Collage: Personalities, Concepts, Techniques*

(Philadelphia and New York: Chilton Co., Book Division, 1962), 15; Feinblatt, 1970, n.p.;

Massimo Carrà, *L'opera completa di Braque (1908–1929)* (Milan: Rizzoli Editore, 1971), 90, no. 95;

Charlotte Buel Johnson, *Contemporary Art: Exploring Its Roots and Development* (Worcester: Davis

Publications, 1973), 19, fig. 10; Nicole Mangin (Worms de Romilly) and Jean Laude, *Catalogue de*

l'oeuvre de Georges Braque, peintures 1908–1915 (Paris: Éditions Maeght, 1982), 187, no. 166

———

EXHIBITIONS

L'art vivant en Europe, exh. cat. (Brussels: Palais des Beaux Arts, 1931); Douglas Cooper,

The Cubist Epoch, exh. cat. (Los Angeles: Los Angeles County Museum of Art, 1970), 184, 278, no. 36;

Isabelle Monod-Fontaine and E. A. Carmean Jr., *Georges Braque: The Papiers Collés,* exh. cat.

(Washington, D.C.: National Gallery of Art, 1982), no. 10 (no. 5 in French edition of catalogue)

———

Mr. and Mrs. William Preston Harrison Collection, 31.12.2

———

Braque went to Paris in 1902 and attended the Académie Humbert and later the atelier of painter Léon Bonnat. He reacted strongly and positively to the exhibition of fauves at the Salon d'Autumne in 1905 and worked in a brilliantly colored expressionist manner until 1908, when he began to incorporate into his art cubist elements that he adopted from Paul Cézanne. Together with Pablo Picasso, Braque was central to the development of cubism, collage, and *papier collé* in the twentieth century.

Glass and Playing Cards traditionally has been dated to 1912, the year Braque invented *papier collé.* He spent the summer and fall of that year in Sorgues, a suburb of Avignon in southern France. He made his first *papier collé* in September, *Fruit Dish and Glass* in a private collection.[1] While Picasso was away for a short time in Paris, Braque went to Avignon and bought a roll of *faux bois* (imitation wood-grain) paper that he cut and pasted onto sheets of paper, incorporating these rectangular forms into compo-

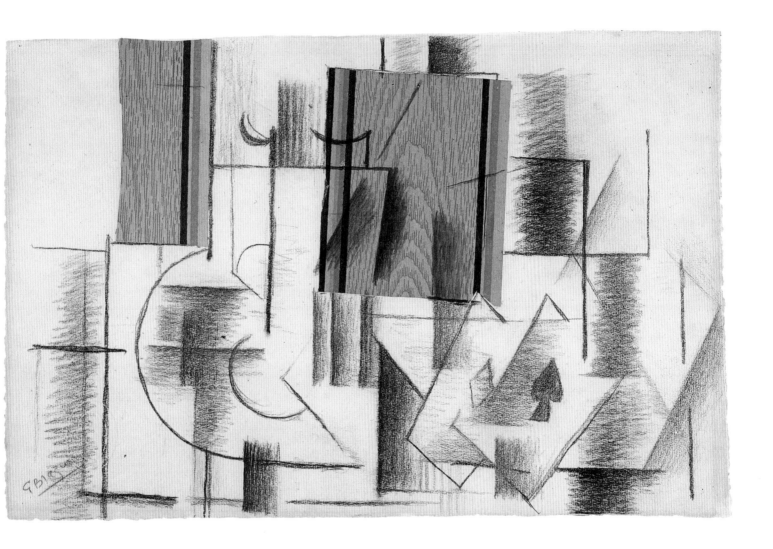

sitions such as *Glass and Playing Cards*. The wood-grain and thick dark lines that suggest molding are evident in these sheets of pasted paper. Indeed, forty-six of Braque's fifty-seven *papiers collés* employ portions of this *faux bois*.

Mangin and Laude have dated *Glass and Playing Cards* to 1913. While it is true that iconographic details such as the ace of spades did not appear in Braque's works until 1913 (like the small oval drawing *The Ace of Spades* in a private collection),[2] the style of the Los Angeles drawing argues for dating the drawing to 1912. The earlier *papiers collés* tend to be simpler in their delineation of forms, and the pieces of pasted paper are regularly rectangular, as here.

NOTES

1. Monod-Fontaine and Carmean, *Braque*, 88–89, no. 1.
2. Ibid., no. 18.

73

ANDRÉ DERAIN

Chatou (France) 1880–1954 Garches

Head of a Woman, about 1913

Watercolor, brown ink, and wash

20 x 16 in. (50.8 x 40.6 cm)

PROVENANCE

André Lhote, Paris; purchased by the donor in 1926

———

BIBLIOGRAPHY

Harrison, 1929, 37, no. 53

———

Mr. and Mrs. William Preston Harrison Collection, 38.17.3

⟨⟩

Derain studied with Eugène Carrière at the Académie Camillo, where he met Henri Matisse, Albert Marquet, Georges Rouault, and his lifelong friend Maurice de Vlaminck. In 1905 he worked with Matisse at the Mediterranean port of Collioure, where they created wildly colored and brushily painted fauve landscapes. By 1908, however, Derain was influenced by cubism, the other great early-twentieth-century development in French art; but after the radical innovations of his early fauve and cubist periods, Derain's art became progressively more conservative.

The masklike treatment of the woman's head clearly reflects the incorporation of elements of "primitivism" into early modern art, particularly as seen in African masks. About 1906 Derain's friend Vlaminck was among the first Parisian artists to discover the expressive and formal qualities of African art.[1] Shortly thereafter Derain bought a Fang mask from Vlaminck and hung it in his studio.[2] This drawing is especially close to the masklike form of a drypoint by Derain, *Head of a Woman*, in the shading of the eye sockets, the hatching on the cheeks and forehead, and the long, thin nose. Adhémar dated the print to about 1910,[3] whereas more recently the dating has varied from 1908[4] to about 1913–14.[5] A date of about 1913 seems convincing for both the print and the drawing.

NOTES

1. The traditional account of Vlaminck's "discovery" is given in Robert Goldwater, *Primitivism in Modern Art*, rev. ed. (New York: Vintage Books, 1967), 86–87. With the dates given here, see Jack D. Flam, "Matisse and the Fauves," in William Rubin, ed., *Primitivism in Twentieth-Century Art: Affinity of the Tribal and the Modern*, exh. cat. (New York: Museum of Modern Art, 1984), 1: 213–15.

2. It is now in the Centre Georges Pompidou in Paris; see Rubin, *Primitivism*, 1: 213.

3. Jean Adhémar, *Derain*, exh. cat. (Paris: Bibliothèque Nationale, 1955), no. 37.

4. *André Derain: Le peintre du "trouble moderne,"* exh. cat. (Paris: Musée d'Art Moderne de la Ville de Paris, 1994), fig. 349.

5. Jane Lee, "The Prints of André Derain," *Print Quarterly* 7, no. 1 (1990): 42–43, fig. 40.

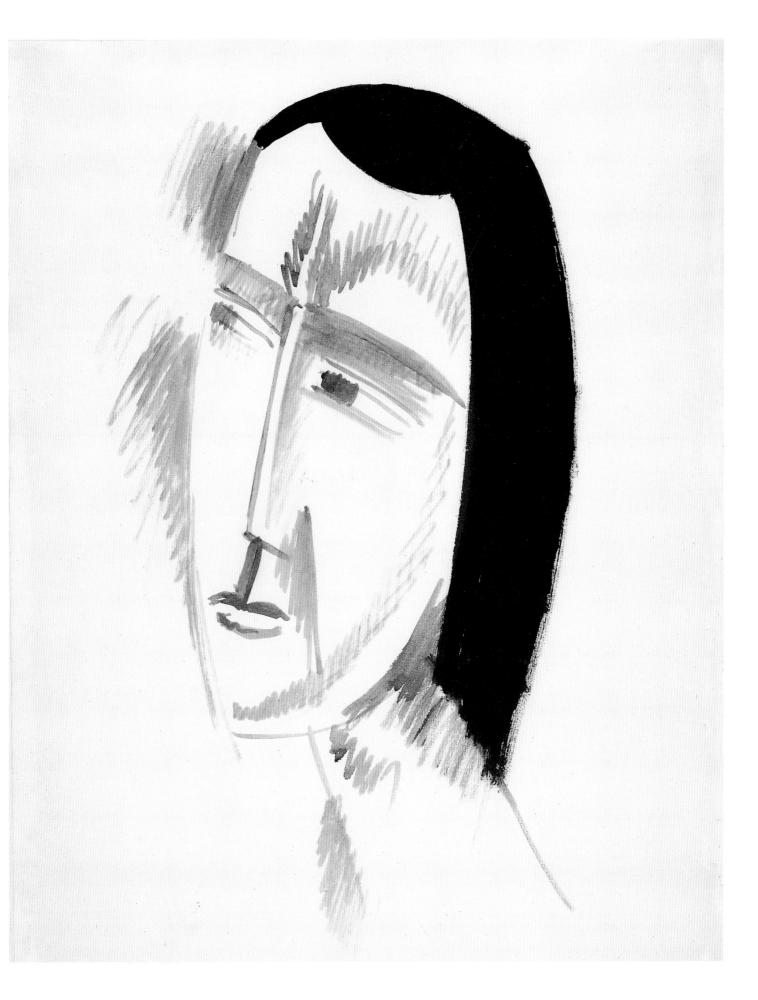

74

ODILON REDON

Bordeaux (France) 1840–1916 Paris

Vase of Flowers—Large Composition, about 1913

Pastel

28 ¾ x 25 ¾ in. (73 x 65.4 cm)

INSCRIPTION

LOWER LEFT: Odilon Redon

———

PROVENANCE

Georges Bénard, Paris; Jacques Seligmann and Co., New York;

Mr. and Mrs. George Gard De Sylva

———

BIBLIOGRAPHY

Vanity Fair's Portfolio of Modern French Art (New York: Condé Nast Publications, 1935): 44; Arthur

Millier, "De Sylva Collection Enriches Los Angeles," *Art Digest* (October 15, 1946): 13;

Aline B. Louchheim, "Today's Collectors. Buddy De Sylva: Gift to Hollywood," *Art News* 45, no. 7

(September 1946): 30, 33; Feinblatt, 1970, n.p. (cover)

———

EXHIBITIONS

Courbet-Seurat, exh. cat. (New York: Jacques Seligmann and Co., 1937), no. 12;

Loan Exhibition of Masterpieces of Painting, exh. cat. (Montreal: Musée des Beaux-Arts, 1942), no. 71;

The George Gard De Sylva Collection, exh. cat.

(Los Angeles: Los Angeles County Museum of History, Science, and Art, 1950), 39

———

Gift of Mr. and Mrs. George Gard De Sylva, M.46.3.1

———

Redon received haphazard training as an artist, the most influential element being the enigmatic works of Rodolphe Bresdin, who worked in isolation in Bordeaux and later Paris and served as Redon's mentor and adviser. Redon began making atmospheric and provocative charcoal drawings in the 1870s and took up lithography in 1879. One of the lasting tributes to him was made by Joris-Karl Huysmans, who used Redon's work to "decorate" his symbolist novel *À Rebours* of 1884. Redon's dreamlike and visionary drawings and lithographs made him the key artistic figure in late-nineteenth-century French symbolism. By 1899, however, Redon's preferred media were oils or pastels in color. It was his flower pieces that eventually brought him considerable fame. He had the most works in the Armory Show in 1913, a total of seventy-four paintings, pastels, drawings, and prints.

Redon's flower pieces from the early twentieth century fall into two groups: naturalistic representations and more visionary evocations. The museum's pastel, executed about 1913, falls into the latter category, in which pensive figures seem to be lost in thought, as though meditating on nature, as represented by the bouquets of

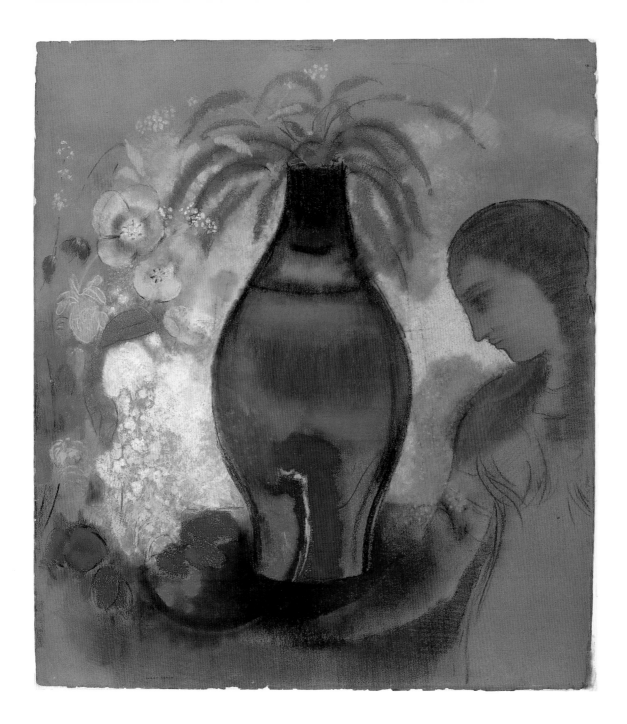

flowers. This drawing's juxtaposition of flowers with a contemplative figure in profile appears in other works by Redon from this period, such as *The Window*, a pastel of about 1907 in the Kunsthaus, Zurich,[1] and *Black Profile (Gauguin)*, a painting of about 1906 in the Musée d'Orsay, Paris.[2]

One of the most striking elements of the museum's pastel is Redon's radiant rendition of the brilliantly multi-

colored vase. He was interested in the handcrafted vases that rose to artistic prominence in the decorative arts revival that occurred at the turn of the century, including those of such masters as Eugène Grasset, René Lalique, and Louis Comfort Tiffany. Gloria Groom has noted the resemblance of several vases in Redon's flower pieces to the colorful drip-glazed stoneware produced at that time.[3]

NOTES

1. Gloria Groom, "The Late Work," in Douglas W. Druick et al., *Odilon Redon: Prince of Dreams, 1840–1916*, exh. cat. (Chicago: Art Institute of Chicago, 1994), 286, fig. 33.

2. Ibid., 299, fig. 43. For other examples, see John Rewald, *Odilon Redon/Gustave Moreau/Rodolphe Bresdin*, exh. cat. (New York: Museum of Modern Art, 1961), 67–73.

3. Groom, "The Late Work," 321–22.

75

L U D W I G M E I D N E R

Bernstadt (Germany) 1884–1966 Darmstadt

Wannsee Train Station, 1913

Black ink, heightened with white

18 ¼ x 23 ¼ in. (46.4 x 59.1 cm)

INSCRIPTION

LOWER RIGHT: L Meidner/Mai 1913

PROVENANCE

Hammelsbeck, Cologne; Galerie Thomas Borgmann, Cologne; Robert Gore Rifkind (1979)

BIBLIOGRAPHY

Thomas Grochowiak, *Ludwig Meidner* (Recklinghausen: Verlag Aurel Bongers, 1966), 240, no. 176;
Helmut Goettl, ed., *Karl Hubbuch 1891–1979*, exh. cat. (Karlsruhe: Badischer Kunstverein, 1981), 84:
Hermann Glaser, *Die Kultur der wilhelminischen Zeit: Topographie einer Epoche* (Frankfurt: S. Fischer
Verlag, 1984), 307; Hermann Glaser, Jackob Lehmann, and Arno Lubos, *Wege der deutschen Literatur:
Eine geschichtliche Darstellung* (Berlin: Ullstein/Propylaen, 1986), 352–53; Victor Carlson, "The
German Expressionist Vision," Apollo 124 (November 1986): 54; Bruce Davis, *German Expressionist
Prints and Drawings: The Robert Gore Rifkind Center for German Expressionist Studies. Volume Two:
Catalogue of the Collection* (Los Angeles: Los Angeles County Museum of Art, 1989), 526, no. 1917

EXHIBITIONS

Eberhard Roters and Bernhard Schulz, eds., *Ich und die Stadt: Mensch und Grossstadt in der
deutschen Kunst des 20. Jahrhunderts*, exh. cat. (Berlin: Berlinische Galerie, 1987), no. 139;
Carol Eliel, *The Apocalyptic Landscapes of Ludwig Meidner*, exh. cat. (Los Angeles: Los Angeles
County Museum of Art, 1989), no. 13; Gerda Breuer and Ines Wagemann, *Ludwig Meidner: Zeichner,
Maler, Literat, 1884–1966*, exh. cat. (Darmstadt: Mathildenhöhe Institut, 1991), in exh. but not in cat.;
Timothy O. Benson et al., *Expressionist Utopias: Paradise, Metropolis, Architectural Fantasy*, exh. cat.
(Los Angeles: Los Angeles County Museum of Art, 1993), no. 134, fig. 90

The Robert Gore Rifkind Center for German Expressionist Studies, M.82.287.86

Meidner first studied in 1903–5 at the Kunstschule in Breslau, followed by study at the Académie Julian in Paris in 1906–7; he then moved to Berlin. He established his familiar style about 1912, after viewing an exhibition of futurism at Galerie Der Sturm in Berlin; shortly afterward he exhibited at the gallery with Richard Janthur and Jakob Steinhardt as the artists' group Die Pathetiker. His style and subjects can be described as apocalyptic, with compositions punctuated by images of earthquakes, burning cities, and other cataclysmic events.[1] After serving in World War I, he was supported by dealers Paul Cassirer and J. B. Neumann. He fled Germany in 1938 but returned in 1952.

The fiercely energetic character of Meidner's view of the Wannsee train station in Potsdam shares with contemporary Italian futurism its emphasis on speed, move-

ment, and dynamism in an urban setting. Meidner conveys these qualities through sharply converging diagonals and the manner in which the ink strokes seem to have been applied in a frenzy of speed. The starlike explosions in the sky also activate the scene. Carol Eliel has compared Meidner's repeating strokes conveying movement to this device in Giacomo Balla's *Dynamism of a Dog on a Leash* of 1912 in the Albright-Knox Gallery, Buffalo.[2] Balla's painting was exhibited in Berlin in 1913.

NOTES

1. For a discussion of Meidner's apocalyptic series as illustrations of the psychic anguish in prewar Europe, see Richard Cork, *A Bitter Truth: Avant-Garde Art and the Great War* (New Haven and London: Yale University Press, 1994), 13–16.

2. Eliel, *Meidner*, 36–37.

76

MAURICE PRENDERGAST
Saint John's (Newfoundland) 1858–1924 New York
Decorative Composition, about 1913–15
Watercolor
13 ½ x 20 in. (34.3 x 50.8 cm)

INSCRIPTION

LOWER CENTER: Prendergast

———

PROVENANCE

Carroll Galleries, New York (1915); John Quinn, New York (1915–24); his estate (1924–27);
his estate sale, American Art Association Galleries, New York, 11 February 1927, lot 433;
C. W. Kraushaar Galleries, New York (1927); purchased by the donor in 1927

———

BIBLIOGRAPHY

John Quinn, 1870–1925: Collection of Paintings, Watercolors, Drawings, and Sculpture
(Huntington, N.Y.: Pidgeon Hill, 1926), 25; Harrison, 1934, 65–66;
Winifred Haines Higgins, "Art Collecting in the Los Angeles Area, 1910–1960"
(Ph.D. diss., University of California, Los Angeles, 1963), 61, no. 114;
"The Noble Buyer": John Quinn, Patron of the Avant-Garde, exh. cat. (Washington, D.C.:
Hirshhorn Museum and Sculpture Garden, 1978), 179; Carol Clark, Nancy Mowll Mathews, and
Wendy Owens, *Maurice Brazil Prendergast/Charles Prendergast: A Catalogue Raisonné*
(Williamstown, Mass.: Williams College Museum of Art; Munich: Prestel Verlag, 1990),
498, no. 1173; Ross Anderson, "Charles Prendergast," in ibid., 85; Fort and Quick, 448–49

———

EXHIBITIONS

Maurice B. Prendergast: Paintings in Oil and Watercolors
(New York: Carroll Galleries, 1915), no. 55; Larry Curry, *American Pastels and Watercolors:
Selections from the Mr. and Mrs. William Preston Harrison Collection*, exh. cat.
(Los Angeles: Los Angeles County Museum of Art, 1969), no. 12;
Eleanor Green and Jeffrey Hayes, *Maurice Prendergast*,
exh. cat. (College Park: Art Gallery, University of Maryland, 1976), no. 70;
Two Hundred Years of American Painting, exh. cat. (Fresno: Fresno Arts Center, 1977), no. 39;
Nancy Mowll Mathews, *Maurice Prendergast*, exh. cat.
(Williamstown, Mass.: Williams College Museum of Art, 1990), 35, 188, no. 98

———

Mr. and Mrs. William Preston Harrison Collection, 31.12.1

———

Prendergast was born in Saint John's, Newfoundland; his family moved to Boston when he was ten years old. In 1891 he and his brother Charles went to Paris, where Prendergast attended classes at the Atelier Colarossi and the Académie Julian. In 1898–99 he was in Venice and produced some of his most sparkling and brilliant watercolors, following the tradition of foreign artists like J. M. W. Turner, James Abbott McNeill Whistler, and John Singer Sargent in his fervent reaction to Venice's exotic allure. He became the most significant postimpressionist American artist, certainly the most "French" (in his response to the art of Paul Cézanne, the Nabis, and the fauves) of the group of painters known as the Eight.

In 1914 Prendergast went to Europe for the last time. The following year he exhibited works from 1908 to 1914 at the Carroll Galleries in New York. The exhibition was arranged by gallery owner John Quinn, one of the most significant collectors of early American modernist art. Quinn purchased his first works by Prendergast from the exhibition, including this watercolor and eight others as well as seven paintings.[1] The stagelike arrangement of the figures in Prendergast's composition is indebted to the classicizing paintings of Puvis de Chavannes, whereas the decorative patterning, simplified brush strokes, and exotically costumed figures illustrate Prendergast's interest at the time in naive and folk art. This interest was shared by his brother Charles, who at precisely this moment began creating painted decorative panels with similar themes and compositions.

NOTE

1. Richard J. Wattenmaker, *Maurice Prendergast* (New York: Harry N. Abrams, Inc., 1994), 125.

77

A L B E R T G L E I Z E S

Paris 1881–1953 Avignon

The Lorraine Pitcher, 1914

Watercolor

12 ¼ x 8 ⅛ in. (31.1 x 20.6 cm)

INSCRIPTION

LOWER RIGHT: Albert Gleizes/Toul 14

PROVENANCE

Purchased by the donor in the early 1920s

BIBLIOGRAPHY

Harrison, 1929, 35, no. 10

EXHIBITIONS

Daniel Robbins, *Albert Gleizes, 1881–1953*, exh. cat. (New York: Solomon R. Guggenheim Museum,
1964), no. 37; Richard V. West, *Painters of the Section d'Or: Alternatives to Cubism*, exh. cat.
(Buffalo: Albright-Knox Art Gallery, 1967), no. 6

Mr. and Mrs. William Preston Harrison Collection, 26.7.7

After his initial experiments in impressionism, Gleizes pursued cubism beginning about 1910 together with his friends Henri Le Fauconnier and Jean Metzinger. In 1911 he frequented meetings in the studio of Jacques Villon along with Marcel Duchamp, Raymond Duchamp-Villon, Francis Picabia, Fernand Léger, František Kupka, Roger de La Fresnaye, and others. In 1912 Gleizes and Metzinger published *Du "Cubisme,"* the first significant book on the subject. In the same year he was among the thirty-two artists who exhibited in the major cubist Section d'Or exhibition at the Galerie de La Boëtie in Paris. He joined the army in 1914 and was stationed at Toul when he executed, signed, and dated this watercolor. The following year he used this drawing as a study for a painting now in the collection of Mr. and Mrs. Herbert M. Rothschild, New York.[1] The drawing will be included in the forthcoming catalogue raisonné on Gleizes by Daniel Robbins and Mailka Noui.

NOTE

1. Robbins, *Gleizes*, no. 38.

CHILDE HASSAM
Boston 1859–1935 New York
Castle Island, Boston Harbor, 1916
Watercolor, gouache, and graphite
9 x 12 ⅞ in. (22.9 x 32.7 cm)

INSCRIPTIONS
LOWER LEFT: Castle Island, Boston/May 15, 1916
LOWER RIGHT: Childe Hassam

———

PROVENANCE
Purchased by the donor in the early 1920s

———

BIBLIOGRAPHY
Harrison, 1934, 64; *The Index of Twentieth-Century Artists* 3,
no. 1 (1935): 170; Fort and Quick, 450

———

EXHIBITIONS
American Water Colors, exh. cat. (Santa Barbara: Faulkner Memorial Art Gallery, 1935), no. 32;
Larry Curry, *American Pastels and Watercolors: Selections from the Mr. and Mrs. William Preston Harrison
Collection*, exh. cat. (Los Angeles: Los Angeles County Museum of Art, 1969), no. 8

———

Mr. and Mrs. William Preston Harrison Collection, 31.12.9

———

Hassam was one of the leading American impressionists. He studied from 1886 to 1889 at the Académie Julian in Paris, where he became familiar with the French impressionists, whose works influenced the lightening of his palette. He was a member of a loose confederation known as the Ten American Painters. Founded in 1898, the group has been considered a kind of academy of American impressionism. Its membership included Frank Benson, Joseph de Camp, Thomas Dewing, Willard Metcalf, Robert Reid, Edward Simmons, Edmund Tarbell, John Twachtman, and J. Alden Weir; William Merritt Chase joined in 1902 after Twachtman's death. They organized exhibitions of their paintings from 1898 (at Durand-Ruel Gallery, New York) until 1917–18 (at the Corcoran Gallery, Washington, D.C.). American impressionism reached its apogee with the Panama-Pacific Exposition of 1915 in San Francisco, where Hassam exhibited thirty-eight paintings.

In the 1890s Hassam began working in pastels, and his interest in their chalky effects influenced his approach to the handling of gouache and watercolor, as he used a dry-brush technique to apply strokes of opaque gouache in imitation of pastel.[1] This technique can be seen especially in the expanse of blue sky in *Castle Island, Boston Harbor*. In this decidedly impressionistic drawing Hassam very effectively used transparent washes of watercolor in combination with the white of the paper to capture the effects of sparkling, brilliant light.

NOTE
1. Sue Welsh Reed and Carol Troyen, *Awash in Color: Homer, Sargent, and the Great American Watercolor*, exh. cat. (Boston: Museum of Fine Arts, 1993), 131.

79
CHARLES DEMUTH
Lancaster (Pennsylvania) 1883–1935 Lancaster
Old Houses, 1917
Watercolor and graphite
9 15/16 x 14 in. (25.2 x 35.6 cm)

INSCRIPTION
LOWER CENTER: C. Demuth/1917

———

PROVENANCE
Edith Gregor Halpert, New York; purchased by the donor in 1927

———

BIBLIOGRAPHY
Harrison, 1934, 62; Emily Farnham, "Charles Demuth: His Life, Psychology, and Works"
(Ph.D. diss., Ohio State University, 1959), 2: 517, no. 278; Winifred Haines Higgins,
"Art Collecting in the Los Angeles Area, 1910–1960" (Ph.D. diss., University of California,
Los Angeles, 1963), 59, no. 74; Emily Farnham, "Charles Demuth's Bermuda Landscapes,"
Art Journal 25 (Winter 1965–66): 132, fig. 4; Emily Farnham,
Demuth: Behind a Laughing Mask (Norman: University of Oklahoma Press, 1971),
88–89, pl. 17; Fort and Quick, 451–52

———

EXHIBITIONS
American Water Colors, exh. cat. (Santa Barbara: Faulkner Memorial Art Gallery, 1935), no. 22;
Watercolors for Asia, exh. cat. (New York: American Federation of Arts, 1955);
Cubism: Its Impact in the U.S.A. 1910–1930, exh. cat. (Albuquerque: University of New Mexico Art
Museum, 1967), no. 20; Larry Curry, *Eight American Masters of Watercolor*, exh. cat.
(Los Angeles: Los Angeles County Museum of Art, 1968), no. 72; Larry Curry, *American Pastels and
Watercolors: Selections from the Mr. and Mrs. William Preston Harrison Collection*, exh. cat.
(Los Angeles: Los Angeles County Museum of Art, 1969), no. 2;
David Gebhard and Phyllis Plous, *Charles Demuth: The Mechanical Encrusted on the Living*,
exh. cat. (Santa Barbara: Art Galleries, University of California, 1971), no. 41;
American Master Drawings and Watercolors: Works on Paper from Colonial Times to the Present, exh. cat.
(Minneapolis: Minneapolis Institute of Arts, 1977), 314–16

———

Mr. and Mrs. William Preston Harrison Collection, 29.18.7

Demuth was one of the major American modernist painters. His painting *My Egypt* of 1927 in the Whitney Museum of American Art is one of the exemplars of the architecturally inspired movement known as precisionism; but Demuth's most renowned achievements were made in watercolor. In this medium he depicted a wide variety of subjects: he is equally notable for still lifes, architectural landscapes, and homoerotic images of the gay underground in New York. In 1916–17 Demuth traveled with his friend Marsden Hartley to Bermuda, where he executed a series of watercolors that foretold his later experimentations in precisionism. These views of buildings in Bermuda reveal Demuth's considerable attention to the transparent effects of impressionistic light combined with the more angular and architectonic compositions of the cubists and constructivists. Demuth employed the limpid character of the watercolor medium to successfully combine the planar geometries and rectilinear forms of the constructivists with the multiple viewpoints of the cubists.

The museum's watercolor is typical of this period in its coloring in pale and muted earth tones. The architectural motifs float on the page, with the voids of the white of the edges of the paper playing a significant compositional role. Like Demuth's *Red-Roofed Houses* of 1917 in the Philadelphia Museum of Art,[1] this watercolor differs from many others by Demuth, with its strong red and rust accents and the near-abstract rendition of the buildings.

NOTE

1. Barbara Haskell, *Charles Demuth*, exh. cat. (New York: Whitney Museum of American Art, 1987), 124, pl. 53.

80

ALEXANDER ARCHIPENKO
Kiev (Ukraine) 1887–1964 New York
Still Life on Table, about 1918
Charcoal and graphite
12 ½ x 19 in. (31.8 x 48.3 cm)

INSCRIPTION

LOWER RIGHT: Archipenko

PROVENANCE

Ernst Wasmuth, Berlin [?]; Roland, Browse, and Delbanco, London; Austin and Irene Young

Gift of the Austin and Irene Young Trust, AC1994.87.1

Archipenko studied at the Kiev Art School and the École des Beaux-Arts in Paris, where he lived from 1908 to 1914 as one of the principal cubist sculptors. He was in Berlin in 1921–23, along with his Russian compatriots Marc Chagall, El Lissitzky, and Wassily Kandinsky. One of his distinctive artistic contributions was the form he called *archipentura*, which was essentially a painted relief sculpture. After 1923 he moved to the United States, where he lived for the rest of his life. In 1933 he taught at the Chouinard Art Institute in Los Angeles, where he also opened his own art school in 1935.

This composition with a still life arranged on a tabletop is similar to lithographs by Archipenko published by Ernst Wasmuth in Berlin in 1921 in the portfolio *Alexandre Archipenko: Dreizehn Steinzeichnungen*.[1] In the museum's drawing and the lithograph *Still Life with Vase* the focus is on the corner of a rectangular table. Likewise, in both works the same semicircular form can be seen near the right edge of the table. All of these lithographs show a checkered parquet floor and a napkin or tablecloth hanging over the table's edge. Whether rectangular or oval, the tables have similar legs with knobs at the top. The viewer is situated at an angle above the table. Although the lithographs were published in 1921–22, the conception of the compositions dates earlier, since in the latter part of the previous decade Archipenko created painted reliefs with similar subjects and compositions.[2] According to Frances Archipenko Gray (letter, departmental files), a photograph of the museum's drawing is in the Archipenko archives, with an embossed stamp ("Ernst Wasmuth Berlin"). The presence of the stamp suggests that the German publisher had the drawing and was considering including a lithograph of it in his portfolio. The photograph is also inscribed by Archipenko, "Nature morte 1918."

NOTES

1. Donald Karshan, *Archipenko: The Sculpture and Graphic Art* (Tübingen: Ernst Wasmuth Verlag, 1974), no. 10 (*Still Life with Vase*), no. 11 (*Still Life*), and no. 22 (*Still Life with Clock*). In 1922 another similar lithograph *Still Life* appeared in *Die Schaffenden* (ibid., no. 28).

2. See the sculptures *Still Life on Round Table* of 1916, private collection, Germany (ibid., 87); *Head and Still Life* of 1916, private collection, Paris (ibid., 87); and *Still Life with Book and Vase on Table* of 1918, private collection, Paris (ibid., 85).

81

MARC CHAGALL
Vitebsk (Russia) 1887–1985 Saint-Paul-de-Vence (France)
Cardplayers, 1919
Watercolor, tempera, and graphite
15 ⅝ x 20 in. (39.7 x 50.8 cm)

INSCRIPTION
LOWER RIGHT: Chagall 9 17

———

PROVENANCE
Probably purchased by the donor in the early 1920s

———

BIBLIOGRAPHY
Harrison, 1929, 35, no. 2; Franz Meyer, *Marc Chagall Life and Work*
(New York: Harry N. Abrams, Inc., 1964), 289, no. 294; Feinblatt, 1970, n.p.; Aleksandr Kamensky,
Chagall: The Russian Years 1907–1922 (New York: Rizzoli, 1988), 316, 320

———

EXHIBITIONS
Chagall et le théâtre, exh. cat. (Toulouse: Musée des Augustins, 1967), no. 8; Ebria Feinblatt,
Marc Chagall: Early Graphic Works, exh. cat. (Los Angeles: Los Angeles County Museum of Art, 1973),
19, no. 122; David W. Steadman, *Works on Paper, 1900–1960, from Southern California Collections*, exh.
cat. (Claremont: Montgomery Art Gallery, Pomona College, 1977), no. 5; Pierre Provoyeur et al.,
Marc Chagall: Oeuvres sur papier, exh. cat. (Paris: Centre Georges Pompidou, 1984), no. 55

———

Mr. and Mrs. William Preston Harrison Collection, 39.9.6

———

Chagall studied initially at the Imperial School of Fine Arts in Saint Petersburg and with the painter and theatrical designer Leon Bakst. More crucial, however, were his years in Paris from 1910 to 1914, when he absorbed the lessons to be learned from the developments of cubism and its offshoots, orphism (practiced by Robert Delaunay and Fernand Léger) and synchromism (practiced by Stanton Macdonald-Wright and Morgan Russell). He returned in 1914 to Russia, where he remained until 1923 as one of the leaders in the movement for avant-garde revolutionary art. After a brief period in Berlin, he moved permanently to France, becoming one of the century's most popular proponents of poetic fantasy in art.

Chagall's image of a game of cards is extraordinarily fanciful in its playful distortions, juxtaposition of scale, and coloring. The body of the principal cardplayer is manipulated to a bizarre angle that suggests ecstasy or agony. He is rendered in such acidic tones of green and yellow that agony seems more likely (perhaps inspired by the worthless cards he has been dealt). This watercolor is related to a commission Chagall received in 1919 to design scenery for a production of Gogol's *The Cardplayers* at the Hermitage Theatre in Saint Petersburg. As noted by Kamensky, Chagall's date of 1917 inscribed on this sheet is incorrect since the theater did not open until 1919.

OTTO DIX
Untermhaus (Germany) 1891–1969 Hemmenhofen
Seaman and Girl, 1919
Black ink on brown paper
16 5/8 x 13 in. (42.2 x 33 cm)

INSCRIPTION
LOWER RIGHT: Dix/1919

PROVENANCE
Galerie Abels, Cologne; Mr. and Mrs. William Preston Harrison

Mr. and Mrs. William Preston Harrison Collection, 48.32.14

Dix attended the Kunstgewerbeschule in Dresden from 1909 to 1914, the Akademie in Dresden from 1919 to 1922, and the Akademie in Düsseldorf from 1922 to 1925. During his service in the German army in World War I his style evolved from one of academic realism to a more expressionist/futurist one, employed for some of the most vitriolic antiwar artistic statements, culminating in his renowned series of fifty etchings, *Der Krieg* (War) of 1924. While Dix was attending school in Dresden, he was affiliated and exhibited with the radical Dresden Sezession Gruppe. After moving to Düsseldorf, Dix became, along with George Grosz in Berlin, one of the principal proponents of *Neue Sachlichkeit*, or new objectivity.

Until now it was not recognized that this rapidly executed sketch is a study for Dix's 1920 etching of the same subject.[1] In addition to being in reverse to the printed composition, the drawing differs in some details. The couple is seated on a bench, whereas in the print they are standing. The sailor's lascivious movement toward the woman is emphasized by his placement of one hand on her exposed breast and the other on her buttocks. In the etching this action has been toned down to where the sailor simply has one hand on her shoulder. The woman also embraces the man in the drawing, whereas in the etching she stands rather chastely, almost unaware of the sailor's animalistic leer.

NOTE
1. For the etching, see Florian Karsch, *Otto Dix: Das graphische Werk* (Hannover: Fackelträger-Verlag Schmidt-Küster, 1970), 133, no. 13.

LOUIS MARCOUSSIS
Warsaw 1878–1941 Cusset (France)
Composition: Figs, Bottle, and Pipe, about 1920–21
Watercolor, gouache, and graphite
10 x 16 in. (25.4 x 40.6 cm)

INSCRIPTION
UPPER RIGHT: a Tristan Tzara/affectueusement/Marcoussis

PROVENANCE
Tristan Tzara; Christophe Tzara, Paris; Roland, Browse,
and Delbanco, London; Austin and Irene Young

BIBLIOGRAPHY
Jean Lanfranchis, *Marcoussis, sa vie, son oeuvre: Catalogue complet des peintures, fixes sur verre,
aquarelles, dessins, gravures* (Paris: Éditions du Temps, 1961), no. D.37

EXHIBITION
Jean Cassou, *Louis Marcoussis*, exh. cat. (Paris: Musée National d'Art Moderne, 1964), no. 98

Gift of the Austin and Irene Young Trust, AC1994.87.33

Marcoussis arrived in Paris from Poland in 1903. He submitted a painting and two etchings to the Salon d'Automne in 1905, and the following year to the Salon des Indépendants. In 1910 he met Guillaume Apollinaire, Georges Braque, and Pablo Picasso and began working in a cubist manner. Born Louis Markus, upon the advice of Apollinaire, Marcoussis changed his name in 1910 after the name of a village in the Ile-de-France. One of Marcoussis's best-known works is an etched portrait of Apollinaire from 1912–20. Apollinaire was one of several avant-garde writers known by Marcoussis and whose works were illustrated by him; others included Max Jacob and Tristan Tzara.[1] The museum's gouache is inscribed to Tzara by the artist.

Before the war, Marcoussis worked in the manner of analytical cubism, with its multiple viewpoints and the objects rendered in transparent planes. After a four-year hiatus during the war, Marcoussis resumed painting, but his manner of cubism changed from the earlier mode influenced by Picasso and Braque to a more synthetic, collagelike style as practiced by Juan Gris. The human figure rarely appears in Marcoussis's works of the 1920s, as he concentrated on still lifes. The museum's gouache, dated by Lanfranchis to about 1920–21, is a fine example of this constructivist aspect of Marcoussis's work, as the composition's several patterned elements overlap and play off against each other. Contrasting to the flatness of these patterned planes of color is the trompe l'oeil effect of the curling paper or cloth at the lower right.

NOTE
1. For a brief discussion, see Jean Cassou's introduction to *Marcoussis: L'ami des poètes*, exh. cat. (Le Havre: Nouveau Musée du Havre, 1966), n.p.

84

ÉDOUARD VUILLARD

Cuiseaux (France) 1868–1940 La Baule

Portrait of M Rosengart, about 1921

Pastel and black chalk on dark tan paper

9 7/16 x 12 3/16 in. (24 x 31 cm)

INSCRIPTION

LOWER RIGHT: Vuillard

PROVENANCE

Galerie Urban, Paris; purchased by the donor in 1962

Gift of Paul J. Gerstley, M.91.136

Vuillard's family moved to Paris in 1877. He enrolled in 1884 in the Lycée Condorcet, where his classmates included the actor Lugné-Poe; the future publisher of *La Revue blanche*, Thadée Natanson; and the painters Maurice Denis and Ker-Xavier Roussel. In 1887 at the Académie Julian he met Pierre Bonnard, Henri-Gabriel Ibels, and Felix Valloton, and in 1889 Vuillard formed with them the artist's group the Nabis. These contacts placed Vuillard at the heart of the most advanced artistic ideas in fin de siècle Paris. He firmly established his reputation in the 1890s in the areas of painting and color lithography. His subject matter was remarkably domestic, drawn primarily from scenes in the home and atelier. He and his close friend Bonnard became known as *intimistes* because of their depictions of family and friends in homey interiors.

After the disruption of the Parisian art world by World War I, Vuillard turned increasingly to portraiture as both a means of private and informal expression and as commissions from clients in the business and art worlds.[1] One of Vuillard's most important dealers was Siegfried Rosengart of the Galerie Rosengart in Lucerne.[2] This drawing was acquired as a portrait of a "M Rosengart." Angela Rosengart believes (letter, departmental files) this is not a portrait of her father, however, but may be Lucien Rosengart (1881–1976), a distant relative who manufactured in France before World War II a popular automobile known as "le petit Rosengart."

NOTES

1. See the chapter "Vuillard and the Portrait: The Inter-War Years," in Belinda Thomson, *Vuillard* (New York: Abbeville Press, 1988), 126–50. For another pastel portrait of a man seated in his study, see Vuillard's *Jean Giraudoux at His Desk* of 1926 in a private collection, in ibid., pl. 128.

2. Martin Kunz, *Von Matisse bis Picasso: Hommage an Siegfried Rosengart*, exh. cat. (Lucerne: Kunstmuseum Luzern, 1988).

85

GEORGE GROSZ

Berlin 1893–1959 Berlin

Street Scene, about 1922

Black ink

24 ⅞ x 19 ⅛ in. (63.2 x 48.6 cm)

INSCRIPTIONS

LOWER LEFT: No. 104 Cassirer

LOWER RIGHT: Made in Germany [stamped]; Grosz;

———

PROVENANCE

Weyhe Gallery, New York; purchased by the donor in 1937

———

BIBLIOGRAPHY

George Grosz, *Der Spiesser-Spiegel* (Dresden: Carl Reissner Verlag, 1925), n.p. [pl. 7];
Feinblatt, 1970, n.p.; Jack Selleck, *Contrast* (Worcester: Davis Publications, 1975), 13

———

EXHIBITION

George Grosz, 1893–1959, exh. cat. (Berlin: Akademie der Künste, 1962), no. 281

———

Mr. and Mrs. William Preston Harrison Collection, 37.18.5

———

Grosz studied at the Akademie in Dresden in 1909–11, the Kunstgewerbeschule in Berlin in 1912–13, and the Académie Colarossi in Paris in 1913. After serving in the German army in World War I, Grosz was associated with the Berlin dada movement and the radical artists' group Novembergruppe, satirizing life in postwar Germany in drawings and prints such as the series *Ecce Homo*, published in 1923. With the political rise of the Nazis, Grosz moved in 1932 to the United States and became an American citizen in 1938.

After World War I, Grosz became Germany's most bitterly satirical social critic, expressing his views in countless drawings, usually in pen and black ink. In these drawings he lamented the unhappy condition of the working class in postwar Germany and sharply satirized the venality and stupidity of the bosses. After 1918 Grosz did not make any original prints but executed drawings intended to be reproduced by photolithography in portfolios published by Malik-Verlag in Berlin, which was founded in 1917 by Grosz and the brothers Wieland Herzfeld and John Heartfield (Helmut Herzfeld) as a means of disseminating Grosz's drawings. The museum's sheet from about 1922 was reproduced in 1925 in one of Grosz's books, *Der Spiesser-Spiegel* (Philistines-Reflections), published in Dresden by Carl Reissner Verlag. It is incorrectly dated to about 1930–31 in the Grosz exhibition catalogue noted above.

86

FERNAND LÉGER
Argentan (France) 1881–1955 Gif-sur-Yvette
Letters and Pipes, about 1925
Gouache
14 ³/₈ x 10 ⁵/₁₆ in. (36.5 x 26.2 cm)

INSCRIPTION
LOWER RIGHT: FL

PROVENANCE
Galerie Mme Bucher, Paris;
probably purchased by the donor about 1925–27

BIBLIOGRAPHY
Harrison, 1929, 35, no. 17

Mr. and Mrs. William Preston Harrison Collection, 27.7.9

⊶

Léger was first trained as an architectural draftsman, but by 1910 he had converted to painting. He associated with the cubists in Paris and came close to fully abstract art with his prewar compositions of tubular and mechanistic forms. This phase ended with the outbreak of World War I, in which he served until he was gassed in 1917. He explored the constructivist tendencies of synthetic cubism in the 1920s, when he developed his mature and elegant style, which probably best exemplifies the aesthetics of the "machine age."

Letters and Pipes can be dated to about 1925. A closely related pencil drawing from 1925 was formerly in the collection of Douglas Cooper.[1] Like many of Léger's works from the mid-1920s, both works come close to purism in their arrangements of common objects into constructivist compositions. *Letters and Pipes* is divided vertically into two parts, with the letters *A* and *B* floating in the right section like children's blocks. The left half of the museum's drawing, however, contains three pipes, whereas the Cooper drawing has only two. A related painting, *The Three Pipes* of 1925, is in the collection of Galerie Louise Leiris, Paris.[2]

NOTES
1. Dorothy M. Kosinski, *Douglas Cooper und die Meister des Kubismus/Douglas Cooper and the Masters of Cubism*, exh. cat. (Basel: Kunstmuseum, 1987), 124, 208, no. 42. The work was sold at Christie's, London, 30 November 1988, lot 529.
2. Kosinski, *Cooper*, 121; and Jean Leymarie, *Fernand Léger*, exh. cat. (Paris: Grand Palais, 1971), no. 89.

87

PRESTON DICKINSON
New York 1891–1930 New York
Washington Bridge, 1926
Pastel and watercolor
12 x 24 in. (30.5 x 61 cm)

INSCRIPTION
LOWER RIGHT: Preston Dickinson

—

PROVENANCE
Daniel Gallery, New York; purchased by the donor in 1930

—

BIBLIOGRAPHY
Harrison, 1934, 62; *The Index of Twentieth-Century Artists* 3, no. 4 (1935): 217;
Richard Lee Rubenfeld, "Preston Dickinson: An American Modernist, with a Catalogue of Selected
Works" (Ph.D. diss., Ohio State University, 1985), 1: 150–51, fig. 151; 2: 475–76, no. 149

—

EXHIBITION
Larry Curry, *American Pastels and Watercolors:*
Selections from the Mr. and Mrs. William Preston Harrison Collection, exh. cat.
(Los Angeles: Los Angeles County Museum of Art, 1969), no.3

—

Mr. and Mrs. William Preston Harrison Collection, 31.12.4

—⚬⚬⚬—

Dickinson was one of the key figures in the 1920s in establishing the distinctive American form of modernism known as precisionism, with its wedding of the stylistic elements of cubism and constructivism to renditions of the American industrial landscape. Around 1922–24 Dickinson made numerous such landscape paintings, pastels, and watercolors depicting bridges in New York, especially Washington Bridge and High Bridge over the Harlem River.[1] In 1924 Dickinson spent several months in Omaha, and his depictions of midwestern grain elevators are among the most distinctive examples of the precisionist aesthetic. In 1926 he was back in New York and returned to themes of the Harlem River, of which the museum's pastel is a notable example. In this work Dickinson's wide-angled panoramic view of Washington Bridge in the background is juxtaposed to a view of a rooftop in the foreground, resulting in a somewhat incongruent spatial relationship. Richard Lee Rubenfeld singles out *Washington Bridge* as an example of Dickinson's willfully discordant manipulations of forms and space during what he calls a "mannerist" phase of the artist's career in the late 1920s.

NOTE
1. For other examples of Dickinson's views of the Washington Bridge, see Ruth Cloudman, *Preston Dickinson 1889–1930*, exh. cat. (Lincoln, Nebr.: Sheldon Memorial Art Gallery, 1979), nos. 25–26, 30–31; and Rubenfeld, *Preston Dickinson*, figs. 75–84.

88

FERNAND LÉGER
Argentan (France) 1881–1955 Gif-sur-Yvette
Still Life with Shell, about 1927
Gouache and graphite
7 ¼ x 5 ¾ in. (18.4 x 14.6 cm)

PROVENANCE
Austin and Irene Young

———

Gift of the Austin and Irene Young Trust, AC1994.87.25

———⧈———

Still Life with Shell features the combination of typescript and objects floating before an architectonic background, also seen in the slightly earlier *Letters and Pipes* (catalogue no. 86) in the museum's collection. The stark geometric forms of circles, rectangles, and grids are balanced somewhat by the curvilinear and organic shell and leaf superimposed on them. Nevertheless, these naturalistic forms seem to be part of the same mechanistic world because Léger has modeled and colored the shell and leaf in cool metallic grays and blues; the shell and leaf resemble manmade machine parts as much as they do objects seen in nature.[1]

This drawing is closely related to a composition of 1927 by Léger, known in three paintings; two are in private collections and one is in the Galerie Beyeler, Basel.[2] It is closest to the Galerie Beyeler canvas but in reverse. The museum's sheet was probably used for the *pochoir* reproduction of the painting that appeared in *Cahiers d'Art* in 1928.

NOTES
1. For two similar studies of mechanistic natural objects, see *Quartier de boeuf (fragment)* of 1928 and an untitled sheet from 1929 in *Fernand Léger*, exh. cat. (Paris: Galerie Claude Bernard, 1970), nos. 28–29.
2. Georges Bauquier, *Fernand Léger: Catalogue raisonné, 1925–1928* (Paris: Adrien Maeght Éditeur, 1990), 165–67, nos. 485–87.

89

WASSILY KANDINSKY

Moscow 1866–1944 Neuilly-sur-Seine (France)

Semicircle, 1927

Watercolor and india ink

19 x 12 ¹¹/₁₆ in. (48.3 x 32.2 cm)

INSCRIPTIONS

RECTO, LOWER LEFT: VK '27; VERSO: Halbkreis 27/228

PROVENANCE

Otto Ralfs, Braunschweig, through Kandinsky Gesellschaft (1927–28);
Stuttgarter Kunstkabinett, Stuttgart, 3 May 1961, lot 191; David E. Bright;
bequeathed to the museum in 1962

BIBLIOGRAPHY

Vivian Endicott Barnett, *Kandinsky Watercolors: Catalogue Raisonné, Volume Two, 1922–1944*
(Ithaca: Cornell University Press, 1994), 167, no. 795

EXHIBITIONS

The David E. Bright Collection, exh. cat. (Los Angeles: Los Angeles County Museum of Art, 1967), 13;
Kandinsky: Watercolors and Drawings, exh. cat.
(Düsseldorf: Kunstsammlung Nordrhein-Westfalen, 1992), no. 112

Estate of David E. Bright, M.67.25.7

After an initial career in law, Kandinsky turned to painting at the age of thirty, moving to Munich, where he studied alongside Alexei Jawlensky and Paul Klee. After first working in the decorative Jugendstil manner, he painted his first *Improvisation* in 1909 and his first *Composition* in 1910, nonfigurative works that have had a profound effect on the development of abstract art in the twentieth century, as did his book *On the Spiritual in Art* of 1912. Like his compatriot Marc Chagall, Kandinsky returned to Russia during World War I, remaining there until the tide turned against avant-garde art in the early 1920s. He spent the years from 1922 to 1933 in Germany as one of the most influential instructors at the Bauhaus, initially in Weimar and then in Dessau. He summarized his aesthetic philosophy in his pedagogical text *Point and Line to Plane* of 1926. After the school was closed by the Nazis in 1933, he moved to Paris.

Kandinsky's period in Russia, when he was in contact with artists deeply immersed in constructivism, resulted in a shift in his style. Geometric forms like circles, triangles, checkerboards, and squares replaced the fluid and freewheeling painterly gestures of his abstract works of the prewar years. In the museum's watercolor the geometric forms appear to float and move in the watery space of the orange-yellow background. The lower half of the composition, with the semicircles and rectangles placed at oblique angles, is especially indebted to Russian constructivist examples by Kasimir Malevich and El Lissitzky.

90

EMIL NOLDE
Nolde (Denmark) 1863–1956 Seebüll (Germany)
Still Life with Red Flower, Candle, and Figurine of Saint John the Baptist, date unknown
Watercolor
13 11/16 x 18 5/16 in. (34.8 x 46.5 cm)

INSCRIPTION
LOWER RIGHT: Nolde

PROVENANCE
Mr. and Mrs. John G. Best

Gift of Mr. and Mrs. John G. Best, 59.61

Nolde was born Emil Hansen but adopted the name of his birthplace of Nolde, a village in the Danish-German border area. In 1898 he made his first etchings and produced in 1905 his *Phantasien* series, his first significant prints. In 1906, as a result of his first solo exhibition at Galerie Ernst Arnold in Dresden, he was invited to join the artists' group Die Brücke. This association, however, was brief. After 1926 he lived reclusively in the north German town of Seebüll. Nolde is infamous for his support of the Nazis, probably as a result of misguided nationalism and love of the German landscape. He was nevertheless declared "degenerate" and forbidden to paint.

Nolde produced thousands of watercolors during his career. Rarely dated or datable, they show a remarkable stylistic consistency, and it is consequently difficult to establish a convincing chronology for them. Dr. Manfred Reuther, director of the Stiftung Seebüll Ada und Emil Nolde, has identified the precise subject of the museum's drawing (letter, departmental files). The figure at the right depicts a wooden north German Renaissance sculpture of about 1510, which Nolde owned.[1] Reuther has identified three other still lifes by Nolde in the Stiftung Nolde which represent the same figurine (inv. nos. A.Bl.F. 11, 12, 31).[2] Like many of Nolde's watercolors, *Still Life with Red Flower, Candle, and Figurine of Saint John the Baptist* is a remarkable exercise in the artist's exploration of the technique, since Nolde used a thin, fibrous Japanese paper which he dampened before applying watercolor that sank into the sheet. This process gives the work a particularly striking luminosity.

NOTES
1. For the sculpture, see *Emil Nolde: Figuren in Bildern*, exh. cat. (Hamburg: BAT-Haus, 1970), 36, no. 41; and *Emil Nolde: Masken und Figuren*, exh. cat. (Bielefeld: Kunsthalle, 1971), 27, no. 43a.
2. For one of the watercolors, dated to about 1930–40, see *Nolde: Figuren*, 36, no. 42; and *Nolde: Masken*, 27, no. 43.

91
JOHN MARIN
Rutherford (New Jersey) 1870–1953 Addison (Maine)
New Mexico Near Taos, 1929
Watercolor, gouache, and graphite
14 1/16 x 21 1/16 in. (35.7 x 53.5 cm)

INSCRIPTION

LOWER RIGHT: Marin 29

———

PROVENANCE

Probably An American Place, New York (1930);
Downtown Gallery, New York (by 1934 to 1947); purchased by the museum in 1947

BIBLIOGRAPHY

Arthur Millier, "Enriched by Hearst," *Art Digest* 21 (1947): 20; Henry J. Seldis,
"The Stieglitz Circle Show at Pomona College," *Art in America* 46 (Winter 1958–59): 62;
Sheldon Reich, *John Marin: A Stylistic Analysis and Catalogue Raisonné*
(Tucson: University of Arizona Press, 1970), 2: 610, no. 29.40;
Gerald F. Brommer, *Landscapes* (Worcester: Davis Publications, 1977), 25

———

EXHIBITIONS

The Stieglitz Circle, exh. cat. (Claremont: Pomona College Galleries, 1958), no. 38;
Marsden Hartley/John Marin, exh. cat. (La Jolla: Museum of Art, 1964), no. 19;
Van Deren Coke, *Marin in New Mexico, 1929 and 1930*, exh. cat.
(Albuquerque: Art Museum, University of New Mexico, 1968), 19, no. 17; Larry Curry,
Eight American Masters of Watercolor, exh. cat. (Los Angeles: Los Angeles County Museum of Art,
1968), no. 54; *Days on the Range: Artists in the American West*, exh. cat.
(Houston: Museum of Fine Arts, 1972), no. 15; Kathleen Plake Howe and
Michael Zakian, *Transforming the Western Image in Twentieth-Century American Art*, exh. cat.
(Palm Springs: Palm Springs Desert Museum, 1992), 33–34

———

Mira Hershey Memorial Collection, 47.9.2

———

Marin studied with Thomas P. Anshutz and Hugh Breckenridge from 1899 to 1901 at the Pennsylvania Academy of Fine Arts in Philadelphia. He spent the years 1905 to 1909 traveling around Europe, where picturesque views were the principal subjects of his paintings and etchings. In 1909 he returned to New York, where he had his first exhibition of watercolors at Alfred Stieglitz's 291 Gallery, becoming one of the central figures in early-twentieth-century American modernism.

At the invitation of Georgia O'Keeffe, Rebecca Strand (wife of photographer Paul Strand), and art patron Mabel Dodge Luhan, Marin spent the summers of 1929 and 1930 in New Mexico. During those periods in the Southwest Marin is reported to have made about one

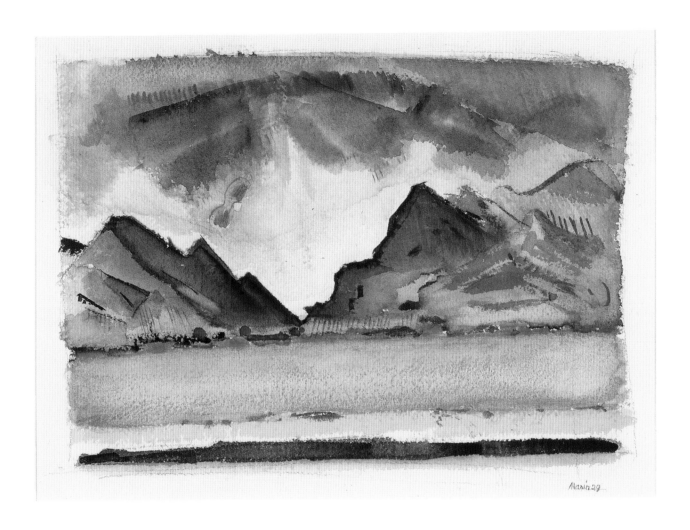

hundred watercolors; of those, thirty-two were exhibited in 1930, including probably the present work, at Alfred Stieglitz's gallery An American Place, and another thirty the following year. Marin was clearly inspired by the vast and majestic landscape he found in New Mexico; the museum's watercolor is especially notable for its simple grandeur. In it Marin suppressed details in the landscape and limited his range of colors in order to focus on the massive blocks of the two mountains. The sublime power of nature is further emphasized by the brilliant light shining through the banks of dark clouds.

HENRI MATISSE
Cateau-Cambrésis (France) 1869–1954 Nice
Odalisque with Turkish Slippers, 1929
Black ink
19¼ x 27 in. (48.9 x 68.6 cm)

INSCRIPTION
LOWER LEFT: Henri Matisse 29

———

PROVENANCE
Galerie Tannhauser, Berlin (1930); Jacques Seligmann and Co., New York (1931);
Hermann Goering, Berlin; Ludwig Charell; purchased by the donor in 1948

———

EXHIBITIONS
Les chefs-d'oeuvre des collections privées françaises retrouvées en Allemagne, exh. cat.
(Paris: Musée de l'Orangerie, 1946), no. 159; Ulrike Gauss, ed., *Henri Matisse: Zeichnungen und
Gouaches Découpées*, exh. cat. (Stuttgart: Graphische Sammlung, Staatsgalerie Stuttgart, 1993), no. 22

———

Gift of George Cukor, M.63.62.10

———

Matisse did not discover painting until the age of twenty, while recuperating from appendicitis. He abandoned a law career and enrolled in the Académie Julian, where he studied with the conservative painter Adolphe-William Bouguereau. In 1895 he was finally admitted to the École des Beaux-Arts, where he studied with Gustave Moreau. He had his first solo exhibition in 1904 at Ambroise Vollard's gallery. The following year his paintings in the Salon d'Autumne created such a sensation of outrage from the critics and public that Matisse and fellow exhibitors André Derain, Henri Manguin, and Maurice de Vlaminck were termed "les fauves," or "the wild beasts." Over the course of the next fifty years Matisse developed a colorful, sensuous, and highly decorative manner that is regarded by many as second only to Pablo Picasso's in its significance in twentieth-century art.

After 1917, when he began spending time each year in Nice, Matisse became increasingly interested in the subject of female nudes in exotically decorative interiors.[1] The examples of odalisques by Jean-Auguste-Dominique Ingres and Eugène Delacroix served as his immediate inspirations, though the tradition dated back to paintings of reclining nudes in Venetian Renaissance art. This sheet from 1929 is a remarkable and visually rich example of Matisse's draftsmanship using pure line. The setting is a riot of contrasting decorative patterns, including the flowery oriental rug, the subject's shawl and slippers, the embroidered pillow, and the screen/wallpaper in the background. Matisse described his draftsmanship of this type: "My line drawing is the purest and most direct translation of my emotion. Simplification of means allows that. But those drawings are more complete than they appear to some people who confuse them with a sketch.... Once I have put my emotion to line and modeled the light of my white paper, without destroying its endearing whiteness, I can add or take away nothing further."[2]

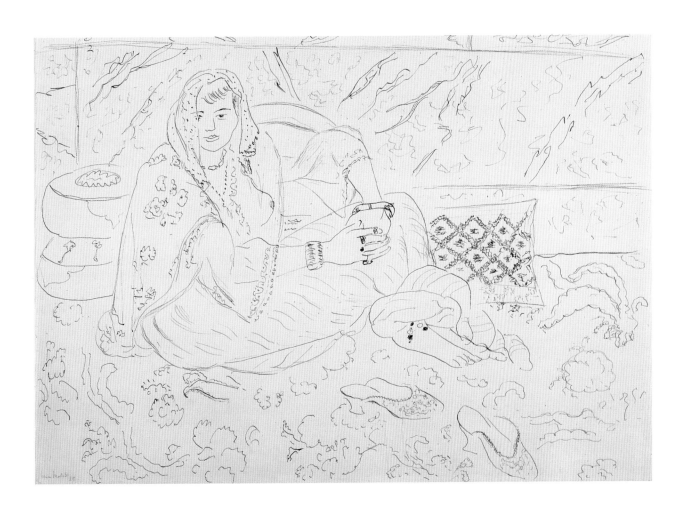

NOTES

1. Gauss, in *Matisse*, cites a number of similar paintings from the period 1923–27; see also John Elderfield, *Henri Matisse: A Retrospective*, exh. cat. (New York: Museum of Modern Art, 1992), nos. 263–66, 268–70, and 279–81.

2. Quoted in Victor Carlson, *Matisse as a Draughtsman*, exh. cat. (Baltimore: Baltimore Museum of Art, 1971), 18.

93

THOMAS HART BENTON
Neosho (Nebraska) 1889–1975 Kansas City (Missouri)
Cotton Pickers, 1931
Watercolor, ink, and graphite
21 1/16 x 26 3/16 in. (53.5 x 66.5 cm)

INSCRIPTION

LOWER LEFT: Benton/31

———

PROVENANCE

Associated American Artists, New York (by 1940); Frank Perls Gallery,
Los Angeles; Anatole Litvak

———

BIBLIOGRAPHY

"International Art News: New York," *Studio* 112 (December 1936): 348;
"Three Paintings by Contemporary American Masters," *Coronet* 8 (September 1940): 19;
"Recent Acquisition," *Los Angeles County Museum Bulletin of the Art Division* 6,
no. 2 (1954): 30; Fort and Quick, 469–70

———

EXHIBITIONS

Fourteenth Annual Exhibition of Watercolors, Pastels, Drawings and Monotypes, exh. cat. (Chicago: Art
Institute of Chicago, 1935), no. 241; *Catalogue of a Loan Exhibition of Drawings and Paintings by Thomas
Hart Benton, with an Evaluation of His Work*, exh. cat. (Chicago: Lakeside Press Galleries, 1937), no. 70

———

Gift of Anatole Litvak, 53.55.2

———⦚⦚⦚———

Beginning in 1926, together with Grant Wood and John Steuart Curry, Benton became one of the principal proponents of American scene painting. These painters and their supporters trumpeted the virtues of what became known as regionalism, in which artists celebrated a particularly homespun American style based on the presumed superiority of depictions of rural life over the evils of modernism (in other words, European-based, nonobjective art) found in the cities. Benton promoted these ideals through several publicly commissioned mural projects as well as through his oil paintings. Although generally grouped with the two midwesterners Wood and Curry, Benton was from Missouri and his subjects, as in *Cotton Pickers*, are more southern than midwestern.[1] He traveled through the South on a sketching trip in 1928; the local black population was one of his most frequent subjects. The almost backward way of life in the rural South depicted by Benton was a decided and intentional contrast to the mechanized urban subjects of American modernists like Stuart Davis and Charles Sheeler. Among Benton's paintings of the subject of cotton pickers are the egg tempera *Cotton Pickers (Georgia)* of 1928–29 in the Metropolitan Museum of Art[2] and the small oil painting *Georgia Cotton Pickers* of 1931 in the Museum of Modern Art.[3] The latter, in fact, is a reduced, painted replica of the museum's watercolor. In the 1930s, when the watercolor was owned by Associated American Artists, the gallery produced and circulated widely an inexpensive reproduction of this work.

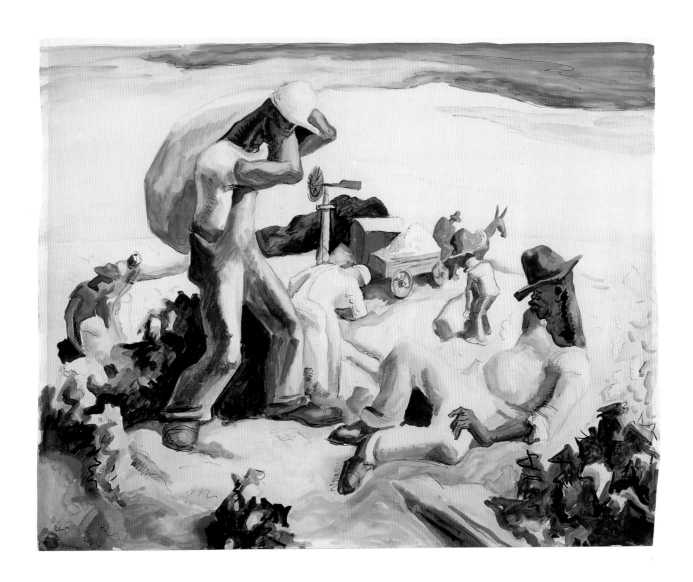

NOTES

1. For a discussion of Benton's southern identity, see Henry Adams, *Thomas Hart Benton: An American Original* (New York: Alfred A. Knopf, 1989), 153–55.

2. Matthew Baigell, *Thomas Hart Benton* (New York: Harry N. Abrams, Inc., 1974), pl. 60.

3. Ibid., pl. 65.

94
KÄTHE KOLLWITZ
Königsberg (Germany) 1867–1945 Moritzburg
Self-Portrait, 1934
Charcoal
17 x 13 ¼ in. (43.2 x 33.7 cm)

INSCRIPTION
LOWER RIGHT: Kathe/Kollwitz/1934

PROVENANCE
Jan Hoowij, Los Angeles (acquired from a German refugee in Holland, 1934);
purchased by the museum in 1969

BIBLIOGRAPHY
Otto Nagel, *Käthe Kollwitz: Die Handzeichnungen*
(Berlin: Henschelverlag Kunst und Gesellschaft, 1972), 442, no. 1246

EXHIBITIONS
A Decade of Collecting, 1965–1975, exh. cat. (Los Angeles: Los Angeles County Museum of Art,
1975), no. 110; Ann Sutherland Harris and Linda Nochlin, *Women Artists, 1550–1950*, exh. cat.
(Los Angeles: Los Angeles County Museum of Art, 1976), no. 107;
Françoise Forster-Hahn, *Käthe Kollwitz, 1867–1945: Prints, Drawings, Sculpture*, exh. cat.
(Riverside: University Art Galleries, University of California, 1978), no. 35;
Stephanie Barron, ed., *German Expressionist Sculpture*, exh. cat.
(Los Angeles: Los Angeles County Museum of Art, 1983), no. 84;
Davis, 42–43, no. 44

Los Angeles County Fund, 69.1

This extraordinarily moving and heroic self-image of Kollwitz, executed the year after her dismissal by the Nazis from her teaching post, is one of several graphic self-portraits by Kollwitz in the museum's collection, including five lithographs in the Robert Gore Rifkind Center for German Expressionist Studies from 1920, 1924, 1934, 1934–35, and 1938[1] and two lithographs in the department of prints and drawings from 1922 and 1927.[2] The museum also has a bronze sculpture self-portrait of 1926–36 by Kollwitz.[3]

Apart from Rembrandt, few artists have perused their own visage as probingly as Kollwitz. In 1934, the year of this self-portrait, Kollwitz began her lithographic series *Death*. At that time, she wrote in her diary, "The period of aging is, to be sure, more difficult than old age itself, but it is also more productive. At the very point when death becomes visible behind everything, it disrupts the imaginative process. The menace is more stimulating when you are not confronting it from close up. When it is upon you, you do not see its full extent; in fact you no longer have such respect for it."[4]

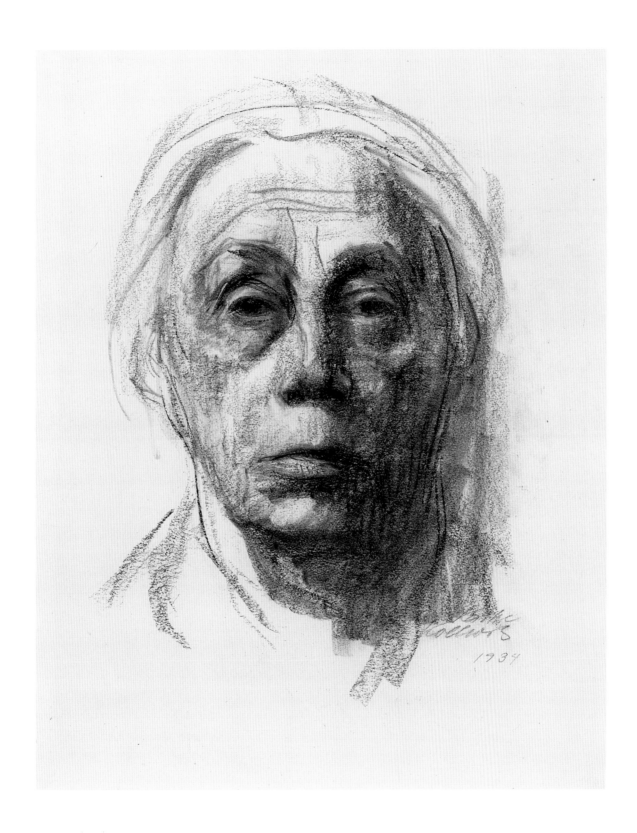

NOTES

1. Bruce Davis, *German Expressionist Prints and Drawings: The Robert Gore Rifkind Center for German Expressionist Studies. Volume Two: Catalogue of the Collection* (Los Angeles: Los Angeles County Museum of Art, 1989), nos. 1605, 1607, 1611, 1616, and 1618. *Summons of Death* (no. 1616) is not a self-portrait per se, but Kollwitz used her own features for the figure of the woman.

2. August Klipstein, *Käthe Kollwitz: Verzeichnis des graphischen Werkes* (Bern: Klipstein and Co., 1955), nos. 159 and 227.

3. Barron, *Sculpture*, no. 83.

4. Hans Kollwitz, ed., *The Diary and Letters of Käthe Kollwitz* (Chicago: Henry Regnery Co., 1955), 123–24.

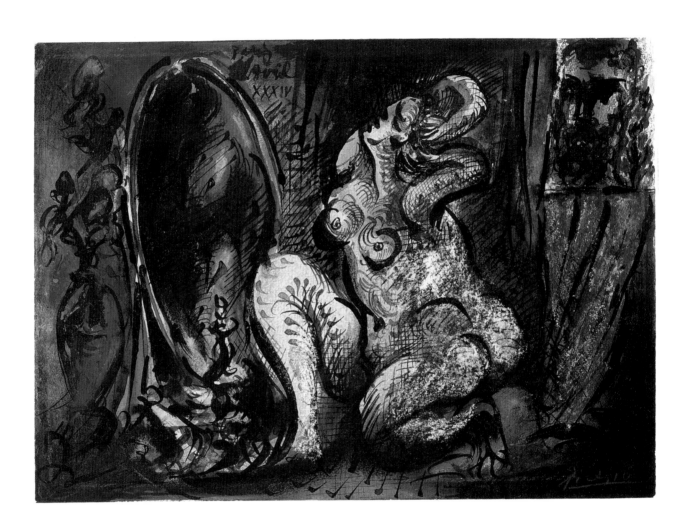

95

PABLO PICASSO

Malaga (Spain) 1881–1973 Mougins (France)

Female Nude Kneeling before a Mirror, Observed by a Bearded Man, 1934

Ink, watercolor, and colored chalks

9 7/8 x 13 5/8 in. (25.1 x 34.6 cm)

INSCRIPTIONS

UPPER CENTER: Paris/11 Avril XXXIV; LOWER RIGHT: Picasso

———

PROVENANCE

Mr. and Mrs. William Preston Harrison

———

BIBLIOGRAPHY

Feinblatt, 1970, n.p.

———

EXHIBITIONS

David W. Steadman, *Works on Paper, 1900–1960, from Southern California Collections*, exh. cat.
(Claremont: Montgomery Art Gallery, Pomona College, 1977), no. 60;
William Rubin, ed., *Pablo Picasso: A Retrospective*, exh. cat.
(New York: Museum of Modern Art, 1980), 324; Werner Spies,
Picasso: Pastelle, Zeichnungen, Aquarelle, exh. cat.
(Tübingen: Kunsthalle Tübingen, 1986), no. 131

———

Mr. and Mrs. William Preston Harrison Collection, 39.9.12

———

Beginning in the winter of 1927, when Picasso was working on illustrations to Balzac's *Le chef-d'oeuvre inconnu*, he was fascinated with the subject of the artist and his model. Discussion of this splendid watercolor has always focused on the nude woman; it has not been noted that she is watched by a bearded man (a frequently encountered surrogate for Picasso himself) in the window at the upper right, thus linking the watercolor to a large number of works by Picasso with similar themes. The drawing's delineation by calligraphic pen lines mixed with the application of rich washes of color are especially similar to two watercolors from 1933, *Artist and Model* in the Galerie Rosengart, Lucerne, and *The Minotaur* in the Musée des Beaux-Arts, Dijon.[1] What is extraordinary about the museum's drawing, however, is the playful modeling of the female form with its combination of cross-hatching and decorative patterning of tear-shaped strokes of the pen. This approach can be found also in Picasso's well-known etching *Winged Bull Watched by Four Children* of 1934.[2]

———

NOTES

1. Spies, *Picasso*, nos. 139–40.

2. Bernhard Geiser, *Picasso peintre-graveur, catalogue raisonné de l'oeuvre gravé et des monotypes 1932–1934* (Bern: Kornfeld and Klipstein, 1968), 230, no. 444.

96
DIEGO RIVERA
Guanajuato (Mexico) 1886–1957 Mexico City
Dance in Tehuantepec, 1935
Charcoal and watercolor
18 15/16 x 23 7/8 in. (48.1 x 60.6 cm)

INSCRIPTION

LOWER RIGHT: Diego Rivera

———

PROVENANCE

Milton W. Lipper; bequeathed to the museum in 1974

———

BIBLIOGRAPHY

Diego Rivera and Bertram D. Wolfe,
Portrait of Mexico: Paintings by Diego Rivera and Text by Bertram D. Wolfe
(New York: Covici, Friede, Inc., 1937), 47, pl. 58;
Diego Rivera: 50 años de su labor artistica
(Mexico City: Instituto Nacional de Bellas Artes, 1951),
445, no. 442

———

EXHIBITIONS

Linda Downs and Ellen Sharp, *Diego Rivera: A Retrospective*, exh. cat.
(Detroit: Detroit Institute of Arts, 1986), 91, 352, no. 221, fig. 194;
Del Istmo y sus mujeres: Tehuanas en el arte méxicano, exh. cat.
(Mexico City: Museo Nacional de Arte, 1992), 125, 182, no. 57

———

Gift of the Milton W. Lipper Estate, M.74.22.4

———⊗⊗⊗———

Rivera studied at the Academia de Bellas Artes San Carlos in Mexico City but spent the years from 1907 to 1921 in Europe, where he absorbed the most avant-garde artistic ideas, particularly cubism. In 1921 Rivera returned to Mexico from Paris and embarked on his career as a muralist. He was the central figure of the mural movement, seemingly covering acres of walls of government buildings with frescoes on the history and social issues of the Mexican people. Under the auspices of the Mexican minister of education, José Vasconcelos, Rivera traveled in 1922 to the isthmus of Tehuantepec in the western Mexican state of Oaxaca, where he was notably impressed by the beauty and nobility of the native people. He made hundreds of sketches of daily life in Tehuantepec, many of which were later employed in murals and paintings.

The subject of the folkloric dance *La zandunga* (known as the "Tehuantepec love dance") appeared in

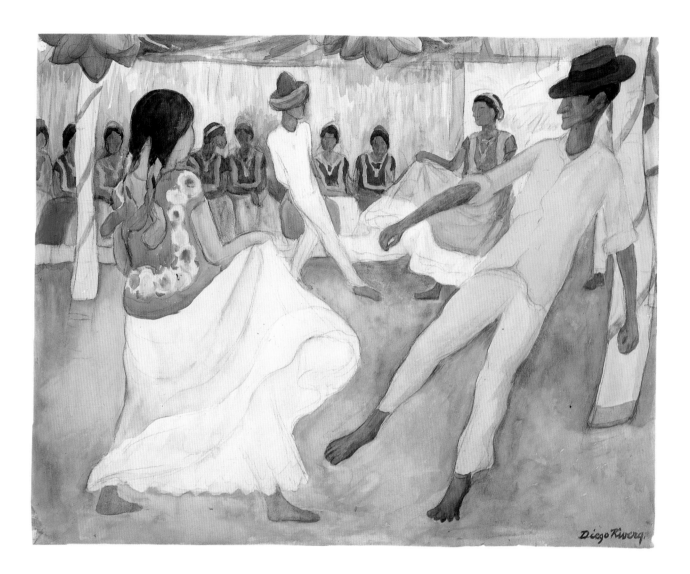

1928 in one of Rivera's murals in the Court of Labor in the Ministry of Education building in Mexico City.[1] The same year he repeated the subject in one of his largest canvases, formerly in the collection of the IBM International Foundation.[2] Rivera was in the United States for a highly controversial sojourn from 1930 to 1934 (his fresco in the new RCA building in Rockefeller Center was ordered destroyed shortly after its comple-tion), and his return to Mexico also signaled his renewed interest in some of his traditional subjects. In 1935, when the museum's watercolor was executed, Rivera painted several watercolors with themes from Tehuantepec. Another watercolor of 1935, illustrating a dance in Tehuantepec, was formerly in the collection of Hollywood director King Vidor.[3]

NOTES

1. Downs and Sharp, *Rivera*, 251, no. 6.

2. Sold at Sotheby's, New York, 17 May 1995, lot 7. The auction catalogue also includes a reproduction of the Mexico City mural.

3. *Diego Rivera*, 445, no. 441.

97

ROBERTO SEBASTIÁN MATTA ECHAURREN
Chiloé (Chile) 1912
Theory of Nature's Strategy (Polypsychology), 1939
Crayon
19 ¼ x 25 in. (48.9 x 63.5 cm)

PROVENANCE
Gift from artist to donor (1940s)

———

BIBLIOGRAPHY
Stephanie Barron with Sabine Eckmann, eds., *Exiles and Emigrés: The Flight of European Artists from Hitler*, exh. cat. (Los Angeles: Los Angeles County Museum of Art, 1997), 176, 405, no. 108, fig. 169

———

Gift of Barbara Poe Levee, M.86.111

After studying architecture at Catholic University in Santiago, Matta went to Paris in 1934 to work in the studio of Le Corbusier. His interests, however, soon shifted away from architecture, as he associated in 1937 with the circle of surrealist artists; he only began painting in 1938. With the advent of war in Europe he emigrated to New York in 1939, at which time this drawing was executed. His first solo exhibition was in 1942 at the Pierre Matisse Gallery, and he was included that year in the "Artists in Exile" exhibition at the same gallery as well as the "First Papers of Surrealism," organized by Marcel Duchamp and André Breton at the Whitlaw Reid Mansion, New York.

Together with Joan Miró and André Masson, Matta was one of the leading artists working in abstract surrealism. In the late 1930s, after his arrival in New York, Matta executed drawings remarkably similar to this one, with fine and feathery pencil strokes defining the sexually biomorphic forms, all set in fantastic and imaginary landscapes and softly colored with wax crayons.[1]

NOTE

1. For a good selection of Matta's drawings from this period, see Paul Schimmel, *The Interpretive Link: Abstract Surrealism into Abstract Expressionism, Works on Paper 1938–1948*, exh. cat. (Newport Beach, Calif.: Newport Harbor Art Museum, 1986), 114–23.

98

HENRI MATISSE

Cateau-Cambrésis (France) 1869–1954 Nice

Portrait of Martin Fabiani, about 1942

Charcoal

21 5/8 x 14 1/2 in. (54.9 x 36.8 cm)

INSCRIPTION

LOWER CENTER: Martin Fabiani par Henri Matisse 1/43 Nice

———

PROVENANCE

Martin Fabiani, Nice; Walter Feilchenfeldt, Zurich;

purchased by the museum in 1983

———

BIBLIOGRAPHY

Martin Fabiani, *Quand j'etais marchand de tableaux*

(Paris: Julliard, 1976), illus. after p. 96

———

EXHIBITION

Davis, 45–46, no. 51

Purchased with funds provided in honor of

Ebria Feinblatt by Lucille Ellis Simon, M.83.196

———⁂———

The subject of this portrait was born in Corsica about 1900. He began his career as an agent for the dealer and publisher Ambroise Vollard, and was one of the executors of Vollard's estate after his death in 1939.[1] Among Fabiani's publications are Matisse's *Dessins: Thèmes et variations* of 1943 and *Pasiphaé, chant de Minos* of 1944. This sheet was probably executed in Nice some time in 1942 when Fabiani, France's premier art publisher during World War II, was visiting Matisse regarding the publication of the group of drawings entitled *Thèmes et variations*. Matisse's portrait of the author of that book, Louis Aragon, though dated March 1943, was executed the previous year.[2] Another more linear portrait of Fabiani by Matisse, likewise dated January 1943, is in the Fondation Maeght, Saint-Paul de Vence.[3]

NOTES

1. Much personal information on Fabiani was provided by Mrs. Walter Feilchenfeldt (letter, departmental files).

2. Louis Aragon, *À la recontre de Matisse* (Saint-Paul de Vence: Fondation Maeght, 1969), 19; and Victor Carlson, *Matisse as a Draughtsman*, exh. cat. (Baltimore: Baltimore Museum of Art, 1971), 154–55, no. 67.

3. Jean-Louis Prat, *Dessins de la Fondation Maeght*, exh. cat. (Saint-Paul de Vence: Fondation Maeght, 1980), no. 116.

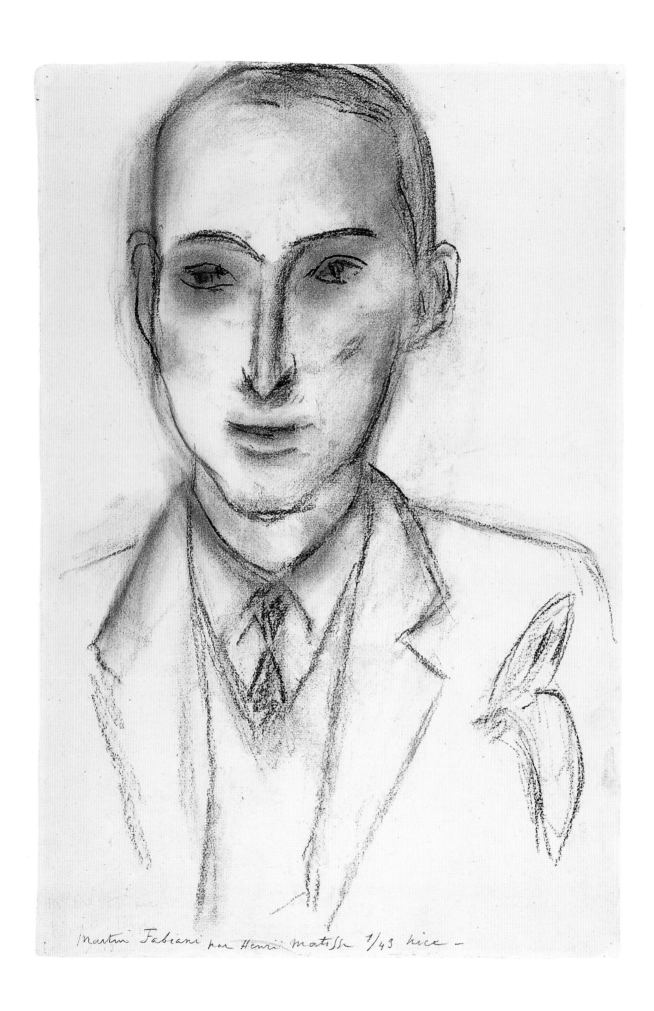

Martin Fabiani par Henri Matisse 1/43 Nice –

99

JACKSON POLLOCK

Cody (Wyoming) 1912–1956 East Hampton (New York)

Untitled, about 1945

Crayon, pastel, and gouache

25 ⁵⁄₈ x 20 ½ in. (65.1 x 52.1 cm)

INSCRIPTION

LOWER RIGHT: Jackson Pollock

———

PROVENANCE

Estate of the artist; Lee Krasner; Pollock-Krasner Foundation;
Jason McCoy Inc., New York; purchased by the museum in 1987

———

BIBLIOGRAPHY

Francis V. O'Connor and Eugene V. Thaw, *Jackson Pollock: A Catalogue Raisonné of Paintings, Drawings,
and Other Works* (New Haven and London: Yale University Press, 1978), 4: 76, no. 1001

———

EXHIBITION

Drawings by Jackson Pollock (New York: Sidney Janis Gallery, 1957), no. 24 in gallery list

———

Gift of Anna Bing Arnold and purchased with funds provided by Mr. William Inge,
Dr. and Mrs. Kurt Wagner, Graphic Arts Council Fund,
and Museum Acquisition Fund, M.87.65

This drawing was executed about 1945. During this pivotal period Pollock's style shifted from his symbolic/totemic manner, especially influenced by Native American art, toward the gossamer fluidity of his mature drip paintings. The thick and black calligraphic lines, circles, and almond-shaped forms in *Untitled* recall the figurative and hieroglyphic references in his works from the early 1940s. At the same time, the loosely flowing curves are interwoven with the architectonic structure of the straight lines of color, creating an effect of complex, flat planes that anticipate the tangled skeins of paint that Pollock employed in his mature drip paintings, the earliest of which dates from 1947.

Untitled was formerly owned by Lee Krasner, Pollock's wife and an important member of the abstract expressionist movement in her own right. They were married in 1945, about the time the drawing was created. That year Pollock also had his second solo exhibition at Peggy Guggenheim's New York gallery, Art of This Century. It was that exhibition that prompted critic Clement Greenberg to proclaim the artist as the most significant American painter of his generation. At that time Greenberg also singled out Pollock's gouaches as providing greater clarity in their artistic realization than the oils.

100

MARK ROTHKO
Dvinsk (Latvia) 1903–1970 New York
Geologic Reverie, 1946
Watercolor and gouache
21 3/4 x 29 3/4 in. (55.3 x 75.6 cm)

PROVENANCE
Mrs. Marion Pike

———

BIBLIOGRAPHY
Irving Sandler, *The Triumph of American Painting: A History of Abstract Expressionism*
(New York: Harper and Row, 1970), 177, fig. 13-1; Diane Waldman, *Mark Rothko, 1903–1970:*
A Retrospective, exh. cat. (New York: Solomon R. Guggenheim Museum, 1978), 271

———

EXHIBITIONS
Mark Rothko: Watercolors (New York: Mortimer Brandt Gallery, 1946);
Oils and Watercolors by Mark Rothko (San Francisco: San Francisco Museum of Art, 1946);
The Artist's Environment: The West Coast, exh. cat.
(Fort Worth: Amon Carter Museum of Western Art, 1962), 92;
Dawn Ades, *Dada and Surrealism Reviewed*, exh. cat.
(London: Arts Council of Great Britain, 1978), no. 15.43

———

Gift of Mrs. Marion Pike, M.53.5

———

Rothko moved to the United States in 1913 and studied briefly at Yale University and the Art Students League in New York. Under the influence of émigré European artists in the 1940s, Rothko moved from social realism to surrealist inspired works, responding particularly to mythic imagery. By the late 1940s he developed his mature nonobjective style with glowing rectangles and bands of color and was recognized as one of the great painters of his generation.

The year 1946, when *Geologic Reverie* was created, marks the fruition of Rothko's surrealist period.[1] Shortly thereafter he began painting more abstract works known as multiforms, with floating areas of color that would become his trademark. As noted by Diane Waldman, the works of the mid-1940s "are the culmination of Rothko's search for the middle ground between surrealism and abstraction. The animation of twirling or revolving forms, sensitivity to nuance of color, shape and detail and careful balance of large and small areas in these lyrical works are unexcelled. Rothko now achieves a synthesis of form, line, and color, which rivals that of the best surrealist painting of the period."[2]

NOTES
1. See Robert Rosenblum, *Mark Rothko: Notes on Rothko's Surrealist Years*, exh. cat. (New York: Pace Gallery, 1981). Rosenblum's essay from the catalogue also appears in Marc Glimcher, ed., *The Art of Mark Rothko: Into an Unknown World* (New York: Clarkson N. Potter, 1991), 13–19.
2. Waldman, *Rothko*, 45.

IOI

MORRIS GRAVES
Fox Valley (Oregon) 1910
Disintegrated and Reanimated, 1947
Tempera on rice paper
13 ¼ x 19 ¾ in. (33.7 x 50.2 cm)

INSCRIPTION

LOWER RIGHT: M Graves 47

———

PROVENANCE

Willard Gallery, New York; Charles Laughton, Los Angeles; Taft B. Schreiber

———

EXHIBITION

Frederick S. Wight, John I. H. Baur, and Duncan Phillips, *Morris Graves*, exh. cat.
(Los Angeles: Art Galleries, University of California, 1956), 44–45

———

Taft B. Schreiber bequest in memory of Charles Laughton, M.81.142.3

——— ❦ ———

In 1945, shortly after the bombing of Hiroshima and Nagasaki, Graves applied for a Guggenheim Foundation fellowship in order to enable him to travel to Japan. He was especially interested in fostering peace through the marriage in his art of Eastern and Western values. He received the fellowship but spent much of 1946 trying to convince the authorities to grant him permission to travel to Japan; the United States government's policy restricted entry to the territory of its recent enemy. In February 1947 Graves sailed to Hawaii, enrolled in a Japanese language course, and continued his efforts, eventually to no avail, to visit Japan.

Graves was inspired by the Chinese ritual bronzes in the collection of the Honolulu Academy of Art. The museum's drawing is from Graves's *Ritual Bronze* series of 1947, executed during his six months in Hawaii.[1] Like other paintings in this group, *Disintegrated and Reanimated* combines an image of a bird with elements suggestive of the form and decorative patterns on these Chinese vessels. The titles of the works in the series also reveal aspects of the artist's personal philosophy, in this case a reference to the phoenixlike recovery of postwar Japan. Describing this drawing, Graves said, "Urgency re-enlivens, reanimates the head and it turns in contemplation of its disintegrating body (the body of the human race) and meditates upon its vital origin, its once spiritually illuminated past."[2]

NOTES

1. For other paintings in this series, see Ray Kass, *Morris Graves: Vision of the Inner Eye*, exh. cat. (Washington, D.C.: Phillips Collection, 1983), 48–53, pls. 83–85, 88.
2. Wight, Baur, and Phillips, *Graves*, 44.

102

WILLEM DE KOONING

Rotterdam (Holland) 1904–1997 East Hampton (New York)

Woman, about 1952

Pastel, graphite, and charcoal

14 ³⁄₈ x 12 ¹⁄₈ in. (36.5 x 30.8 cm)

INSCRIPTIONS

UPPER LEFT: 3; LOWER RIGHT: de Kooning

PROVENANCE

Fourcade, Droll, Inc., New York; purchased by the museum in 1975

BIBLIOGRAPHY

Stephanie Barron, "De Kooning's Woman, c. 1952:

A Drawing Recently Acquired by the Museum,"

Los Angeles County Museum of Art Bulletin 22 (1976): 66–71;

Los Angeles County Museum of Art Handbook

(Los Angeles: Los Angeles County Museum of Art, 1977), 148–49;

Lorna Price, *Masterpieces from the Los Angeles County Museum of Art Collection*

(Los Angeles: Los Angeles County Museum of Art, 1988), 134

EXHIBITIONS

Philip Larson and Peter Schjeldahl, *De Kooning Drawings/Sculptures*, exh. cat.

(Minneapolis: Walker Art Center, 1974), no. 64, pl. 41;

David W. Steadman, *Works on Paper, 1900–1960, from Southern California Collections*, exh. cat.

(Claremont: Montgomery Art Gallery, Pomona College, 1977), no. 9;

Paul Cummings, Jörn Merkert, and Claire Stoullig, *Willem de Kooning: Drawings, Paintings, Sculpture*,

exh. cat. (New York: Whitney Museum of American Art, 1983), no. 55

Purchased with funds provided by the estate of

David E. Bright, Paul Rosenberg and Co., and Lita A. Hazen, M.75.7

De Kooning received his formal art education at the Rotterdam Akademie voor Beeldende Kunsten en Wettenschappen but moved permanently to the United States in 1926. In the 1930s he painted murals for the Federal Art Project. With his first solo exhibition in 1948 De Kooning was recognized as one of the central figures in postwar American abstract expressionism. In June 1950 he moved away from his earlier black-and-white abstractions when he began preliminary work on what would become one of his landmark paintings, *Woman I* of 1950–52 in the Museum of Modern Art. Figures of women were De Kooning's predominant subjects in the early 1950s, and they remained highly controversial in evaluations of his career. He later moved to more lyrical formal language and to a very sparse and elegant style.

He produced numerous drawings (at least thirty-four according to Stephanie Barron's count) in connection with the series, often with pastel, as in the museum's sheet. The museum's drawing may be related to De Kooning's painting *Woman IV* of 1952–53 in the Nelson-Atkins Museum in Kansas City. In both works the figure is wearing a yellow blouse with black straps and a red skirt, with suggestions of a chair on which the woman is seated. This drawing is unusual within the series because the figure lacks the menacing presence of some of the works in the series, most of which have large staring eyes and grotesque mouths with bared teeth. In this sheet the head has been abstracted to a boxlike rectangular form intersected by a swirling parabola that echoes the forms of the figure's voluminous breasts.

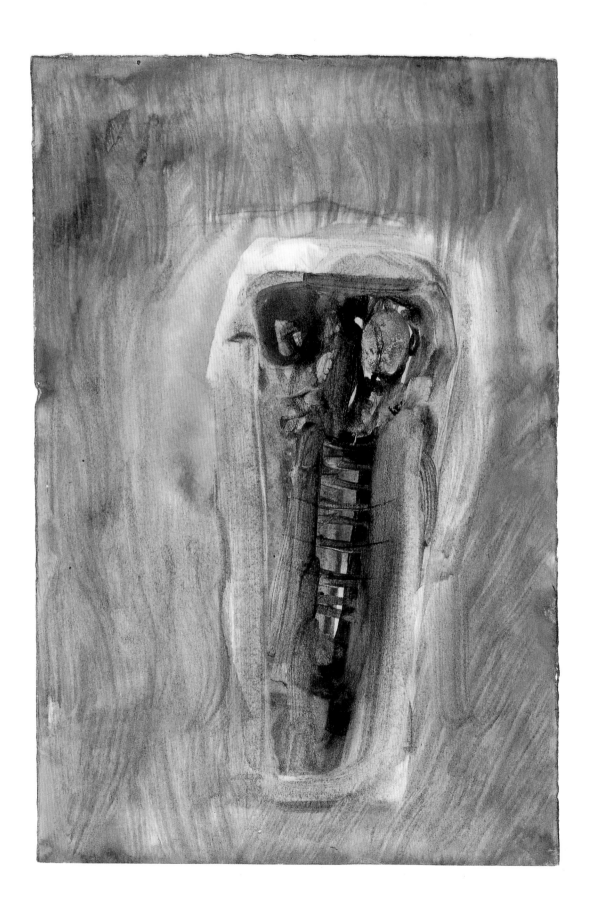

103

EVA HESSE

Hamburg (Germany) 1936–1970 New York

Untitled, 1960

Gouache, ink, and wash

9 x 6 in. (22.9 x 15.2 cm)

PROVENANCE

Robert Miller Gallery, New York; purchased by the museum in 1989

———

EXHIBITION

Eva Hesse Gouaches 1960–61, exh. cat.
(New York: Robert Miller Gallery; Paris: Renos Xippas Gallery, 1991), no. 35

———

Graphic Arts Council Fund, M.89.106

———⊗———

To escape Nazi persecution, Hesse's family immigrated in 1939 to New York. There she attended Cooper Union and later Yale University, where she studied painting with Josef Albers and Rico Lebrun. After graduation in 1959, she moved to New York. In 1964 she traveled to Germany and began sculpture, becoming in her abbreviated career one of the leading sculptors of her generation. She died of a brain tumor at the age of thirty-four.

In 1960 and 1961, when the museum's sheet was drawn, Hesse still considered herself a painter. During this two-year period she concentrated on small drawings executed in brown, gray, and black washes. Despite its small scale (particularly in the context of many late-twentieth-century drawings), this composition has remarkable visual power because of the focus on the organic, remotely sexual form centered on the sheet. While imaginary, this form anticipates some of the visual issues explored later by Hesse in her sculpture.

104
EDWARD RUSCHA
Oklahoma City 1937

L.A., 1970
Gunpowder and pastel
11 ½ x 29 in. (29.2 x 73.7 cm)

INSCRIPTION
LOWER LEFT: E. Ruscha 1970

———

PROVENANCE
Purchased by the museum from the artist in 1972

———

BIBLIOGRAPHY
Bruce Davis, *Made in L.A.: The Prints of Cirrus Editions*
(Los Angeles: Los Angeles County Museum of Art, 1995), 28

———

Gift of the Contemporary Art Council, M.72.7.3

———

In 1956, after graduating from high school, Ruscha moved from Oklahoma City to Los Angeles with a high school friend, musician and writer Mason Williams. He attended Chouinard Art Institute, intending to become a commercial artist but eventually gravitating to painting. In 1962 he made his first lithographs, and in 1963 he published his first book, *Twentysix Gasoline Stations*. Ruscha has become one of the best-known artists from Los Angeles, at the forefront of American pop art with his use of common objects and deadpan idiomatic text as the subject of his art.

From 1968 to 1970 Ruscha worked exclusively on drawings and prints. During this period he also experimented with the incorporation of various organic and nonart materials into his graphic art. Among the most notable examples are the 1970 portfolio *News, Mews, Pews, Brews, Stews, Dues*, printed in London with various English foodstuffs, and the screenprints *Pepto-Caviar*

Hollywood of 1970 and *Fruit-Metrecal Hollywood* of 1971, printed at Cirrus Editions in Los Angeles.[1] Beginning in 1967 Ruscha used gunpowder rather than the more traditional charcoal or graphite in his drawings.[2] Ruscha chose gunpowder as a medium because he liked the brownish tonality of it compared to conventional charcoal. The gunpowder was applied by the artist with cotton swabs, then secured with a commercial fixative. Words seemingly floating in air, either in the form of thin ribbons or pieces of folded paper, as in *L.A.*, were frequently the subjects of these drawings, such as *Lips* of 1970 in the collection of Byron Meyer, San Francisco,[3] and *Are* of 1971 in the Los Angeles County Museum of Art. The museum also has three other gunpowder and pastel drawings, though they feature objects suspended in space; *Suspended Book (Crackers)* of 1970, *Aspirins* of 1971, and *Ball Bearing and Pencil* of 1971.

NOTES

1. Davis, *Made in L.A.*, 21, 338, 340.
2. For this period in Ruscha's work, see Peter Plagens, "Ed Ruscha, Seriously," in Anne Livet, *The Works of Edward Ruscha*, exh. cat. (San Francisco: San Francisco Museum of Modern Art, 1982), 36–37.
3. Ibid., no. 75, pl. 45.

INDEX

Numbers refer to catalogue entries

A

AACHEN, HANS VON 10

ARCHIPENKO, ALEXANDER 80

———

B

BANDINELLI, BACCIO 6

BARBIERI, GIOVANNI FRANCESCO *see Guercino*

BEARDSLEY, AUBREY 65

BENTON, THOMAS HART 93

BERRETTINI, PIETRO *see Pietro da Cortona*

BERTIN, JEAN-VICTOR 44

BISCAINO, BARTOLOMEO 20

BORDONE, PARIS 1

BOUCHER, FRANÇOIS 30

BRAQUE, GEORGES 72

BURNE-JONES, EDWARD 54

———

C

CAMBIASO, LUCA 4, 8

CANUTI, DOMENICO MARIA 24

CASSATT, MARY 66

CASTIGLIONE, GIOVANNI BENEDETTO 21

CHAGALL, MARC 81

CHASSÉRIAU, THÉODORE 49

CRESTI, DOMENICO *see Passignano*

D

DEGAS, EDGAR 50, 57–58

DELACROIX, EUGÈNE 48

DEMUTH, CHARLES 79

DERAIN, ANDRÉ 73

DICKINSON, PRESTON 87

DIX, OTTO 82

DORÉ, GUSTAVE 53

———

E

D'ENRICO, ANTONIO *see Tanzio da Varallo*

———

F

FERRI, CIRO 27

———

G

GANDOLFI, GAETANO 37

GLEIZES, ALBERT 77

GOGH, VINCENT VAN 59–60

GRAVES, MORRIS 101

GROSZ, GEORGE 85

GUARDI, ANTONIO 33

GUARDI, FRANCESCO 38

GUERCINO 17, 19

———

H

HASSAM, CHILDE 78

HENNER, JEAN-JACQUES 61

HESSE, EVA 103

HOMER, WINSLOW 64

[239]

I

INGRES, JEAN-AUGUSTE-DOMINIQUE 47

ISRAËLS, JOZEF 52

J

JACOPO, GIOVANNI BATTISTA DI *see Rosso Fiorentino*

JORDAENS, JACOB 22

K

KANDINSKY, WASSILY 89

KOKOSCHKA, OSKAR 69

KOLLWITZ, KÄTHE 71, 94

KOONING, WILLEM DE 102

L

LAGRENÉE THE YOUNGER, JEAN-JACQUES 40

LÉGER, FERNAND 86, 88

LETHIÈRE, GUILLAUME-GUILLON 42

LUTI, BENEDETTO 29

M

MANETTI, RUTILIO 14

MARATTA, CARLO 26

MARCOUSSIS, LOUIS 83

MARIN, JOHN 91

MATISSE, HENRI 92, 98

MATTA ECHAURREN, ROBERTO SEBASTIÁN 97

MAZZOLA, GIROLAMO FRANCESCO MARIA *see Parmigianino*

MEIDNER, LUDWIG 75

MILLET, JEAN-FRANÇOIS 51

N

NEGRETTI, JACOPO *see Palma Giovane*

NOLDE, EMIL 90

P

PALMA GIOVANE 11

PARMIGIANINO 2

PASSIGNANO, DOMENICO 12

PENNELL, JOSEPH 62

PICASSO, PABLO 68, 95

PIETRO DA CORTONA 23

PINO, MARCO 5

PIOLA, DOMENICO 28

PISSARRO, CAMILLE 55–56

POLLOCK, JACKSON 99

PRENDERGAST, MAURICE 76

PRUD'HON, PIERRE-PAUL 46

R

REDON, ODILON 74

RENI, GUIDO 15

RIVERA, DIEGO 96

ROBERT, HUBERT 39

ROSSO FIORENTINO 3

ROTHKO, MARK 100

RUSCHA, EDWARD 104

S

SAINT-OURS, JEAN-PIERRE 41

SARGENT, JOHN SINGER 70

SIGNAC, PAUL 67

SOLIMENA, FRANCESCO 31

T

TAILLASSON, JEAN-JOSEPH 43

TANZIO DA VARALLO 18

TAUNAY, NICOLAS-ANTOINE 47

TIBALDI, PELLEGRINO 7

TIEPOLO, GIOVANNI BATTISTA 34–35

TIEPOLO, GIOVANNI DOMENICO 36

TINTORETTO, DOMENICO 13

———

V

VAN LOO, CARLE 32

VEDDER, ELIHU 63

VELDE, ADRIAEN VAN DE 25

VIGNALI, JACOPO 16

VUILLARD, ÉDOUARD 84

———

Z

ZUCCARO, TADDEO 9